The Print

LIFE LIBRARY OF PHOTOGRAPHY

The Print

Revised Edition

BY THE EDITORS OF TIME-LIFE BOOKS

TIME-LIFE BOOKS, ALEXANDRIA, VIRGINIA

For information about any
Time-Life book, please write:
Reader Information, Time-Life Books,
541 North Fairbanks Court,
Chicago, Illinois 60611.

TIME-LIFE is a trademark of
Time Incorporated U.S.A.

Library of Congress Cataloguing in Publication Data
Time-Life Books.
 The print.
 (Life library of photography)
 Bibliography: p.
 Includes index.
 1. Photography — Printing processes. I. Title.
II. Series.
TR330.T54 1981 770'.28 81-9009
ISBN 0-8094-4164-0 AACR2
ISBN 0-8094-4162-4 (retail ed.)
ISBN 0-8094-4163-2 (lib. bdg.)

ON THE COVER: A girl's face seems
to look through a lens system from an
enlarger in this picture of a print,
reproduced here in both negative and
positive forms. Evelyn Hofer made
the photograph by removing the light-
distributing condenser lens unit from
her enlarger and placing it over a portrait
of the girl and aiming her camera
directly down through the condenser.
The corrugated ring is part of
the lens mount, and the bright spots
on the lens surfaces are reflections of
windows in the studio.

Contents

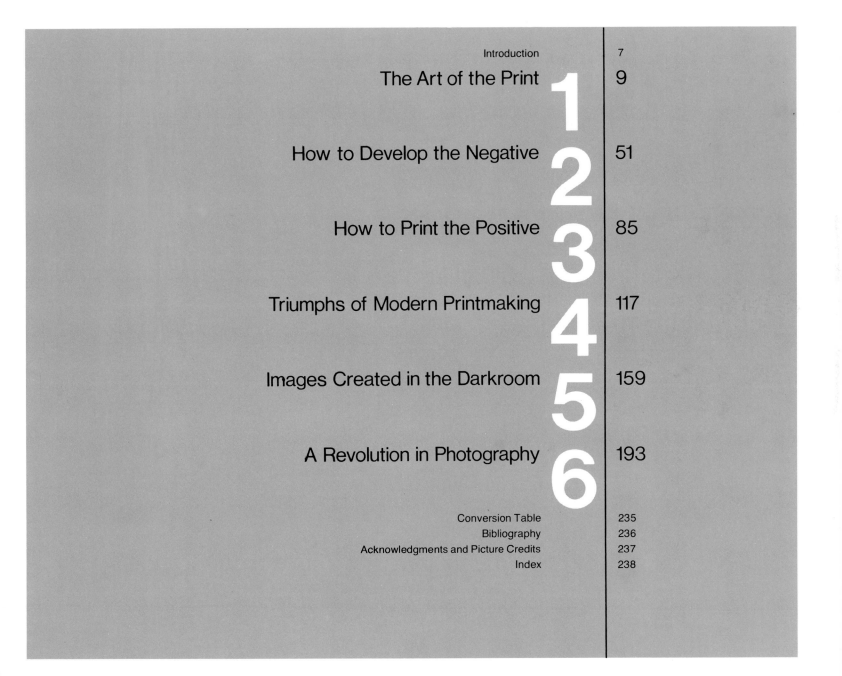

Time-Life Books Inc.
is a wholly owned subsidiary of
TIME INCORPORATED

FOUNDER: Henry R. Luce 1898-1967

Editor-in-Chief: Henry Anatole Grunwald
President: J. Richard Munro
Chairman of the Board: Ralph P. Davidson
Executive Vice President: Clifford J. Grum
Chairman, Executive Committee: James R. Shepley
Editorial Director: Ralph Graves
Group Vice President, Books: Joan D. Manley
Vice Chairman: Arthur Temple

TIME-LIFE BOOKS INC.
MANAGING EDITOR: Jerry Korn
Executive Editor: David Maness
Assistant Managing Editors: Dale M. Brown
(planning), George Constable, Martin Mann,
John Paul Porter, Gerry Schremp (acting)
Art Director: Tom Suzuki
Chief of Research: David L. Harrison
Assistant Art Director: Arnold C. Holeywell
Assistant Chief of Research: Carolyn L. Sackett
Assistant Director of Photography: Dolores A. Littles

CHAIRMAN: John D. McSweeney
President: Carl G. Jaeger
Executive Vice Presidents: John Steven Maxwell,
David J. Walsh
Vice Presidents: George Artandi (comptroller);
Stephen L. Bair (legal counsel); Peter G. Barnes;
Nicholas Benton (public relations); John L. Canova;
Beatrice T. Dobie (personnel); Carol Flaumenhaft
(consumer affairs); James L. Mercer (Europe/South
Pacific); Herbert Sorkin (production); Paul R. Stewart
(marketing)

LIFE LIBRARY OF PHOTOGRAPHY
EDITORIAL STAFF FOR THE
ORIGINAL EDITION OF *THE PRINT*:
EDITOR: Robert G. Mason
Text Editors: James A. Maxwell, Peter Chaitin
Designer: Raymond Ripper
Assistant Designer: Herbert H. Quarmby
Staff Writer: Peter Wood
Chief Researcher: Peggy Bushong
Researchers: Kathleen Brandes,
Rosemarie Conefrey, Sigrid MacRae,
Gail Hansberry, Shirley Miller, Don Nelson,
Kathryn Ritchell
Art Assistant: Jean Held

EDITORIAL STAFF FOR
THE REVISED EDITION OF *THE PRINT*:
EDITOR: Edward Brash
Designer/Picture Editor: Sally Collins
Chief Researcher: W. Mark Hamilton
Text Editor: John Manners
Researchers: Elise Ritter Gibson,
Jeremy N. P. Ross, Jean Strong
Assistant Designer: Kenneth E. Hancock
Art Assistant: Carol Pommer
Editorial Assistant: Jane H. Cody

Special Contributor:
Mel Ingber (technical research)

EDITORIAL PRODUCTION
Production Editor: Douglas B. Graham
Operations Manager: Gennaro C. Esposito,
Gordon E. Buck (assistant)
Assistant Production Editor: Feliciano Madrid
Quality Control: Robert L. Young (director),
James J. Cox (assistant), Daniel J. McSweeney,
Michael G. Wight (associates)
Art Coordinator: Anne B. Landry
Copy Staff: Susan B. Galloway (chief),
Victoria Lee, Ricki Tarlow, Celia Beattie
Picture Department: Charlotte Marine
Traffic: Kimberly K. Lewis

CORRESPONDENTS
Elisabeth Kraemer (Bonn); Margot Hapgood,
Dorothy Bacon, Lesley Coleman (London); Susan
Jonas, Lucy T. Voulgaris (New York); Maria Vincenza
Aloisi, Josephine du Brusle (Paris); Ann Natanson
(Rome). Valuable assistance was also provided by:
Judy Aspinall (London); Carolyn T. Chubet, Miriam
Hsia, Christina Lieberman (New York); Mimi Murphy
(Rome); Katsuko Yamazaki (Tokyo).

The editors are indebted to the following individuals
of Time Inc.: George Karas, Chief, Time-Life Photo
Lab, New York City; Herbert Orth, Deputy Chief,
Time-Life Photo Lab, New York City; Melvin L. Scott,
Assistant Picture Editor, Life, New York City; Photo
Equipment Supervisor, Albert Schneider; Time-Life
Photo Lab Color Technicians, Peter Christopoulos,
Luke Conlon, Henry Ehlbeck, Robert Hall.

Many photographers consider a finished black-and-white print an end in itself. For it is in this final stage of photography—in the production of a negative and print—that the creative vision is realized. In its most exalted form, a print can stand on its own as a true work of art—as do the scores of outstanding prints reproduced in this book.

Recognition of the artistic worth of the photographic print first came in the early decades of the 20th Century, largely as a result of the efforts of such pioneers as Alfred Stieglitz in the United States, László Moholy-Nagy and John Heartfield in Germany, and Man Ray in France. Today, artists who are finding new ways to express personal visions in the print are flourishing as never before. Galleries, museums and collectors vie for exam-ples of their work, driving prices skyward.

In this revised edition, notable prints by 14 photographers appear for the first time in the series. And printmaking tech-niques that have grown popular since the volume was first published in 1970 are on pages 178-192; one of them—the gum-bichromate process—is a revival of a process perfected around the turn of the century by an associate of Alfred Stieg-litz': a young lithographer's assistant from Milwaukee named Edward Steichen.

To deserve attention a print must be seen in the mind's eye even before the shutter is tripped, but it still must be made in the darkroom. To ease this proc-ess, modern chemical compounds, de-veloping tanks and printing devices are available to eliminate guesswork; they do not, however, eliminate the need for judg-ment and understanding. The pictorial result of a black-and-white photograph depends entirely on material substance: deposits of metallic silver in the negative and print. Those deposits must convey the vision of the mind's eye, and how they are laid down can be controlled at almost every step during processing.

It is possible to compensate for out-of-the-ordinary conditions during picture taking—too little light or too much, a scene that is too uniform in tone or too varied. But it is also possible to turn the influences of processing to purely imagi-native ends, to alter a scene to suit the photographer's own esthetic intent (how-ever far removed it is from the physical reality of the natural world), or to create a wholly new pattern of lights and darks that could never be found in reality.

The Editors

The Art of the Print 1

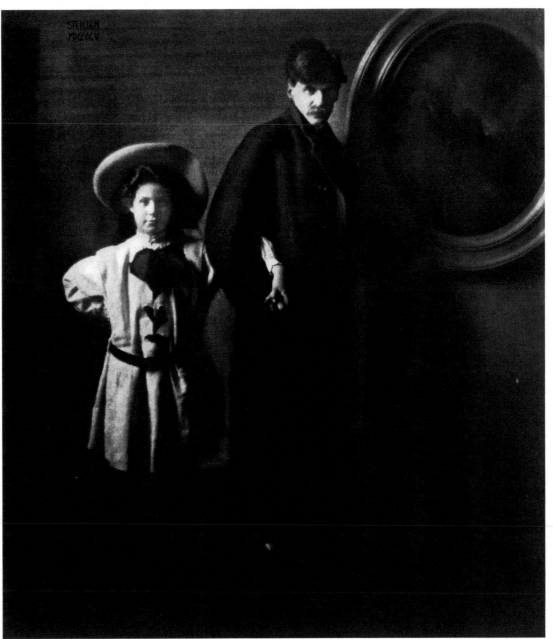

EDWARD STEICHEN: *Platinum print of Alfred Stieglitz and his daughter, Kitty, New York,* 1905

The Artist as Photographer

Today, in New York City alone, more than 40 galleries display and sell the works of art photographers; at the turn of the century, such exhibitions were almost unknown. Today, in the museums of the world, the photographic print occupies an honored place among the arts; in 1900 not a single museum in America included photographs in its permanent collection. Today, art critics of major newspapers and magazines regularly review the work of photographers; not many decades ago most would have thought such an assignment beneath contempt—or at least beneath their delicate sensibilities. That such a drastic change has occurred reflects, in very large measure, the achievement of one man—an arrogant, brilliant, irritating, uncompromising, irresistible force of nature named Alfred Stieglitz.

His influence on photography, and, indeed, on all 20th Century art, is hard to overestimate. Not only did he force curators and critics to yield to photography, however hesitantly, a place beside elder media, but by influence, example and sheer force of personality he twice set the style for American photography: first toward romanticized pictures suggesting impressionistic paintings; and later, in a dramatic reversal, toward sharply realistic works that stood proudly on their own as photographs. His interest in creative photography inevitably led him into a companion interest in all forms of art, and he introduced America to what is now called modern art, providing the first exhibits in the United States of the works of such European giants as Cézanne, Matisse and Picasso, as well as calling attention to such young Americans as John Marin, Arthur Dove and Georgia O'Keeffe. For more than four decades he encouraged the intellectually stimulating in art, and in the end he lived to see most of his judgments confirmed by patrons and critics, whose sophisticated tastes could be traced in part to his pioneering efforts.

The son of a prosperous woolen merchant, Alfred Stieglitz was born in Hoboken, New Jersey, on New Year's Day, 1864. His father, Edward, had immigrated from Germany in 1850 and, after achieving modest financial success as a precision instrument manufacturer, joined the Union Army at the outbreak of the Civil War. In 1863 he was discharged a lieutenant and that same year married Hedwig Werner, a young lady of German-Jewish background similar to his own. In the years that followed, the elder Stieglitz prospered greatly in the textile business, so much so that he soon accumulated what in those days was a considerable fortune, $400,000, enough to permit him to retire from business, buy a town house in Manhattan and savor the life of a cultured bon vivant. Thus it was in comfortable, secure surroundings that Alfred Stieglitz and his five sisters and brothers were raised. From fall through spring, life was a round of visits from New York's intelligentsia —successful writers, painters, actors and art patrons, who gathered each Sunday afternoon in the salon of the Stieglitz home for witty and often pen-

etrating discussions. The teen-age Alfred was not only encouraged to join the conversation but also served as keeper of the keys to the wine cellar. On signal, he ran down the staircases to choose the vintages to slake the thirst of his father's talkative guests.

Summers were rustic. Each June, Edward Stieglitz bundled his family and servants off to Lake George in upstate New York. It was at Lake George that young Alfred first took an active interest in photography. It was a characteristic encounter in which the youngster, then 11 years old, displayed all the self-assurance and forthrightness for which he later became famous. He persuaded a local portrait photographer to permit him in the darkroom to watch a blank plate turn into a photograph and stood by fascinated as the picture appeared as if by magic in the developing bath. But later, as the photographer was retouching a plate, Stieglitz demanded, "Why are you doing that?" "Makes 'em look more natural," was the photographer's reply. Instinctively recognizing (he later claimed) that the retouching detracted from the impact of the picture's realism, young Stieglitz startled his host with a flat, "*I* wouldn't do that if I were you."

But photography was then only a passing fancy for young Stieglitz. Mathematics had more appeal, and this interest led Alfred, after attending the City College of New York from 1879 to 1881, to Germany—then the world center of learning in science and engineering—to study at the Berlin Polytechnic. At this point, the young man's future seemed assured: a degree in engineering from the prestigious Polytechnic would almost guarantee him a leading role in the rapid industrial expansion of the United States. But one day in 1883 Stieglitz noticed a camera in a Berlin shopwindow as he was strolling by. Recalling the event many years later, he wrote: "I bought it and carried it to my room and began to fool around with it. It fascinated me, first as a passion, then as an obsession."

Before long Stieglitz had dropped out of his engineering courses and enrolled in a class in photochemistry. Soon he was roaming through the alleys and boulevards of Berlin, making pictures of street scenes, buildings and ordinary people. Often he took the same view several times to satisfy himself that he had captured its essence, and then, when the day's outing was over, returned to his room and, improvising a light-tight tent from a stretched-out blanket, developed his plates. It was ironic that this man, who was to become a master craftsman of the photographic print, never owned a fully-equipped darkroom until a few years before old age and illness forced him to abandon his career as an active photographer.

Frequently Stieglitz left Berlin for picture-taking excursions to south Germany, Switzerland and Italy. Unlike the many photographers of the era who imitated the sentimental scenes of academic paintings by posing costumed

13

models against painted backdrops, Stieglitz made pictures of real people engaged in workaday activities: peasant girls swinging along a country lane, fishermen beside beached boats, street urchins lounging near a well and laughing at some private joke. This last picture he submitted to a contest that was sponsored by a British magazine, and it won a medal and a small cash award. It had caught the eye of the contest's judge, the prominent photographer Dr. Peter Henry Emerson, who remarked that it was "the only spontaneous work" entered.

Encouragement from so eminent an authority convinced Stieglitz that his future lay with photography. Increasingly, he saw the potential of the photographic print as a work of art, equal in every respect to the work of the painter. And the more he became committed to this view, the angrier he grew when it was challenged. "Artists who saw my early photographs," Stieglitz recalled, "began to tell me that they envied me; that they felt my photographs were superior to their paintings, but that, unfortunately, photography was not an *art*. . . . I could not understand why the artists should envy me for my work, yet, in the same breath, decry it because it was *Machine-Made* —their . . . 'art' painting—because *Hand-Made*—being considered necessarily superior. . . . Then and there I started my fight . . . for the recognition of photography as a new medium of expression, to be respected in its own right, on the same basis as any other art form."

In 1890, after nine years abroad, Stieglitz returned to America. But in the New York of the 1890s, the possibilities of earning a livelihood as a creative photographer were nil, and when his father offered to give him an interest in a small printing and photoengraving business, the young photographer, more out of despair than enthusiasm, seized upon the opportunity. For five years, Stieglitz and his partners tried to run the business. But being totally inexperienced they managed poorly, and finally, in 1895, Stieglitz turned over his share of the business to his partners and returned to his photographic interests on a full-time basis.

For even during these early, painful years in New York, Stieglitz had remained a passionate photographer of life as it is really lived. Carrying a hand-held camera he roamed the city streets, training his lens upon the solitary figure of a streetcar conductor watering his horse or a coachman urging his team up Fifth Avenue in a blizzard. He made picture after picture of city life—brooding and powerful studies that were to become recognized as technical and artistic milestones. His advice to photographers on the making of unposed pictures—using a portable, or "hand," camera—remains as valid today as ever. "The one quality absolutely necesssary for success in hand camera work," wrote Stieglitz, "is *Patience*. . . . It is well to choose your subject . . . and carefully study the lines and lighting. After having deter-

mined upon these watch the passing figures and await the moment in which everything is in balance; that is, satisfies your eye. This often means hours of patient waiting. My picture, 'Fifth Avenue, Winter,' is the result of a three hours' stand during a fierce snow-storm . . . awaiting the proper moment." Thus, it was at the very moment when such painters as John Sloan and Robert Henri of the "ashcan school" were turning to American city streets for their subject matter that Stieglitz was also discovering the beauty to be achieved through realism.

It was during this period, in 1893, that Stieglitz married Emmeline Obermeyer, the wealthy young sister of one of his partners in the ill-fated photoengraving venture. The marriage was never a particularly happy one, for Emmeline, try though she might, could not share her husband's growing enthusiasm for either photography or art. She was a typical well-brought-up young woman of the late Victorian period, primarily concerned with establishing a comfortable home, raising their one child (a girl, Kitty, born in 1898), making grand tours of Europe, and buying clothes. Yet at first Emmeline was an attentive wife. She spent much of her time accompanying Stieglitz to the darkroom of New York's Camera Club, where she dutifully and silently sat watching him develop pictures. In time she became considerably less docile, fretting over her husband's disheveled appearance, objecting to his interests and imploring him to moderate what she considered his scandalous ideas on art and society. Finally, in 1917, after many years of discord, Emmeline ordered her husband out of the house in a fit of jealousy, and the stormy marriage came to an end.

It was in the year of their marriage that Stieglitz took what was to be a fateful step; he assumed the part-time position of editing the prestigious periodical the *American Amateur Photographer,* and with it he also assumed the power to influence the course of photography. Determined to enhance the artistic reputation of the photographic print, he rejected pictures from longtime contributors with the brusque note, "technically good, pictorially rotten." Photographers accustomed to having their work accepted without question bridled at the editor's dictatorial manner, and circulation fell; when the publisher complained, Stieglitz merely ignored him. Even then, at the very beginning of his career, Stieglitz just could not bend with the wind. And it was a matter of principle that brought about his abrupt resignation in 1896, when the publisher refused to print a credit line with pictures by a photographer whose work Stieglitz favored.

By this time, Stieglitz had established an enviable reputation as a photographer. Time and again he had won medals in European competitions, and it was not difficult for him to find a new forum for his ideas. In 1897, at the request of the Camera Club of New York, he took over the quarterly publi-

cation of that society, a magazine he renamed *Camera Notes*. The Camera Club at this time was all but moribund, for the fad for photography as a rich man's pastime was beginning to wear thin. The club's members—most of whom were more interested in socializing than in taking pictures—had even been casting about for a new purpose; some of them had suggested abandoning photography in favor of bicycling.

Stieglitz, of course, had a very different end in mind. He was determined to turn the club, or at least its magazine, into a showcase for the finest photographs to be found. It was his intention, he announced, to find and publish only those photographs that showed "the development of an organic idea, the evolution of an inward principle; a picture rather than a photograph, though photography must be the method of graphic representation." If this meant ignoring the work of prominent club members in favor of nonmembers and even unknowns, Stieglitz could not have cared less. Some members — primarily those of little or no ability — attacked Stieglitz for being undemocratic. They accused him of running the magazine for the benefit of the few and neglecting the majority.

With *Camera Notes* as his personal platform, Stieglitz began gathering about him a circle of talented photographers, many of whom had never before seen their pictures published. There were, among others, Gertrude Käsebier, a New York matron who operated a professional portrait studio. Her metier was idyllic pictures of women and children tastefully posed in the style of old masters. Another New Yorker, Joseph Keiley, a lawyer by profession, submitted moody landscapes to *Camera Notes,* and from Boston, F. Holland Day, a wealthy eccentric, sent in mysteriously lit studies of male nudes. Publication of these photographers encouraged others. From Newark, Ohio, a young bookkeeper named Clarence White sent romantic landscapes and portraits. From Milwaukee, Edward Steichen, an apprentice lithographer, submitted landscapes reminiscent of the work of impressionistic painters. Steichen, who wanted to be a painter, eventually went to Paris to study. On his way Steichen stopped off in New York to salute Stieglitz and to promise that whatever his future as a painter, he would never abandon the art of photography.

Despite the success of *Camera Notes,* Stieglitz was far from satisfied. He may have convinced a few that photography could be an art, but for most of the experts in the art establishment, the picture made with a camera remained a soulless illustration. Faced with their hostility, Stieglitz came to realize that to achieve recognition for photography he had to find new ways to publicize his views. In 1901 the National Arts Club offered an avenue. The Arts Club had been founded by Charles de Kay, art editor of *The New York Times,* and one of the few American critics sympathetic to Stieglitz' ideas.

"One day," reminisced Stieglitz, "he appeared at the Camera Club and said, 'Stieglitz, why don't you show . . . American photographs in New York. . . .' I told him that there was no place in New York fit to hold such a show, and there wasn't. . . . 'Well, de Kay,' I said, 'if your club will give me a room in your gallery to show such prints as I see fit, and let me hang them in my own way, not a soul coming into the room before I open the doors, it's a go.' " It was typical of Stieglitz to demand such complete control; when de Kay suggested that his club's art committee might like to have some say in the matter, Stieglitz archly informed him, "I do not recognize committees. Either you want to show or you don't." De Kay gave in, and for the first time Stieglitz had a gallery in which to exhibit the original prints of photographers who *he* thought merited artistic recognition.

De Kay suggested calling the show an "Exhibition of American Photographs arranged by the Camera Club of New York," but Stieglitz demurred, saying, "Why, the members of the *Camera Club,* the big majority, hate the kind of work I'm fighting for." Then, in a moment of inspiration, Stieglitz said, "I've got it—it's a good one—call it *An Exhibition of American Photography arranged by the Photo-Secession.*"

Thus came tripping off the tongue of its founder the name of one of the major artistic movements of the century. At first, before the show at the National Arts Club opened, the Photo-Secession consisted of one man, Alfred Stieglitz; but the name came to stand for those photographers, led by Stieglitz, who had seceded from the majority that was concerned only with technical considerations, who believed that good photography went far beyond technique. Shortly after the opening of the exhibition at the National Arts Club—a show built around the work of Steichen, White, Käsebier and Stieglitz himself, but including pictures by others—the Photo-Secession organized itself into a formal, though loosely structured group whose founding members included the aforementioned photographers. To Stieglitz these photographers formed a photographic elite, bound together not by any adherence to one style, but by their determination to make the world recognize photography "not as the handmaiden of art, but as a distinctive medium of individual expression."

While upholding the banner of photography, most Photo-Secessionists patterned their work quite frankly on painting. The fashionable painters of the day were men like Whistler and Corot, for whom mood was more important than subject. The work of these artists influenced the Photo-Secession toward mist-colored landscapes, blurry cityscapes, women draped in long, flowing garments and rural folk at their chores and pastimes. The light was diffused, the line was soft and details were suppressed in favor of an overall impression.

To achieve these effects, members of the Photo-Secession adopted a variety of techniques for making prints. Many favored gum-bichromate printing, a process that replaced the thin, hard emulsions of standard photographic papers with a thick coating, often tinted, that the photographer applied by hand to the printing paper. The coated, colored surface of the print could look surprisingly like a painting *(pages 29, 44-45)*. Other members took extraordinary license with the photograph itself, scratching or drawing upon its surface in order to make it look handmade *(page 42)*. Indeed, the Photo-Secession, by such tactics, seemed to have confirmed the charges of its critics that in order to qualify as art the photograph was being disguised to mask the fact that it had been made by a machine. But Stieglitz vigorously defended these practices, saying, "The result is the only fair basis for judgment. It is justifiable to use any means upon a negative or paper to attain the desired end." It was a view he had once renounced and would, in but a few years, renounce again; most of his own work at this time was devoid of the intricate darkroom-produced effects favored by his colleagues.

Typical was his now-famous photograph of one of New York City's first skyscrapers, the 22-story Flatiron Building, so-named because its narrow, wedge-shaped site at the junction of Fifth Avenue and Broadway dictated a flatiron shape for the structure. Recalling the circumstances surrounding the taking of the photograph, Stieglitz later said: "One day during the winter season of 1902-1903, there was a great snowstorm. I loved such storms. The *Flat Iron Building* had been erected. . . . I stood spellbound as I saw that building in that storm. . . . I suddenly saw the building as I had never seen it before. It looked, from where I stood, as though it were moving toward me like the bow of a monster ocean-steamer— a picture of the new America that was still in the making."

For the most part, however, Stieglitz now had precious little time to devote to his own work. In January 1903, about a year after he first used the term Photo-Secession, Stieglitz launched a new magazine, *Camera Work (pages 26-50),* designed to record the achievements of the movement. Financed, edited and published by Stieglitz, it was one of the most beautiful magazines ever published. Its illustrations were often printed in photogravure on fine Japanese tissue and pasted onto the magazine pages by hand. Looking at them is like viewing a portfolio of finely wrought original prints. *Camera Work's* articles were printed on a luxurious, soft paper in a handsome type and were often written by leading authors of the day. Maurice Maeterlinck, George Bernard Shaw *(pages 33-36)* and Gertrude Stein contributed to *Camera Work*— sometimes on subjects only indirectly related to photography. Within its elegant pages, new and unknown photographers— and eventually, new and unknown painters— had their first showing.

In addition to publishing *Camera Work,* Stieglitz arranged for the exhibitions of the work of Photo-Secession members, dictating where the prints would be shown and under what conditions they would be exhibited. Sometimes these restrictions angered his colleagues, particularly those who hungered for more outlets for their work. But Stieglitz' dictatorial methods got results. In 1904, for example, he succeeded in arranging two important shows, one at the Corcoran Gallery of Art in Washington, D.C., the other at the Carnegie Institute in Pittsburgh.

While he was assembling the Corcoran Gallery show, Stieglitz got help from his friend Edward Steichen. The young painter-photographer had returned from Europe the year before, and to support himself in New York he opened a portrait studio. Stieglitz helped him get one of his first commissions, a portrait of J. P. Morgan that shows the noted financier glaring into the camera, his hand apparently brandishing a dagger. (The "weapon" is actually a highlight on the arm of the chair in which he was sitting.) The fame this picture has attained is ironic, for it was intended only to be a study, not a showpiece. Steichen made the photograph for the portrait painter Fedor Encke, who commissioned it to work from while painting. But the Encke painting turned out to be far less effective than the photograph from which it was made, and Steichen's work is remembered as the portrait. It lays bare the arrogance and disdain of the subject, the most powerful man of his time, for only the instantaneous directness of the camera in the hands of an artist could capture the force of such a personality.

Some years after Steichen had made the portrait and had turned the original print over to Stieglitz, Morgan became interested in buying it. He sent an assistant to Stieglitz to negotiate for its sale, but Stieglitz insisted that he would not sell the portrait at any price. "What!" exclaimed Morgan when told of the abortive transaction, "Is there anything that cannot be bought?" Morgan's disbelief probably turned to astonishment when Stieglitz then offered to give him the portrait without charge on the condition that it be hung at The Metropolitan Museum of Art, an institution of which the magnate was a trustee. Morgan, a dyed-in-the-wool conservative on artistic matters, of course refused the offer.

It was Steichen who suggested what turned out to be a lifetime mission for Stieglitz: that of an art exhibitor and educator of the public's taste. Despite the success of the Corcoran and Carnegie Institute exhibits, Stieglitz was still having trouble arranging shows on his terms. In 1905 Steichen proposed that they open up their own gallery in the flat next door to the Steichen apartment, on the top floor of a town house at 291 Fifth Avenue. Stieglitz agreed, although at first he may not have thought of this venture as more than an informal and perhaps temporary expedient that would provide

Photo-Secession photographers with a place where they could gather, discuss their work and exhibit. On November 24, 1905, the Little Galleries of the Photo-Secession (soon it would be known simply by its street address, 291) opened. The rooms were small, and Steichen had covered the walls with burlap in various subdued colors, making an excellent backdrop for the photographs to be shown there. The last one-man show of the first full season was devoted entirely to the work of Edward Steichen, and after it closed the young painter-photographer announced to Stieglitz that he was once again going to Europe.

The impending departure of Steichen posed a problem for Stieglitz. If the gallery was to continue in operation it would obviously consume more and more of his energies. Evidently this was a problem that was quickly resolved in Stieglitz' mind, for in fact, if not in name, he was already becoming a professional advocate of contemporary art. He was not an art dealer in the sense that he was operating a business, for to Stieglitz the idea of turning a profit from any of the galleries he was to operate was abhorrent. His contempt for those who made money by selling works of art was recorded by his longtime friend, the poet and critic Herbert J. Seligmann, who wrote: "Of art dealers, Stieglitz remarked more than once that the essential difference between a dealer and the madam of a house of prostitution was that [though] the madam, at need, could substitute for a girl, the art dealer could not for an artist."

In the world of New York artists and critics, 291 was an instant success. Not only was the work of photographers exhibited, but as the years went on, talented and little-known artists in other media found a welcome extended to them in Stieglitz' gallery. For Stieglitz was now growing increasingly restive in his role as a combination guru and publicist for the Photo-Secession photographers. "Jealousies had been developing . . . amongst the Secessionists," he recalled. "They had come to believe that my life was to be dedicated solely to them and did not realize that my battle was for an idea bigger than any individual." That idea was indeed big: to present to the American public the best that modern art had to offer, whether in photography, painting or sculpture. Accordingly, in 1907 when Steichen, then living in Paris, cabled asking if Stieglitz would be interested in showing drawings made by the great French sculptor Auguste Rodin, Stieglitz cabled back an enthusiastic yes. The Rodin exhibition opened at the Little Galleries on January 2, 1908, to a press that was generally friendly, although one critic observed pessimistically—and with some truth—that Rodin's work would "doubtless . . . be pretty nearly incomprehensible to the general public." The Rodin show was followed in April 1908 with an exhibition devoted to another European artist whose work was even less comprehensible—and, indeed, proved offensive to almost all the critics. The artist was Henri Matisse.

Matisse, leader of *Les Fauves,* the "wild beasts" whose violent colors and unfamiliar distortions had shocked the art establishment, naturally attracted Steichen, as well as many other young artists then studying in Paris. Steichen had no difficulty arousing an equal enthusiasm in Stieglitz, and soon a selection of Matisse lithographs, etchings, watercolors and drawings was hanging on the walls of 291. It was the first Matisse show in America, and predictably it set off a storm of protest. Matisse's "splotches of color," as one critic described them, to say nothing of his frankly erotic and unabashed rendering of the female form, were much too daring for American tastes, and Stieglitz, for his pains in bringing the dangerous works of Matisse to the public, was pilloried as a threat to the morals of America.

If the indignant howls of the art establishment had any effect upon Stieglitz at all, it was merely to set him ever more firmly in his ways. During the next few years he introduced America to the work of such other little-known Europeans as Picasso, Braque and Cézanne, and also presented the paintings of several of America's most promising painters—Marin, Dove, Alfred Maurer and Marsden Hartley—then considered as shocking as the radical Frenchmen. It was curious, said an editorial comment in *Camera Work,* that "while men of the lens busied themselves with endowing their new and most pliable medium with the beauties of former art expressions, those of the brush were seeking . . . a technique that was novel and—unphotographic."

Stieglitz himself was now sensing that the ideas of the Photo-Secession had been developed to their limit, and in 1909 he agreed to organize one last great exhibition of the members' work. It was held in the neoclassic halls of the Albright Art Gallery in Buffalo, New York, and occupied well over half the museum. From November 4 through December 1, 1910, a steady stream of visitors attested to the show's popularity with the general public, and it won equal acclaim from the critics. In a sense, Stieglitz had achieved his goal: Photography was now accepted in a major museum as a medium of expression fully as valid as painting. But success had left a somewhat bitter taste in Stieglitz' mouth. In its victory, Photo-Secession had reached an artistic dead end; its emphasis was on pictorial expression and this placed it in the rear guard rather than the vanguard of the arts.

In his own work, Stieglitz had already begun to turn away from the misty, painting-like effects of the Photo-Secession, and he now concentrated on the detailed clarity that gives the photographic process its remarkable sense of truthfulness. "After claiming for photography an equality of opportunity with painting," wrote his friend Charles Caffin in *Camera Work* in 1912, "Stieglitz turns about and with devilishly remorseless logic shows the critics, who have grown disposed to accept this view of photography, that they are again wrong." Instead of insisting that painting and photography were equals, that

what could be done in one medium could be done in another, Stieglitz began to search for esthetic values that applied to photography alone.

It was in the work of a young New Yorker, Paul Strand, that Stieglitz began to see his new vision for photography realized. In 1915 Strand brought Stieglitz a group of photographs he had taken. Some were cityscapes; others were close-ups of objects that caught his fancy—a picket fence *(page 50),* a group of bowls *(page 48).* All of them revealed a startling new approach that suggested how photographers might explore the unfamiliar worlds of art opened up by such painters as Sloan and Henri in America and Picasso and Braque in Europe. In the streets of the city, Strand found terror, the terror of the urban environment: A blind woman *(page 49),* a fat man and elderly derelicts, unaware of the camera, play out the tragedy of their existence against the looming, threatening forms of the buildings they inhabit. Where Stieglitz' prints of 15 or so years before had suggested a mood of loneliness and isolation, Strand's pictures forthrightly declared that the life of urban man was a nightmare existence. And in his pictures of bowls and picket fences there was a new kind of photographic beauty, not the misty evocations of the Photo-Secessionists, but hard, sharp patterns of light and shadow abstracted from the natural world by the camera.

In 1916 Stieglitz gave the 26-year-old Strand a show at 291, the only purely photographic exhibit during the last four years of the gallery's existence. He also devoted the last two issues of *Camera Work* to him, calling Strand "the man who has actually done something from within . . . who has added something to what has gone before." He spoke of Strand's work as "devoid of flim-flam, devoid of trickery and of any 'ism,' devoid of any attempt to mystify an ignorant public, including the photographers themselves. These photographs are the direct expression of today."

They were also harbingers of things to come. Strand was finding images and symbols within the real world to express his innermost thoughts, and in that synthesis of reality and abstraction lay a new field for photography —and particularly for Stieglitz—to explore. With Stieglitz and Paul Strand leading the way, a new photographic esthetic that mixed symbolism with realism was born: an esthetic that continues to this day to be a powerful influence among art photographers.

The esthetic turning point marked by Strand's photographs came at a turning point in Stieglitz' own life, personal as well as professional. Not only was his marriage breaking up, but the financial burden of maintaining his gallery and magazine was growing onerous. Stieglitz had a small annuity from his father, but it was insufficient to make up the deficits that were taken for granted in the operation of 291 and *Camera Work*. Even the times were sadly out of joint for Stieglitz. The American entry into World War I caused

him considerable pain, setting as it did the nation of his birth against the land of his student days. In addition to his financial and emotional troubles, the building that housed his gallery was torn down in 1917. He closed 291, and *Camera Work,* deserted by subscribers who could not follow Stieglitz' switches in artistic goals or objected to the emphasis on contemporary painting within its pages, ceased publication.

But Stieglitz was already moving in a new direction. In 1915 a young woman appeared at 291 with a portfolio of drawings under her arm. The drawings had been sent to her by an art teacher from Texas, Georgia O'Keeffe, with the injunction that they be shown to no one. She was so impressed by the drawings that she ignored the request and brought them to Stieglitz, who took one look and exclaimed, "At last, a woman on paper."

When he exhibited the O'Keeffe drawings at 291, they caused a stir among artists and critics. The critic William Murrell Fisher was to sense in O'Keeffe's work "visible . . . emotional forms quite beyond the reach of . . . reason—yet strongly appealing to that . . . sensitivity in us through which we feel the grandeur and sublimity of life." Inevitably word of the exhibit reached Miss O'Keeffe. She felt her privacy had been invaded and she appeared one day at 291 in a cold fury—a girl with "fine enormous eyes," Stieglitz later recalled. "She was wearing a black dress with a white collar and had a Mona Lisa smile. She said 'I want those pictures taken down.' "

"Who are you?" Stieglitz asked, and she replied, "Georgia O'Keeffe."

Stieglitz quickly soothed her injured feelings and she left the pictures where they were. So began a lifelong relationship that was to culminate in marriage in 1924. Unlike Stieglitz' first marriage, this one was marked by mutual understanding and affection despite many long separations—O'Keeffe was stifled by the city and spent much of her time working in the mountains of New Mexico, while Stieglitz was committed to New York and suffered from a heart ailment that precluded living at mountainous altitudes. Stieglitz often acknowledged his spiritual debt to O'Keeffe. In 1922, when they had known each other for six years, he remarked to fellow-photographer Edward Weston: "Friends made me out a god, when all I asked was to be treated as a human being. . . . There has been one who stood by me through it all—a girl from Texas. You see her paintings here stacked all around this room, this room that my brother allows me. . . . I have nothing left, deserted by friends and wife and child—yet in no period of my life have I been so enthusiastic and interested in photography and anxious to work."

With Georgia O'Keeffe encouraging him, Stieglitz was able to get on with the difficult task of finding a new esthetic in his own photography. He continued his experiments with a new kind of symbolic photography, trying to give voice to his feelings about life in pictures of clouds, trees, fields of

grass. He also began a most unusual project, a pictorial biography of his life with Georgia O'Keeffe. He took literally thousands of pictures of her and discovered that expression was not limited to the face. In her hands, in her legs, in her body, as well as in her face, he found images for his camera that seemed to have in them the breath of life.

This work remained unknown to the general public for some time, since with the death of 291 and *Camera Work,* Stieglitz dropped out of sight. When a retrospective show of his work—his first one-man show in seven years —was held at the Anderson Galleries in New York City in 1921, people came to pay tribute to an old master. They left marveling at a new master. The photographs of Georgia O'Keeffe, a series Stieglitz thought of as a composite portrait, were recognized as more than a portrait of a single individual. Stieglitz was using his camera to explore a deeply personal relationship, the relationship between a man and a woman. In doing so he transcended private emotion to create images that expressed the sublime nature of all human relationships. The O'Keeffe portraits are symbols, and it was this use of photography that occupied Stieglitz for the rest of his life.

The 1921 show marked Stieglitz' reemergence not only as an active photographer but also as a major influence in the world of art. By 1928 the very apex of the artistic establishment, The Metropolitan Museum of Art in New York, added to its permanent collection a group of his prints. The most hallowed sanctuary of fine art in America had thus been breached by photography, and with this triumph the place of photography among the recognized arts was secure.

But Stieglitz was more interested in the opinions of the young photographers and painters who gathered about him in his galleries: the Intimate Gallery, opened in 1925, and its successor, An American Place, which he operated from 1929 until his death in 1946. Both were homes for fine art and creative artists, not art sales rooms. For the art collector, the chic who merely wished to purchase "the latest thing" and the investor who bought in hopes of making a profit on resale, Stieglitz had only scorn. An announcement for An American Place summed up his straitlaced philosophy of running a gallery. In bold letters the card stated: "*No* formal press views; *No* cocktail parties; *No* special invitations; *No* advertising; . . . *Nothing* asked of anyone who comes." Stieglitz could also have added, "no listing in the telephone directory." When asked why he had no phone listing, Stieglitz archly replied: "If people really need a thing they will find it."

An incident recalled by Dorothy Norman, a close friend, illustrates Stieglitz' approach:

One day when there are pictures on the walls, a woman who has been walking about looking at them suddenly addresses Stieglitz, who stands

there as usual, seemingly as integral a part of the Place as the walls themselves:

"This is a very exciting show. What else ought I to see in New York?"

Stieglitz replies: "I have no idea what else you ought to see. . . ."

Woman: "Could you tell me, by any chance, where Mr. Stieglitz' gallery is? I hear that he has the finest things in New York, but I cannot find his gallery listed anywhere."

"Mr. Stieglitz has no gallery."

"You are mistaken. I was distinctly told that he has, and that I must surely go there when I came to New York."

Stieglitz finally raises his voice: "Well, I ought to know. I am Mr. Stieglitz and I tell you he has no gallery."

The woman, utterly taken aback by this apparent madman, fled. When Stieglitz was asked why he had not been more helpful, he replied: "Something more was at stake than her knowing where she was for the moment. And I am not in business. I am not interested in exhibitions. . . . I am not a salesman, nor are the pictures here for sale, although under certain circumstances certain pictures may be acquired."

As before, Stieglitz seldom took a commission for his services. For his own work, he almost always refused payment. Once, when he was so short of funds he accepted a fee for a portrait, he apologized. "I hated to take the money," he said. "It was against my principles. . . . What is a masterpiece worth? A million dollars. . . . But on the other hand, as public property, it has no selling price."

Day after day, through the 1930s and into the 1940s, he walked from his apartment to An American Place, there to sit or lie upon a camp cot, waiting for whatever visitors the day might bring. He had become an institution, and photographers and painters from every corner of the world visited him in the sparse gallery. It was at his apartment, only a stone's throw from his beloved American Place, that he suffered a fatal stroke on July 10, 1946—three days later, he was dead at the age of 82.

In his obituary notice in *The New York Times,* a writer was quoted as saying of Alfred Stieglitz: "A most incessant talker, he raised his voice for more than half a century to proclaim his powers as a prophet soothsayer. . . . With absolute faith in his own vision, . . . he was long ago recognized as a born leader and he has not neglected his eminence. He has not been defeated because he has not acknowledged defeat; . . . and his voice will go on ringing down the corridors of art forever."

Stieglitz, perhaps, wrote a better summation of his life and career for the catalogue of his 1921 one-man show: "I was born in Hoboken. I am an American. Photography is my passion. The search for Truth my obsession." □

Photography's Lavish Showcase

As the big gun in their campaign to win photography its own place among the fine arts, Alfred Stieglitz and his band of followers, the Photo-Secessionists, brought out a new camera magazine in 1903. It proved to be a weapon of very high caliber. With a boldly artistic cover *(opposite),* elegant type, textured paper, such noted writers as playwright George Bernard Shaw *(pages 33-36),* and pages filled with superbly reproduced pictures, *Camera Work* was one of the handsomest magazines of any kind that was ever published.

It was also one of the most influential journals in the annals of photography. Stieglitz' only requirement was that anything he printed must be worthy of the word "art." Under this ambiguous aegis *Camera Work* offered, in its 50 issues, pictures that ranged from meticulously realistic recordings of the real world *(pages 49 and 50)* to hazy pseudo-paintings *(pages 39 and 45).* Indeed, painting became at one point the magazine's main fare *(pages 46-47).*

The hand that held everything together was beauty—of subject matter, of printing technique and of the magazine itself. In *Camera Work,* luxury was a necessity. Stieglitz, in the double-barreled role of editor and publisher, saw to it that, as he assured the magazine's subscribers, "no expense was stinted." He promised them, and he delivered, "a magazine more sumptuous than any other which had ever been attempted in photography."

The subscription rate also was sumptuous: eight dollars for four issues— at a time when Henry Ford stunned the world by offering his workers a minimum wage of five dollars a day. Even so Stieglitz had to use large amounts of his own money to keep the standards up. To get the best possible fidelity in his reproductions, he used not one, but six different engraving and printing processes.

The one printing method that brought *Camera Work* enduring renown, however, was photogravure. This was (and still is) the finest of all processes for reproducing black-and-white (and other single-color) photographs. It actually forms an image on paper in much the same way that darkroom chemicals do. Just as the darkroom process deposits chemicals in varying thicknesses to build up the light and dark tones of a photographic print, the photogravure process deposits ink in various thicknesses to build up light and dark portions of the reproduction. A good photogravure and the photograph from which it was made are all but indistinguishable to the naked eye. This was gratifyingly evident when a collection of original photographs from *Camera Work* contributors once was lost on the way to an exhibition in Brussels. The sponsors simply clipped some pictures from the magazine, had them mounted and hung, and no one was the wiser.

With *Camera Work* carrying their artistic banner, the Photo-Secessionists by 1910 had largely won the recognition they sought. Stieglitz then increasingly turned the magazine to promoting modern painting and sculpture. Subscribers deserted in droves. From a peak of 1,000 in the early years, the paying customers dropped to just 37 by the time Stieglitz called it quits in 1917. Momentarily dispirited, he made a drastic break with the past, burning hundreds of leftover copies. But canny art dealers saved a few. In 1979, the October 1911 issue sold for $5,250.

CAMERA WORK

A PHOTOGRAPHIC QUARTERLY
• EDITED AND PUBLISHED BY •
ALFRED STIEGLITZ NEW YORK

Allegories were a favorite subject of
Gertrude Käsebier, a highly successful New
York portraitist. This picture was one of a
famous series depicting the joys and duties
of motherhood. The mistily romantic style,
perhaps a reflection of Mrs. Käsebier's early
preoccupation with painting, was a very
popular one at the time and many similar
pictures appeared in Camera Work. Mrs.
Käsebier was much admired by fellow
photographers for her skill as well as charm
and tact, and it came as no surprise that
Camera Work devoted its first issue mainly
to showing and discussing her pictures.

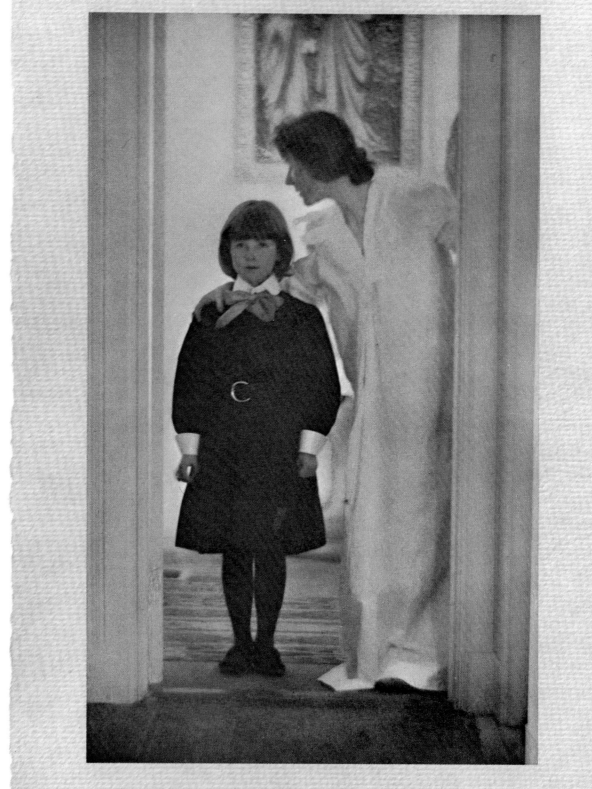

GERTRUDE KÄSEBIER
Blessed Art Thou among Women, c. 1898

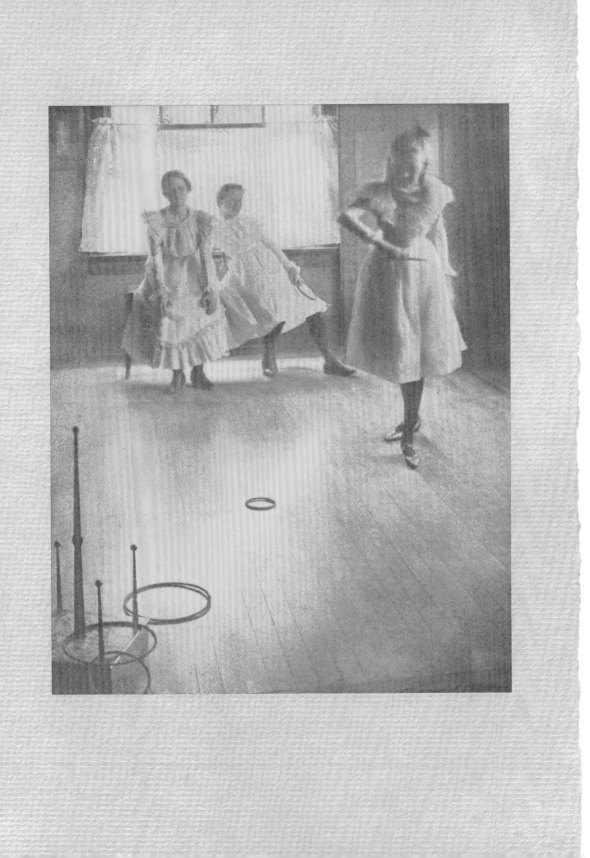

After 16 years as a bookkeeper in Newark, Ohio, Clarence White turned full time to the camera and was appointed to the faculty of Columbia University, becoming one of the most influential photographers in the country. His pictures were carefully composed but had a natural, easygoing ambiance, as in this scene of girls at play. White, together with many other first-rate photographers of the time, varied his printing procedure if he felt it would improve the picture. Here he has blotted out detail in the lower half of a window to keep it from cluttering up the background. The warm, reddish cast was achieved by pigment that creates the image in the so-called gumbichromate printing process, which White employed to make this photograph.

CLARENCE H. WHITE
Ring Toss, 1899

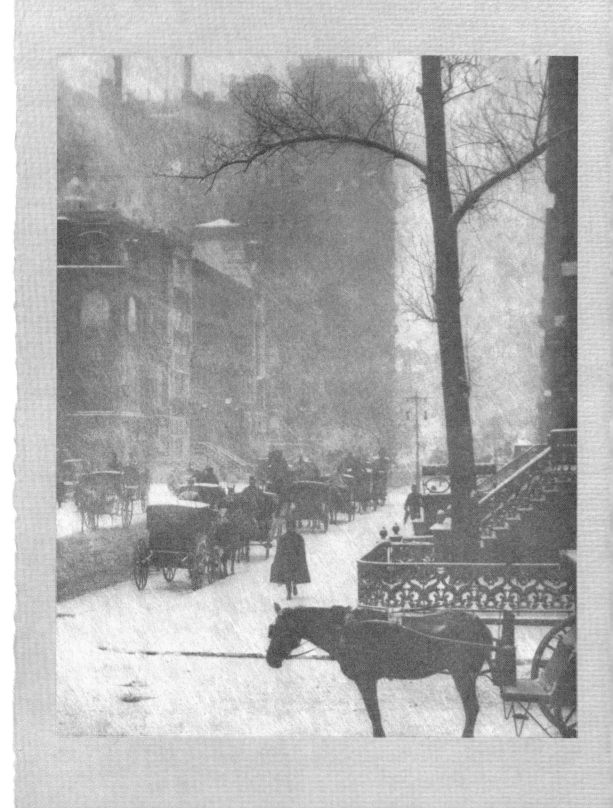

As editor of Camera Work, Alfred Stieglitz welcomed a variety of styles from others, but he himself generally followed a straightforward approach. He meticulously controlled the planning of a picture but then let the camera record the scene without further interference. Here he has carefully chosen his place (New York's lower Fifth Avenue) and his time (he often waited hours for just the right moment to snap the shutter). The result is a deliberately conceived scene, plainly recorded. Although the title suggests that Stieglitz intended to use this picture as a poster, his real purpose was to show how photography could create a poster design.

ALFRED STIEGLITZ
The Street, Design for a Poster, c. 1900

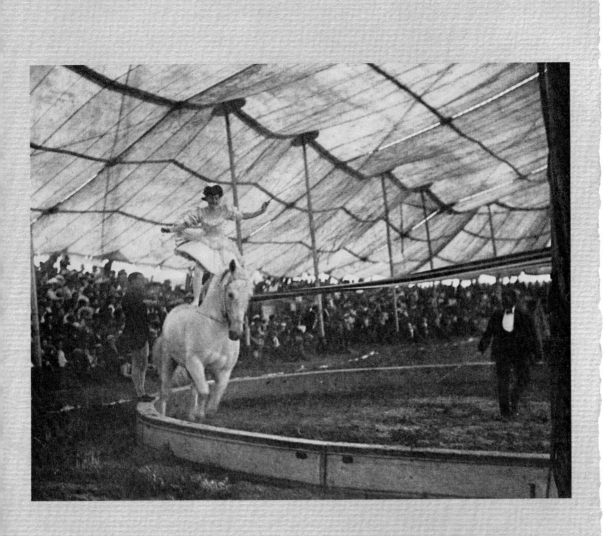

Denver amateur Harry Rubincam was, like Stieglitz, an early exponent of the straightforward approach. This picture has been called a landmark in modern photography because of its natural lighting, stopped motion and spur-of-the-moment realism. The photogravure plates for this and the picture opposite were engraved for Camera Work directly from the photographers' negatives, bypassing the usual step of working from photographic prints. Thus the photogravure magazine reproductions were, in effect, original prints.

HARRY C. RUBINCAM
In The Circus, 1905

To catch the brilliant shafts of light and subtle shadows of cathedrals, the English photographer Frederick Evans almost always printed his pictures by the platinotype process, using a paper that was coated with platinum compounds rather than silver ones. Platinum yields a range of delicate tones and subtly shaded highlights that no other metal can match. There was no one who appreciated such esthetic technicalities more than playwright George Bernard Shaw, who wrote the following profile of Evans and his work. A fervid and knowledgeable amateur himself, Shaw recognized the artistry that was to be found in Evans' prints: "You occasionally hear people say of him that he is 'simply' an extraordinarily skilful printer in platinotype. This, considering that printing is the most difficult process in photography, is a high compliment."

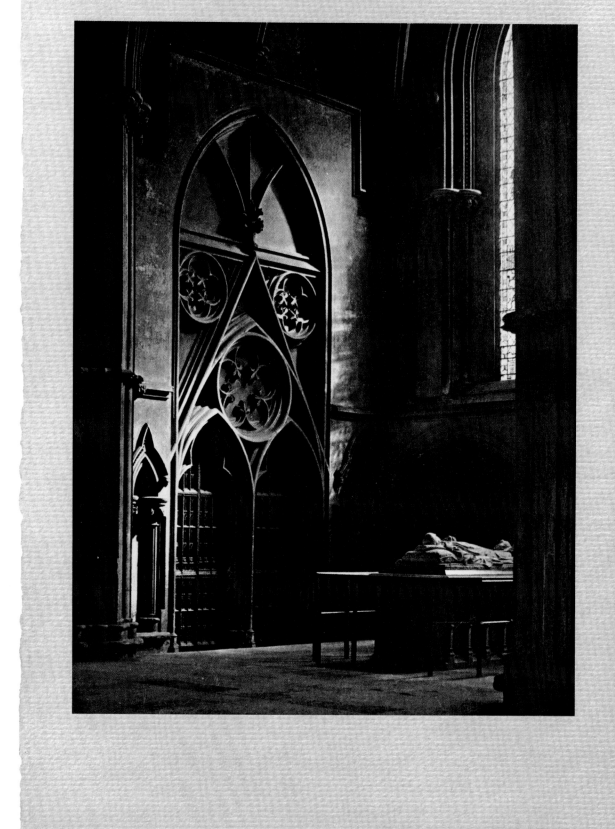

FREDERICK H. EVANS
York Minster, c. 1904

EVANS—AN APPRECIATION.

YES: NO doubt Evans is a photographer. But then Evans is such a lot of things that it seems invidious to dwell on this particular facet of him. When a man has keen artistic susceptibility, exceptional manipulative dexterity, and plenty of prosaic business capacity, the world offers him a wide range of activities; and Evans, who is thus triply gifted and has a consuming supply of nervous energy to boot, has exploited the range very variously.

I can not say exactly where I first met Evans. He broke in upon me from several directions simultaneously; and some time passed before I coördinated all the avatars into one and the same man. He was in many respects an oddity. He imposed on me as a man of fragile health, to whom an exciting performance of a Beethoven Symphony was as disastrous as a railway collision to an ordinary Philistine, until I discovered that his condition never prevented him from doing anything he really wanted to do, and that the things he wanted to do and did would have worn out a navvy in three weeks. Again, he imposed on me as a poor man, struggling in a modest lodging to make a scanty income in a brutal commercial civilization for which his organization was far too delicate. But a personal examination of the modest lodging revealed the fact that this Franciscan devotee of poverty never seemed to deny himself anything he really cared for. It is true that he had neither a yacht, nor a couple of Panhard cars, nor a liveried domestic staff, nor even, as far as I could ascertain, a Sunday hat. But you could spend a couple of hours easily in the modest lodging looking at treasures, and then stop only from exhaustion.

Among the books were Kelmscott Press books and some of them presentation copies from their maker; and everything else was on the same plane. Not that there was anything of the museum about the place. He did not collect anything except, as one guessed, current coin of the realm to buy what he liked with. Being, as aforesaid, a highly susceptible person artistically, he liked nothing but works of art: besides, he accreted lots of those unpurchasable little things which artists give to sympathetic people who appreciate them. After all, in the republic of art, the best way to pick up pearls is not to be a pig.

But where did the anchorite's money come from? Well, the fact is, Evans, like Richardson, kept a shop; and the shop kept him. It was a bookshop. Not a place where you could buy slate-pencils, and reporter's note-books, and string and sealing-wax and paper-knives, with a garnish of ready-reckoners, prayer-books, birthday Shakespeare, and sixpenny editions of the Waverley novels; but a genuine book-shop and nothing else, in the heart of the ancient city of London, half-way between the Mansion House and St. Paul's. It was jam full of books. The window was completely blocked up with them, so that the interior was dark; you could see nothing for the first second or so after you went in, though you could feel the stands of books you were tumbling over. Evans, lurking in the darkest

corner at the back, acquired the habits and aspect of an aziola; the enlargement of his eyes is clearly visible in Mrs. Käsebier's fine portrait of him. Everybody who knows Evans sees in those eyes the outward and visible sign of his restless imagination, and says "You have that in the portraits of William Blake, too"; but I am convinced that he got them by watching for his prey in the darkness of that busy shop.

The shop was an important factor in Evans's artistic career; and I believe it was the artist's instinct of self-preservation that made him keep it. The fact that he gave it up as soon as it had made him independent of it shows that he did not like business for its own sake. But to live by business was only irksome, whilst to live by art would have been to him simply self-murder. The shop was the rampart behind which the artist could do what he liked, and the man (who is as proud as Lucifer) maintain his independence. This must have been what nerved him to succeed in business, just as it has nerved him to do more amazing things still. He has been known to go up to the Dean of an English Cathedral—a dignitary compared to whom the President of the United States is the merest worm, and who is not approached by ordinary men save in their Sunday-clothes—Evans, I say, in an outlandish silk collar, blue tie, and crushed soft hat, with a tripod under his arm, has accosted a Dean in his own cathedral and said, pointing to the multitude of chairs that hid the venerable flagged floor of the fane, "I should like all those cleared away." And the Dean has had it done, only to be told then that he must have a certain door kept open during a two hours' exposure for the sake of completing his scale of light.

I took a great interest in the shop, because there was a book of mine which apparently no Englishman wanted, or could ever possibly come to want without being hypnotized; and yet it used to keep selling in an unaccountable manner. The explanation was that Evans liked it. And he stood no nonsense from his customers. He sold them what was good for them, not what they asked for. You would see something in the window that tempted you; and you would go in to buy it, and stand blinking and peering about until you found a shop-assistant. "I want," you would perhaps say, "the Manners and Tone of Good Society, by a member of the Aristocracy." Suddenly the aziola would pounce, and the shop-assistant vanish. "Ibsen, sir?" Evans would say. "Certainly; here are Ibsen's works, and, by the way, have you read that amazingly clever and thought-making work by Bernard Shaw, *The Quintessence of Ibsenism?*" and before you are aware of it you had bought it and were proceeding out of the shop reading a specially remarkable passage pointed out by this ideal bookseller. But observe, if after a keen observation of you in a short preliminary talk he found you were the wrong sort of man, and asked for the Quintessence of Ibsenism without being up to the Shawian level, he would tell you that the title of the book had been changed, and that it was now called "For Love and My Lady," by Guy de Marmion. In which form you would like it so much that you would come back to Evans and buy all the rest of de Marmion's works.

This method of shopkeeping was so successful that Evans retired from
business some years ago in the prime of his vigor; and the sale of
the Quintessence of Ibsenism instantly stopped forever. It is now out of
print. Evans said, as usual, that he had given up the struggle; that his
health was ruined and his resources exhausted. He then got married; took
a small country cottage on the borders of Epping Forest, and is now doing
just what he likes on a larger scale than ever. Altogether an amazing chap,
is Evans! Who am I that I should "appreciate" him?

I first found out about his photography in one of the modest lodgings of
the pre-Epping days (he was always changing them because of the coarse
design of the fireplace, or some other crumple in the rose leaf). He had a
heap of very interesting drawings, especially by Beardsley, whom he had
discovered long before the rest of the world did; and when I went to look
at them I was struck by the beauty of several photographic portraits he had.
I asked who did them; and he said he did them himself—another facet
suddenly turned on me. At that time the impression produced was much
greater than it could be at present; for the question whether photography
was a fine art had then hardly been seriously posed; and when Evans
suddenly settled it at one blow for me by simply handing me one of his
prints in platinotype, he achieved a *coup de théâtre* which would be
impossible now that the position of the artist-photographer has been
conquered by the victorious rush of the last few years. But nothing that
has been done since has put his work in the least out of countenance. In
studying it from reproductions a very large allowance must be made for
even the very best photogravures. Compared to the originals they are
harsh and dry: the tone he produces on rough platinotype paper by
skilful printing and carefully aged mercury baths and by delicately chosen
mounts, can not be reproduced by any mechanical process. You occasion-
ally hear people say of him that he is "simply" an extraordinarily skilful
printer in platinotype. This, considering that printing is the most difficult
process in photography, is a high compliment; but the implication that
he excels in printing only will not hold water for a moment. He can not
get good prints from bad negatives, nor good negatives from ill-judged
exposures, and he does not try to. His decisive gift is, of course, the gift
of seeing: his picture-making is done on the screen; and if the negative
does not reproduce that picture, it is a failure, because the delicacies he
delights in can not be faked: he relies on pure photography, not as a
doctrinaire, but as an artist working on that extreme margin of photographic
subtlety at which attempts to doctor the negative are worse than useless.
He does not reduce, and only occasionally and slightly intensifies; and
platinotype leaves him but little of his "control" which enables the gummist
so often to make a virtue of a blemish and a merit of a failure. If the
negative does not give him what he saw when he set up his camera, he
smashes it. Indeed, a moment's examination of the way his finest portraits
are modeled by light alone and not by such contour markings or impression-
ist touches as a retoucher can imitate, or of his cathedral interiors, in which

the obscurest detail in the corners seems as delicately penciled by the darkness as the flood of sunshine through window or open door is penciled by the light, without a trace of halation or over-exposure, will convince any expert that he is consummate at all points, as artist and negative-maker no less than as printer. And he has the "luck" which attends the born photographer. He is also an enthusiastic user of the Dallmeyer-Bergheim lens; but you have only to turn over a few of the portraits he has taken with a landscape-lens to see that if he were limited to an eighteenpenny spectacle-glass and a camera improvised from a soap-box, he would get better results than less apt photographers could achieve with a whole optical laboratory at their disposal.

Evans is, or pretends to be, utterly ignorant of architecture, of optics, of chemistry, of everything except the right thing to photograph and the right moment at which to photograph it. These professions are probably more for edification than for information; but they are excellent doctrine. His latest feat concerns another facet of him: the musical one. He used to play the piano with his fingers. Then came the photographic boom. The English critics, scandalized by the pretensions of the American photographers, and terrified by their performances, began to expatiate on the mechanicalness of camera-work, etc. Even the ablest of the English critics, Mr. D. S. McCall, driven into a corner as much by his own superiority to the follies of his colleagues as by the onslaught of the champions of photography, desperately declared that all artistic drawing was symbolic, a proposition which either exalts the prison tailor who daubs a broad arrow on a convict's jacket above Rembrandt and Velasquez, or else, if steered clear of that crudity, will be found to include ninety-nine-hundredths of the painting and sculpture of all the ages in the clean sweep it makes of photography. Evans abstained from controversy, but promptly gave up using his fingers on the piano and bought a Pianola, with which he presently acquired an extraordinary virtuosity in playing Bach and Beethoven, to the confusion of those who had transferred to that device all the arguments they had hurled in vain at the camera. And that was Evans all over. Heaven knows what he will take to next!

GEORGE BERNARD SHAW.

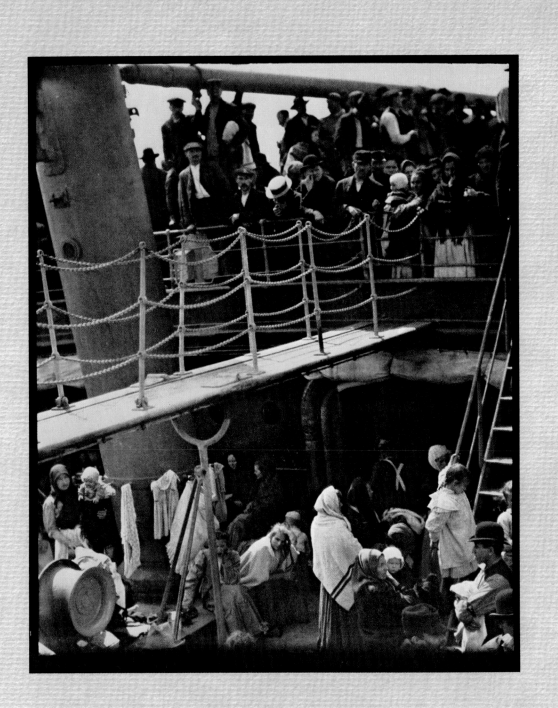

During a crossing to Europe, Stieglitz chanced to look down from the first-class deck to the steerage, where passengers huddled amid walkways and funnels. He was struck by the random patterns made by men and machinery, and he sensed a strength and clarity of purpose in the people below him. "I saw a picture of shapes, and underlying that the feeling I had about life," he said. Quickly he got his Graflex, the large (4 x 5) hand-held single-lens reflex that was to become a favorite of many serious photographers, and exposed his last plate. In later years he said that if all his other pictures were somehow lost he would be content to be remembered for this one alone.

ALFRED STIEGLITZ
The Steerage, 1907

A wealthy Bostonian, Alvin Coburn learned photography at the age of eight, had his first show at 18 and spent a long career in Europe and America promoting new concepts of taking and printing photographs. He found a ready platform in Camera Work, which published these examples of the tricky print technique called gum platinum, a process that Coburn favored for its ability to reproduce shadows. In this method the negative was first printed on paper coated with platinum compounds. The platinum print was then covered with a fresh semitransparent coating based on gum arabic. Using the same negative as before, Coburn printed the picture again on top of the first one. The double-layered image gave luminous highlights and ethereal shadows like those in this view of Notre Dame cathedral in Paris. Pigments added to the gum coating gave the pictures their color.

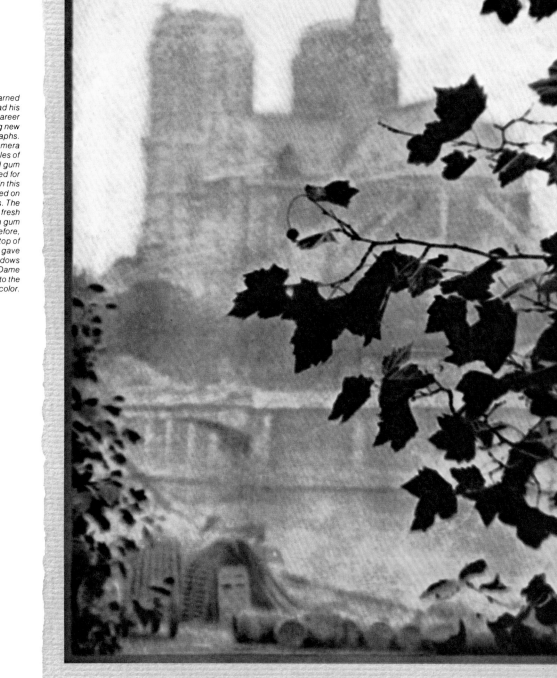

ALVIN LANGDON COBURN
Notre Dame, c. 1908

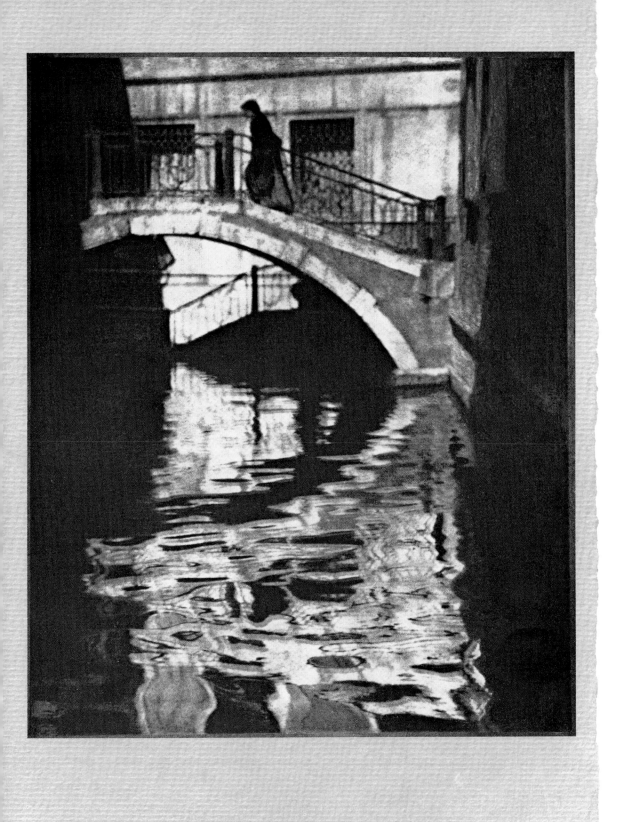

"Sunshine and water form, I believe, the landscape photographer's finest subject matter," wrote Alvin Coburn about the gum-platinum photograph shown at left. "I have spent hours on the canals of Venice and on the waterways of many other places feasting my eyes on the rhythmic beauty and the poetry of liquid surfaces, hours punctuated at intervals of exceptional charm by the click of my shutter. . . . That photography is able to render sunshine is one of its especial charms."

ALVIN LANGDON COBURN
The Bridge, Venice, 1905

This picture and the one opposite, among the first full-color photographs to be printed anywhere, appeared in Camera Work in April 1908. They had been made the year before in London by Steichen, who had learned a new color process, the first crude precursor of modern color films, called Autochrome. Taking the chemicals that were necessary with him, he went to London and used Autochrome plates to photograph some English friends, including Lady Ian Hamilton (right). "The first results," he reported in Camera Work, "brought the conviction that color photography had come to stay." As it turned out, practical color photography was still more than a quarter century away, but Autochrome did serve until a better system came along.

EDWARD STEICHEN
Portrait of Lady H., 1907

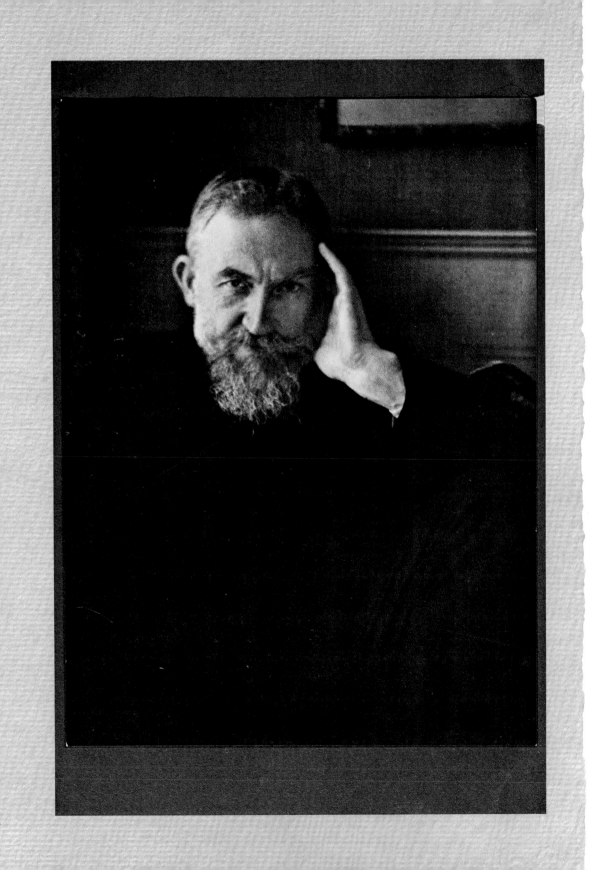

Photography fan that he was, George Bernard Shaw doubtless took just as much interest as Steichen in the making of this color portrait by the Autochrome process. He posed many times for Steichen and other photographers and maintained that, in portraiture, photography could hold its own with the other arts. That same year Steichen returned the compliment by titling another portrait of him "The Photographer's Best Model—George Bernard Shaw."

EDWARD STEICHEN
G. Bernard Shaw, 1907

Among the Camera Work contributors who reworked their developed negatives, Frank Eugene went further than most. Having started out as a painter, he still found it hard to keep his hands off his pictures after switching to photography. An extreme example of his tampering is this picture of two nudes. Perhaps to subdue a highlight or to produce one, or simply to avoid a machine-made look, Eugene scratched the negative of Adam and Eve so that his final print (right) looked more like an etching than a photograph. While some critics were shocked by such manipulation, considering it a dishonest twisting of the camera's truthful vision, they had to admit that the results had a certain semblance of art —and that was what counted in Camera Work.

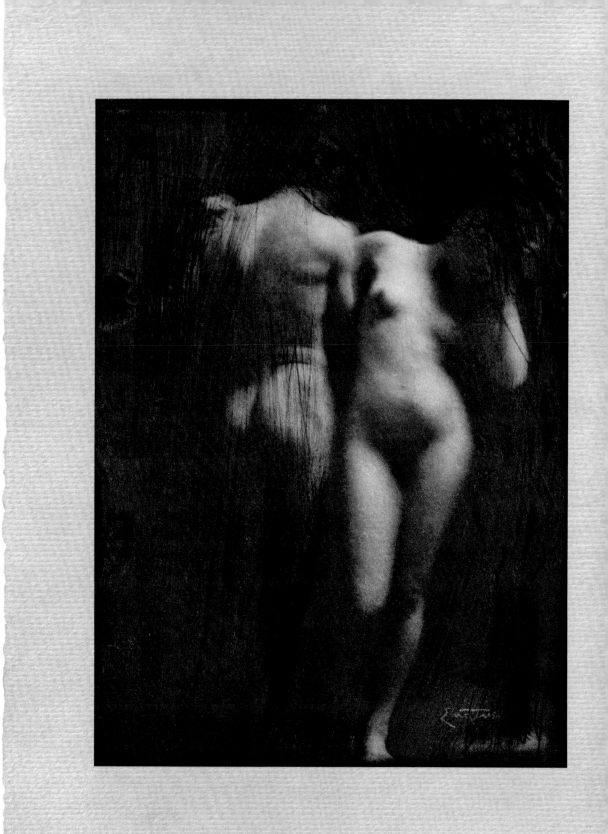

FRANK EUGENE
Adam and Eve, c. 1910

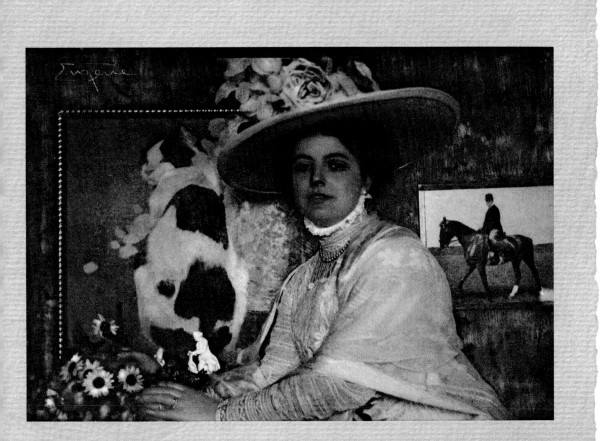

Some painters' styles as well as their techniques showed up now and then in Eugene's photographs. An American, he had spent most of his career in Europe, where early in the century he mingled with painters and got to know the work of various schools. This portrait of a German lady uses both a pose and some of the trappings—fancy hat, busy background, even a life-sized picture of somebody's cat—that make it reminiscent of works by Renoir and Toulouse-Lautrec.

FRANK EUGENE
Frau Ludwig von Hohlwein, c. 1910

Steichen was another painter turned photographer, and when the mood was on him he could mix the media in pictures that, like many published in the pre-World War I *Camera Work*, resembled paintings of the time. He has done this in the two photographs shown here: Steichen printed them by one of the processes he used to create an effect he called "painting with light." It was the gum-bichromate process, which used a semitransparent mixture based on gum arabic and potassium bichromate for the coating on the printing paper. By varying the thickness of the coating and the amount of light hitting it during printing, he could suggest different moods. A thick coating gave a granular effect, excellent for representing broad masses of light and dark, as in the picture at right of a shadowy Versailles stairway. A thinner coating allowed finer grain and greater detail, as in the picture opposite.

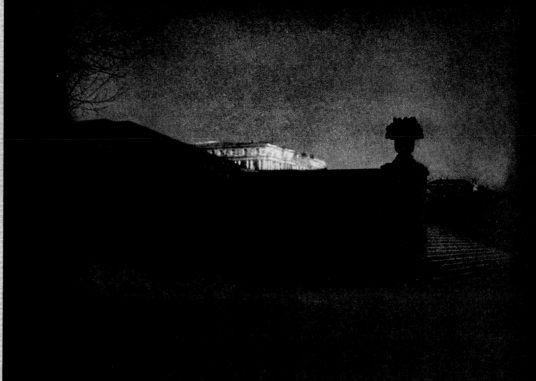

EDWARD STEICHEN
Orangerie Staircase, Versailles, c. 1910

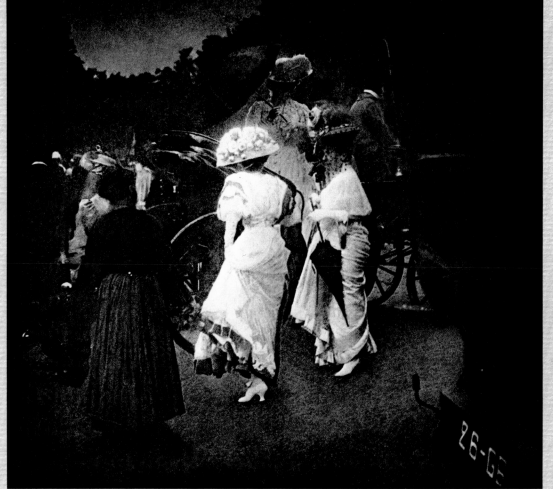

Even in prints that seem most like paintings in their celebration of luminous patterns, such as this scene of sumptuously gowned ladies returning to their carriages after a race in Paris, Steichen applied a reporter's perception. "One day in the summer of 1907," he recalled in his autobiography, "I borrowed from a friend a German hand camera called the Goerzanschutz Klapp Camera. Armed with this camera, I made my first attempt at serious documentary reportage. I went to the Longchamps Races and found an extravagantly dressed society audience, obviously more interested in displaying and viewing the latest fashions than in following the horse races."

EDWARD STEICHEN
Steeplechase Day, Paris, 1907

45

In 1911, Camera Work switched abruptly from the camera to the paintbrush. The April-July issue, twice the usual length, was devoted almost entirely to works by Auguste Rodin—not the famous sculptor's statues but some of his drawings, including the two shown here. They were sent in by Steichen, who had photographed Rodin in his Paris studio, admired his work and wanted to make it better known. Few subscribers to Camera Work could appreciate Rodin's art —then unknown outside Europe—and fewer still could understand why it was in a camera magazine. But Stieglitz, like Steichen, had tastes ahead of the times. He felt a mingling of photography and the older arts would be mutually invigorating, and he made Camera Work a herald of modern art in America.

AUGUSTE RODIN
Drawing, c. 1906

To preserve the subtle nuances of color and line in these Rodin drawings, Camera Work lavished even more than its usual care on their reproduction. A combination method was used in which collotype played an important role. This is a lithographic process that employs a sheet of ground glass for the printing plate. Invented in 1855, collotype can produce a few thousand copies at most, but it renders such faithful and fine detail that it is still used today when extremely high-quality results are required.

AUGUSTE RODIN
Drawing, c. 1906

The two final issues of Camera Work (the last was double the usual length) were devoted to the work of a newcomer, Paul Strand. His pictures were "brutally direct," as Stieglitz observed, but they did more than simply record the world around him. This close-up photograph of kitchen bowls, inspired by the paintings of Picasso and fellow artists, becomes an abstraction. "I was trying," Strand explained, "to apply their then strange abstract principles to photography in order to understand them."

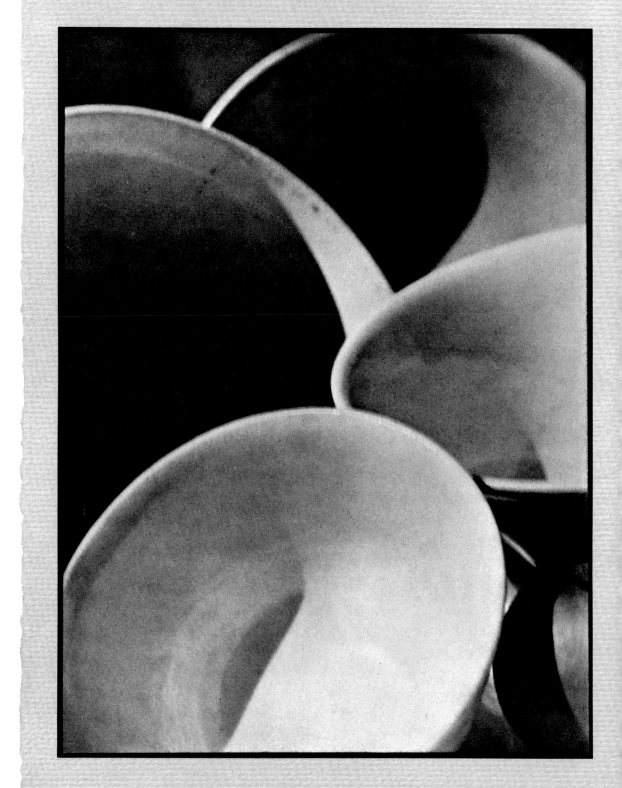

PAUL STRAND
Pattern Made by Bowls, 1916

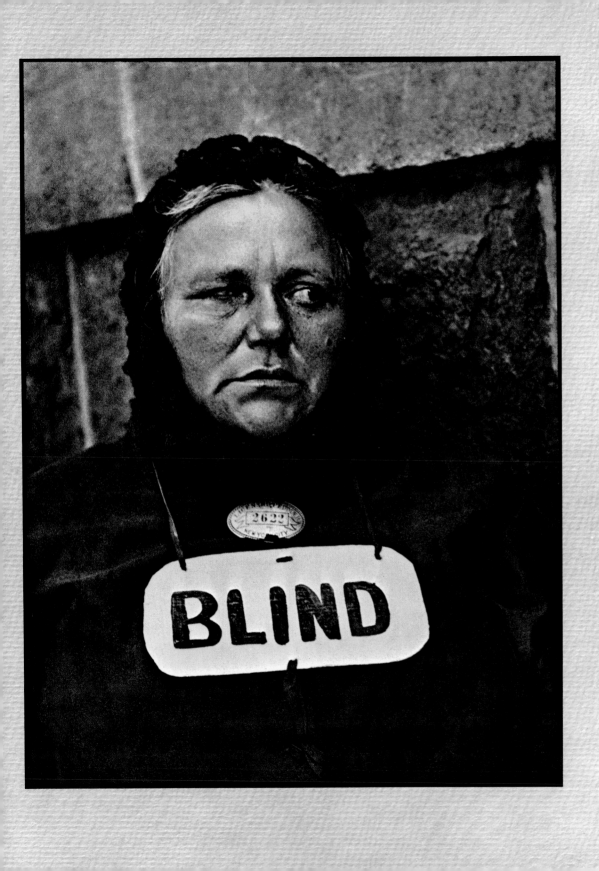

In his search for realism, Strand sought unposed pictures of people on New York City streets, using a small camera with a false lens sticking out one side. While apparently pointing the camera away from his unsuspecting subject he was able to snap the picture he wanted through the real lens. Such ingenuity may have been lost on the blind woman at the left, but it was often essential to getting what Strand felt were truly "objective" photographs. "This objectivity," he wrote in Camera Work, "is of the very essence of photography."

PAUL STRAND
Blind Peddler in New York, 1915

*How far Camera Work (and Stieglitz'
taste) had come from the soft romanticism of
Gertrude Käsebier was revealed in the light
and shade patterns that Strand abstracted
from such ordinary scenes as this Port Kent,
New York, barnyard. "Look at the things
around you, the immediate world around
you," he urged his fellow photographers. "If
you are alive it will mean something to you,
and if you care enough about photography,
and if you know how to use it, you will
want to photograph that meaningness."*

PAUL STRAND
The White Fence, 1916

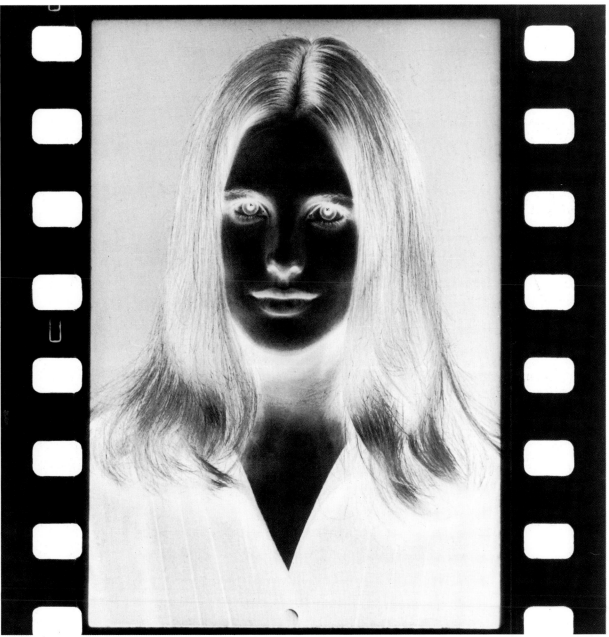

EVELYN HOFER: *A fully developed 35mm frame, printed in negative form,* 1969

Molding an Image in Silver

In one sense, the moment the camera shutter clicks the picture has been made. Yet nothing shows on the film: The image is there but it is transient, reversed — invisible. Not until it is brought out by development and then printed is the picture there to be enjoyed. How enjoyable it will be largely depends on how the steps are carried out. For they give the photographer who processes his own pictures unparalleled opportunities to control results.

This control begins with the development of the negative. The techniques are simple, and using them to govern picture quality may mean nothing more than exercising care to get crisp detail and to keep off dust spots, stains and scratches. Control at the next level means adjusting the developing process to suit one's taste: for example, to produce especially fine grain in the image so that a precise detail will show clearly in an enlargement, or to make pictures lighter or darker than average. Finally, control affords a chance, by the use of special chemicals and techniques, to salvage negatives that were wrongly exposed and to rectify mistakes in developing.

At all levels, such control aims to reproduce the original scene (or one's vision of it) by manipulating two basic characteristics: density and contrast. Density, the degree of darkness of the black-and-white negative image, depends on the amount of black metallic silver in the image. A dense, dark, negative is generally heavy with silver (its opposite, a "thin" negative, has little silver and looks pale). The image is formed by differences in density — the contrast between one tone and another. Density and contrast together build up the detail of an image and determine whether it is crisp or indistinct, grainy or smooth.

A number of factors affect this image-molding process. The developer itself, a complicated solution containing several chemicals, is the active molder of the image *(pages 66-67)*. But equally important are the final steps of the process. The stop bath must apply a chemical brake to halt development quickly; the fixer must dissolve leftover emulsion crystals lest they too darken *(pages 68-69);* and finally, clean water must wash away chemicals that might injure the image *(pages 70-71)*.

The actions of all these substances depend on their temperatures *(pages 76-77)* and on how long they are permitted to work on the film *(pages 74-75)* — seemingly minor variations from recommended conditions have a strong influence on contrast and density. Time is easily controlled with timers. Temperature regulation requires more attention. All solutions must be kept at a standard temperature. For films manufactured for use in the United States, this is usually 68° F.; for films manufactured for use elsewhere, recommended temperatures may be given in Celsius degrees, the metric measurement used in most countries. (A table converting metric to U.S. measurements and vice versa appears on page 235.) To maintain the required temperature, place all bottles in a pan of water that has been heated or cooled as necessary; even the tank for de-

veloping film is set into a tray of temperature-controlled water during use.

Standard conditions should be adhered to rigidly for the routine processing of most negatives, though two radically different black-and-white roll films, introduced in 1980, are processed not in the normal way, but by the techniques used for color negative film. The pictures on pages 58-64 show the normal procedure for handling the roll films most amateurs use. The processing of sheet films follows the same steps but can be carried out in open trays — much like the processing of prints (Chapter 3) — or in special tanks. But these procedures may have to be altered to achieve complete control over negative quality. This calls for an understanding of the role played by each factor involved — exactly how and why contrast, density and other characteristics of the negative are influenced by developer, stop bath, fixer, washing, time, temperature. Their effects are described in the second part of this chapter (pages 65-84).

The skills needed to develop good negatives are quickly learned, and the equipment demanded is modest. Most amateurs get along with temporary work areas in kitchen or bathroom — a sink with running water is a necessity for washing negatives (and prints) and a convenience during other steps. If a kitchen is used as a part-time darkroom, particular care must be taken with photographic chemicals. They, like many ordinary household supplies, are potent substances; many stain flooring and textiles, some may cause skin irritations and a few are poisonous.

The word "darkroom" is something of a misnomer, for most steps in processing do not call for total darkness. Bright room lights can be left on most of the time during the development of film (printmaking is carried out in the illumination of a "safelight," which emits light of a color that does not affect printing paper). Total darkness is required, however, while film is being taken off its camera spool and loaded into the developing tank. During those five or 10 minutes, not even a glimmer of light can be tolerated; even a work area that seems pitch-dark may still be unsafe for unshielded film.

If there is any doubt about the risk of light, make a darkness test. Clip off a few inches of unexposed film and lay it on the work surface, making sure the emulsion (the side of the film that feels smooth but not glassy) is facing up. Cover half the film with cardboard for about 15 minutes. Then process the film clip as if it were an entire roll (pages 56-64). After processing, examine the film closely. If it is uniformly blank the work area is safe; if a tinge of gray distinguishes the half not shielded by cardboard, the work area is not dark enough.

Total darkness is hard to attain in daytime without special tight-fitting window shutters (ordinary shades do not block all light). Even at night, windows should be shaded against light from the street. A closet serves well for film handling; once the film is loaded into the tank and the tank closed up, the remaining steps of development can be carried out in ordinary room illumination. □

Processing Film Step by Step

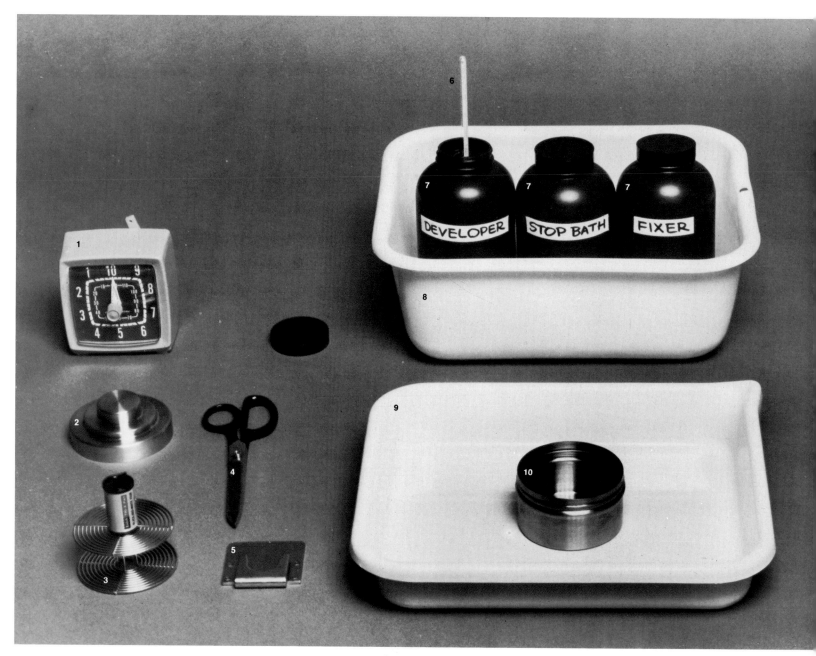

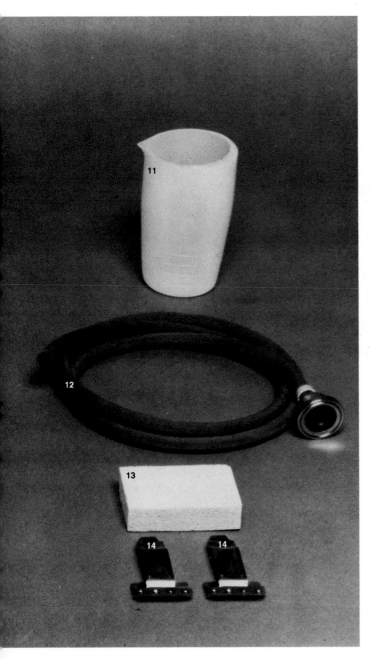

1 interval timer
2 developing tank cover
3 developing reel
4 scissors
5 film cassette opener
6 thermometer
7 chemical solutions
8 temperature control pan
9 temperature control tray
10 developing tank
11 one-quart graduate
12 washing hose
13 viscose sponge
14 film drying clips

Most items needed to develop roll film are inexpensive, but it is wise not to skimp on the developing tank (the one shown is designed for 35mm film; other models will accommodate all sizes of roll film). The specialized timer is a necessity; kitchen timers are not built to mark time by seconds. Any sort of dark bottles can be used for solutions, so long as they pour easily, have tight-fitting caps and are carefully cleaned. Some of the equipment, such as the graduate, tray and washing hose, can be used later in making prints.

What is essential is an orderly and convenient arrangement of the equipment. Development will begin in total darkness and the rest of the process, once begun, moves briskly. Even before laying out the equipment, make sure that the chemicals needed are ready. Most of the commonly used developers come in powder form. Follow the manufacturer's mixing directions exactly. Some developers are used once and then discarded; others can be reused. Buy the stop bath as a concentrated liquid and dilute it for use. Buy fixer also in concentrated liquid form, at least to start (it is cheaper as a powder).

After mixing and diluting each solution adjust the temperature to 68° F. *(Step 1, page 58),* and place the bottle in the temperature control pan with water at 68°. Fill the empty developing tank with 68° water and place it in the temperature control tray with water at 68°. A variation of even a degree or two in developer may make a difference *(pages 76-77).* Only after the basic developing procedure has been mastered should the rigid time and temperature stipulations be varied to achieve special results *(pages 80-83).*

1 adjust the temperature

Make a temperature check of the three solutions
(rinse the thermometer each time). All of them
should be at 68° F. — which is just about where
they will stay normally in the average house. To
adjust a solution that is not right on the dot, hold
the bottle under a faucet of hot or cold running
water. Leave the thermometer in and watch
it carefully as the temperature changes (but be
sure that the water does not splatter into the
bottle). Once the solutions themselves are right,
recheck the water in the temperature control
bath, the developer tank and its temperature
control tray, adding hot or cold water to
stabilize it at 68° during the entire period.

2 fill the tank with developer

After emptying the tank of the 68° water that was
used to stabilize its temperature, pour in the
developer. Fill the tank almost full. Recap the
developer bottle and replace it in the pan. (If the
working area ordinarily used cannot be made
absolutely dark — see page 55 for a total
darkness test — handle the film in a closet and
delay until later the tank-filling step. In this case,
load the film on the developing reel — Steps 4
through 7 — place the reel in the unfilled tank
and put the light-tight cover on the tank. This
shields the film from light and it can be taken to
the regular working area. There, fill the tank
with developer, pouring the solution through
the special pouring opening in the tank cover.)

3 set the timer

The interval timer is set — but not started —
in advance of development (when following the
standard development procedure), for actual
development of the film begins while the room is
in total darkness. Development times for various
brands of film are listed in a chart for "small-
tank development" in the instructions that come with
the developer. Or use the developing instructions
that come with the film. Follow the recommended
time closely or the negatives will be too thin
and flat or too dense and harsh (pages 74-75).

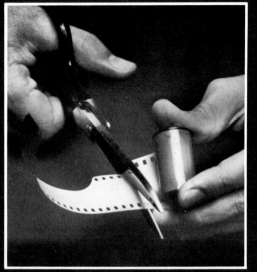

With all lights turned off, open the roll of film. To remove film from a standard 35mm cassette, find the spool end protruding from one end of the cassette. Pick up the cassette by this end, then pry off the other end with the cassette opener or a soda-bottle opener. Slide the spool out. Larger sizes of roll film are not contained in cassettes: With one of these, simply break the paper seal, unwind the roll a bit and free the film from its paper backing. To open a plastic cartridge used in an instant-loading camera, twist the cartridge apart and remove the spool. Be sure that the film loading area is totally dark (page 55). Then take one more precaution. Lock or block the door. Many a film has been ruined by Junior inadvertently bursting in at the wrong moment.

With the scissors, cut off the protruding end of the film to square it off. Do not try to tear the film; besides injuring the emulsion the friction of tearing could cause a flash of static electricity —a tiny bit of light but enough to streak the film. Keep the scissors handy —they will be needed again in a moment —but put them where the blades or points cannot scratch the film.

Hold the spool in either hand so that the film unwinds off the top. Unwind about three inches and bow it slightly between thumb and forefinger. The reel must be oriented properly in the other hand or the film will not slip into the grooves. Each side of the type shown is made of wire in a spiral starting at the core of the reel (marked "a" in this picture) and running to the outside; the space between the spirals of wire forms the groove that holds the film edge. Hold the reel so that the sides are vertical and feel for the blunt ends (b) of the spirals. Rotate the reel until the ends are at the top. If the ends then face the film the orientation is correct. Then insert the squared-off end of the film into the core of the reel. Now rotate the reel away from the film to start the film into the innermost spiral groove. Practice this and the next step with a junked roll of film until you can perform

7 wind the film on the reel

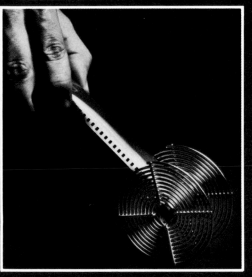

To finish threading the reel, place it edgewise on a flat surface. Continue to hold the film spool as before, with thumb and forefinger bowing the film just enough to let it slide onto the reel without scraping the edges. Now unwind three or four inches of film and push the film so that the reel rolls forward. As it rolls it will draw the film easily into the grooves. When all the film is wound on the reel, cut the spool free with the scissors. Check that the film has been wound into an open spiral, each coil in its groove. Determine — with a junked roll — how your film should fit on your reel. If, after loading, you find more — or fewer — empty grooves than the length of your film allows for, pull the film out, rolling it up as it comes, then reload the reel. Unless the reel is correctly loaded, sections of film may touch, stopping development at those points.

8 put the reel into the tank

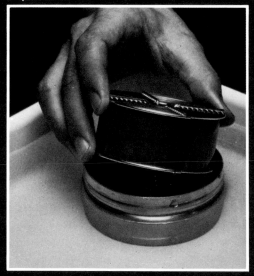

Now actual development can begin and you must do two things at once. With one hand, drop the loaded reel gently into the developer in the tank. Simultaneously, with the other hand, feel for the starting lever of the timer (you are still in total darkness). As the reel touches the bottom of the tank, start the timer. Put a finger in the core of the reel and joggle the reel up and down several times, gently but firmly, to dislodge any air bubbles that might be clinging to the film.

9 cover the tank

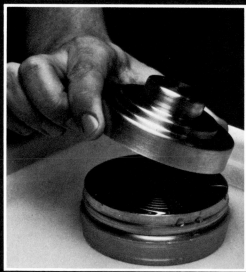

Put the light-tight cover on the developing tank. Lift it out of the temperature control bath immediately, and tap the bottom of the tank lightly on a hard surface. This will dislodge air bubbles and keep them from transferring to the film. Now the room lights may be turned on.

10 agitate

As soon as the lights are on, agitate the tank, using the motion shown in the multiple-exposure photograph above; turn it gently upside down, then right side up again. Agitate for 5 seconds once every 30 seconds. This is an essential part of the developing process because it keeps bringing fresh portions of the developer solution into contact with the film emulsion (pages 78-79). Between agitations, leave the tank in the temperature control bath.

11 remove the cap from the pouring opening

About 30 seconds before development is completed, get ready to empty the developer from the tank. Remove the cap from the center pouring opening — BUT DO NOT REMOVE THE TANK COVER ITSELF. Pick up the bottle containing the developing solution, set it in the tray near the tank and unscrew its cap.

12 pour the developer back

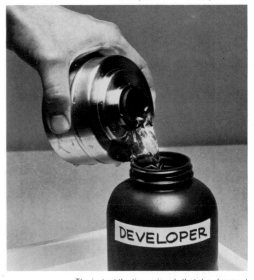

The instant the timer signals that development is completed, start pouring the developer from the tank away — or back into its bottle if it is a reusable type. If the bottle has a small mouth, or if the tank does not pour out smoothly, use a funnel to speed pouring. As soon as the tank is empty set it back in the tray. Recap the developer bottle and open the stop-bath bottle.

13 fill the tank with stop bath

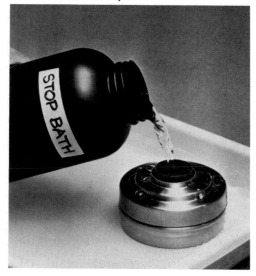

Quickly pour stop bath into the tank through the center pouring opening of the cover. *DO NOT REMOVE THE TANK COVER. Fill the tank just to overflowing to make sure the film is entirely covered.* On some tanks the light baffle in the opening is arranged so that the tank must be held at a slight angle to facilitate pouring.

14 agitate

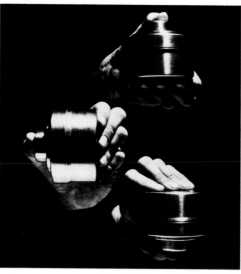

After replacing the pouring opening cap, agitate the tank gently for about 30 seconds, using the same technique described in Step 10.

15 pour back the stop bath

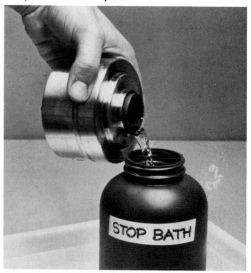

Empty the tank of stop bath. *DO NOT REMOVE THE TANK COVER.* Some photographers throw out used stop bath, since it is inexpensive and easier to store as a concentrated solution.

16 fill the tank with fixer

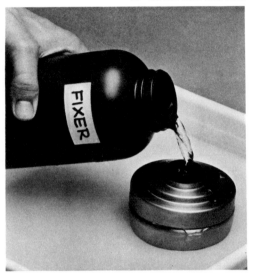

With the tank cover still on, pour fixer through the pouring opening in the cover. Fill to overflowing. If the workroom is very hot or cold it is a good idea to recheck the temperature of the fixer before filling the tank. Make sure it is within two or three degrees of 68° F.; if its temperature must be corrected, fill the developing tank temporarily (without removing the cover) with water at 68° F. When the temperature of the fixer is properly adjusted, empty the tank of water and fill it with fixer.

17 set the timer

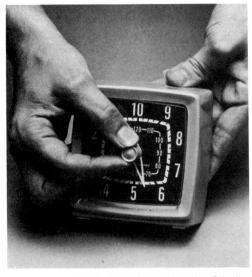

Turn the timer pointer to the optimum fixing time recommended in the chemical manufacturer's instructions: 5 to 10 minutes is usual for standard fixer, 2 to 4 minutes for rapid fixer. When both minimum and maximum times are given, use the longer time, or close to it, because too short a fixing period may make the image subject to fading (pages 68-69). Be sure to use the figures specified for films; most fixing solutions can also be used to process prints, but the dilutions and times needed are different.

18 agitate

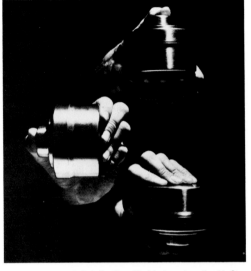

Agitate the fixer-filled tank as described in Step 10. When the timer signals that the period is up, pour the fixer back into its container. The entire cover of the tank may now be removed, since the film is no longer sensitive to light.

19 wash the film

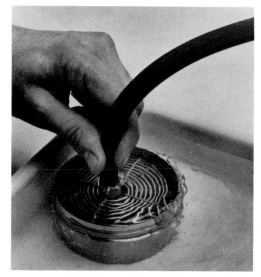

With the faucets adjusted to provide running water at 68° F., insert the hose from the tap into the core of the reel. The reel should be left inside the open tank in the sink. Let the water run rather slowly; too much force can damage the film emulsion, for it is relatively soft when soaked with water. About 30 minutes' washing is needed to prevent later deterioration or discoloration of the image (pages 70-71).

20 dry the film

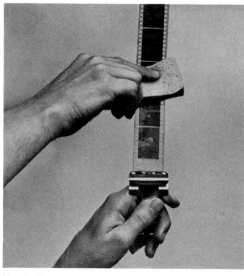

Now the film can be unwound from the reel for drying and you get a chance to look at your negatives. Unwind gently; the emulsion is still wet and soft, and easily scratched. Attach a clip to one end of the film and hang it in a dust-free place where the room temperature will remain constant during the drying period—one or two hours at least. The middle of a room, away from walls and windows, is best since it is usually less plagued by dust and temperature fluctuations. Attach a weighted clip to the bottom of the film. Pull the film taut and remove excess water from the surface by gently drawing a damp, nonscratchy viscose sponge, held at a 45° angle, down both sides of the strip of film.

21 record the work done

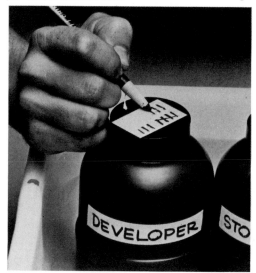

Write down the number of rolls developed on a label affixed to the developer bottle. The instructions that came with the developer tell how many rolls may be processed in a given amount of solution and how to alter the procedure as it is reused. Each succeeding roll of film requires either an extension of developing time or, with some developers, addition of a "replenisher." Also record the date the developer was first mixed, because even with replenishing most developers deteriorate as time passes (pages 72-73). Keep the same usage records for stop bath and fixer.

Avoiding Development Problems

Developing negatives strictly by the book would always turn out good pictures—except that the book is written for average negatives, and far-from-average ones are all too common. For them the standard procedure is not enough; they will come out too grainy, too light or too dark, too harsh or too flat. An understanding of the reasons behind the rules is needed, so that standard procedures can be modified to prevent such defects.

A photographer whose negatives consistently turn out too dark, for instance, can get lighter ones if he knows how to modify the length of development time. It is even possible, when a bad exposure is suspected, to break the cardinal rule of total darkness and, with special precautions, turn on a safelight for a look at the film; the photographer can then take remedial action while the process is still going on.

Whatever the circumstances, and whatever modifications they may call for, the photographer is almost always pursuing the same goals: normal density and contrast, and the least possible graininess (if he has different goals in mind, they are best pursued in printing, not in negative development). There are several ways to achieve these three goals, and nearly all are interrelated.

Density, which is a measure of how dark the image gets, is influenced most readily by time—the length of time the film is in the developer. More time gives a darker negative, less time a lighter negative. Density can also be changed by altering the temperature of the developer solution, although this method of control is less common than changing the time. Another factor that influences density is the amount of agitation the film receives during development. However, it is not varied to control density, as time and temperature are, but is kept constant to guarantee that development continues at a steady pace so all parts of the film are affected equally.

Contrast, being a product of the way density varies in different parts of the negative, is influenced by the same factors that affect density itself. Any modification that increases the density usually increases contrast. Also, graininess is closely related to contrast—the more contrast the more grain—and is altered in much the same ways.

Another dimension of control over negative quality is provided by the choice of developer. Normal developers work deliberately to create even gradations of gray tones—that is, even contrast—with moderate graininess in all parts of the negative.

However, there are special developers that quickly build up density and contrast, greatly reducing developing time. These "high-energy" developers compensate for underexposure by concentrating on the highlights. Fine-grain developers turn out negatives that produce big, sharply detailed enlargements. And still other developers are made to increase or decrease contrast.

Since so many of the factors that influence the negative are interrelated, the photographer will find many ways, as he becomes more familiar with the development process, of adjusting procedures to fit his particular needs. There is a limit, of course, to how much modification the rules will stand. The aim should be to change them only when necessary, and then only as much as is necessary, to make each negative as nearly normal as possible.

Chemicals That Affect a Picture

A working acquaintance with developers—with their ingredients, capabilities, limitations—is useful insurance against bad negatives. Such an understanding helps the photographer know what to expect of a given formulation, how to alter those results if need be, and how to choose, from dozens on the market, one to suit his taste.

The key ingredient in any developer formula is the developing agent. Its job is to free metallic silver from the emulsion's crystals so it can form the image. The crystals contain silver atoms combined with bromine atoms in the light-sensitive compound silver bromide. When hit by light during an exposure, the silver bromide crystals undergo a partial chemical change. The exposed crystals (forming the latent image) provide the developing agent with a ready-made working site. It cracks the exposed crystals into their components: metallic silver, which stays to form the dark parts of the image *(pictures at right),* and bromine, which unites chemically with the developer.

Sometimes a single developing agent is used, but often two together have complementary properties, as can be seen in the pictures of a bathtub in the top row on the opposite page. One combination is made of the compounds Metol and hydroquinone. If hydroquinone is omitted from the usual formula, the result is a loss of contrast *(opposite, top center)* as compared with a normal negative *(top left).* If there is no Metol in the compound, the image may fail to appear during the usual developing period *(top right).*

When developing begins, the action is sluggish, so an "accelerator" is added; without it a negative comes out underdeveloped *(opposite, bottom left).* Once started, though, the process goes so fast that unexposed areas are developed unless a "restrainer" is included; without it a negative is overdeveloped *(bottom center).* Finally the developers deteriorate in air, and they release by-products that weaken their action and may discolor the negative *(bottom right)*—unless a "preservative" is added.

For normally exposed films of moderate or high speed, the best developer is one that will give normal contrast with moderate grain. Some examples of these are Kodak D-76, Ilford ID-11 Plus and Ethol TEC. Finer grain can be obtained—but usually with some loss of contrast and film speed—with such developers as Kodak Microdol-X, Ilford Microphen or Edwal Super 20.

Electron microscope pictures of four emulsions show how exposed crystals of silver bromide (magnified 5,000 times) are converted to pure silver during development. At first (top) the crystals show no activity (dark specks on some crystals are caused by the microscope procedure). After 10 seconds parts of two small clusters (arrows) have been converted to dark silver. After a minute, about half the crystals are developed, forming strands of silver. In the bottom picture all exposed crystals are developed; undeveloped crystals have been removed by fixer solution and the strands now form the grain of the finished negative.

undeveloped silver bromide crystals

developed 10 seconds

developed 1 minute

developed 5 minutes and fixed

normally developed negative

negative developed without hydroquinone

negative developed without Metol

negative developed without accelerator

negative developed without restrainer

negative developed without preservative

What Fixer Does

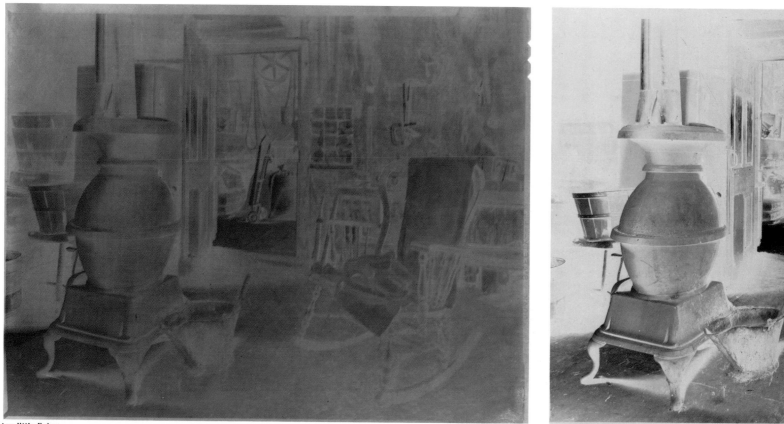

too little fixing

normal negative

After the developer has done its work the image on the negative is visible but very perishable. If exposed to light it vanishes into total blackness. To prevent this, the fixer sets the image permanently on the film and prepares it for printing—if it is used properly.

The fixing agent is needed because the negative image is surrounded by the leftover crystals of silver bromide; since they represent shadows in the scene, they were not exposed and they should not be converted to dark metallic silver. But, if allowed to remain, these leftover crystals will darken in the light and black out almost the entire image *(above, left)*. The fixer prevents this by getting rid of the unneeded crystals. It dissolves them out of the emulsion.

Finding the right solvent to accomplish this took a third of a century and was a major stumbling block in the early evolution of photography. The man who solved the problem was Sir John Frederick Herschel, the famous English astronomer and an early photographic chemist. In 1839 he suggested using sodium thiosulfate, and no better fixer for general use has yet been found. (For a long time photographers thought they were using sodium hyposulfite, and hypo is still a common name for fixer.)

One other important substance, although not technically part of the fixing operation, is added to the solution. This is the hardener compound, usually po-

too much fixing

tassium alum, which prevents the film emulsion from becoming so soft or swollen that it is damaged during the washing that follows fixing.

Under normal conditions the fixer dissolves only the unexposed crystals of silver bromide and does not affect the metallic silver making up the image itself. But if the film is left too long in the fixer a side reaction converts the silver into a compound that will, in time, cause the image to dissolve *(above,*

right). This upper limit to the fixing period is quite long—about three times the recommended maximum.

Ordinarily the danger is not too much fixing but too little. If the fixer is not given sufficient time to complete its work, silver bromide crystals are left undissolved and they later darken. Often, the fault is simply repeated use of the same solution: A given amount of fixer can dissolve only so much silver bromide. Then it stops working.

The Importance of Washing

Too often a photographer is lulled into false security by the term "fixed." Even the most carefully fixed films, he discovers, can fade or turn yellow if not thoroughly washed.

The cause of this damage is the fixer itself. The fixing solution contains dissolved sulfur compounds, and if any fixer remains on the finished print, the sulfur tarnishes the silver image of the negative. It is exactly the same kind of reaction that causes silverware to tarnish. The unexposed silver bromide crystals dissolved in the fixer tarnish too, streaking and spotting the entire negative. Worse still, the tarnish often becomes soluble in water. When this happens moisture in the air will gradually cause the negative image to dissolve and fade away.

Of all the misfortunes that can befall the photographer, these are the easiest to avoid. All that is needed is water. But water is a very special liquid, not to be taken casually. It must be clean, near the temperature of the earlier solutions and, perhaps most important, kept constantly moving to get out all the fixer that has soaked deep into the emulsion. This is why washing takes a long time — half an hour or more for a roll of film. The time can be shortened to a few minutes, however, by using a washing aid called hypo eliminator. It cleans up the film chemically and more efficiently than long washing. Another chemical, called a wetting agent, can help prevent streaks caused by uneven drying.

poorly washed negative

normal negative

The Danger of Overworked Solutions

A mistake that many photographers make is overworking developer or fixer solutions. The consequences, as shown here, can be serious. A good negative, properly exposed and developed, can be damaged or completely ruined because the chemicals in the solutions are used up.

An overworked developer produces underdeveloped negatives *(top row)*; there is just not enough developing agent left to build up density. With partially exhausted developer, details, particularly in shadow areas—the model's sleeve—grow dim *(center)*; in extreme cases the image is all but lost *(far right)*. Damage may be worse than that caused by underdevelopment because impurities in exhausted solution may stain the negative. Development may be patchy and uneven, and remedial treatment that might ordinarily have helped *(pages 82-83)* will be of no avail.

An overworked fixer produces negatives that seem overdeveloped compared to a normal one *(bottom row)*. The solution is so overloaded with silver bromide dissolved from earlier negatives that it cannot take up more unexposed crystals from the negative. These leftover grains turn dark and cause the negative to grow denser. As highlight areas—the model's forehead —darken, the overall image grows flatter *(center)*. Such details as strands of hair are obscured, and a grayish density extends like a pall of smoke over the entire negative, even clouding unexposed borders *(far right)*.

Preventing these problems is easy enough. Developer and fixer manufacturers specify how much film may be processed per quart of solution and this limit should never be exceeded.

developer exhaustion

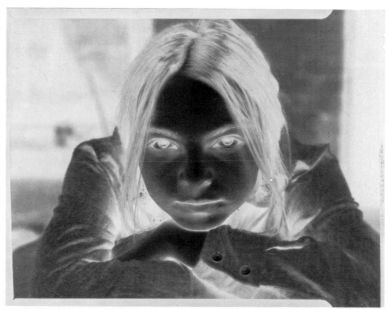

negative developed in fresh solution

fixer exhaustion

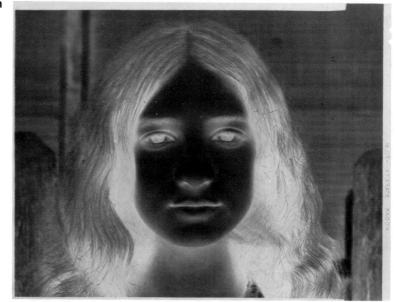

negative fixed in fresh solution

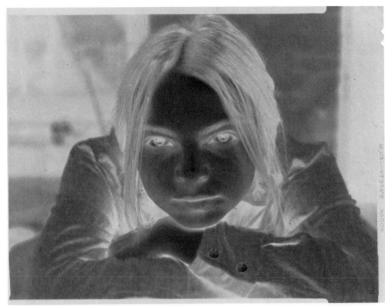

negative developed in partially exhausted solution

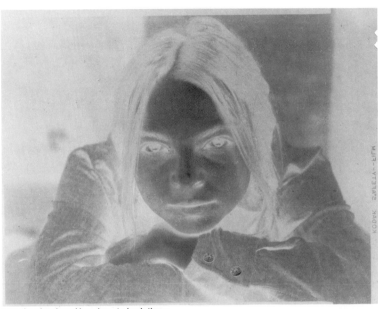

negative developed in exhausted solution

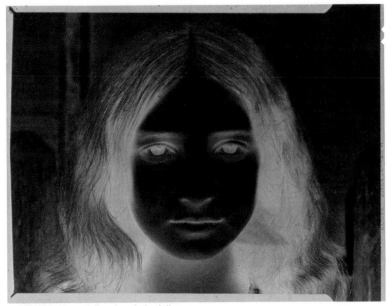

negative fixed in partially exhausted solution

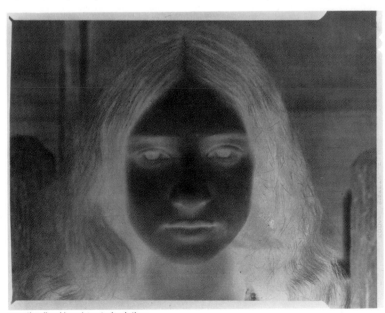

negative fixed in exhausted solution

Time: The Crucial Factor

negative developed for 45 seconds

negative developed for 4 minutes

negative developed for 2 minutes **negative developed for 5 minutes** **negative developed for 15 minutes**

Grains of silver, enlarged about 2,500 times in this cross section of film emulsion, get denser as development is extended. Grains near the surface (top) form first and grow in size. As developer soaks down, subsurface grains form.

In solving development problems, the most useful tool the photographer has is time. It can be stretched or shortened while development is going on, thereby controlling the amount of development and, in turn, the quality of the finished negative. The image can be affected in a similar way by other factors involved in development—temperature for one *(pages 76-77)*—but none is so easily controlled as time.

The longer the developer is allowed to act on the film, the greater the number of crystals converted to metallic silver and the darker the negative image becomes *(above)*. A negative that would be too light because of underexposure when the shot was made can be darkened; a negative that would other-

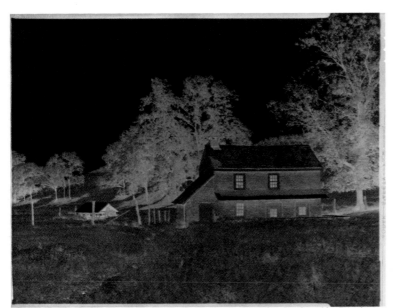

negative developed for 7½ minutes

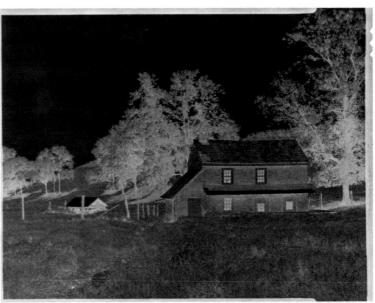

negative developed for 30 minutes

wise turn out too dark from overexposure can be lightened by shortening development time. There is a catch, however. The density of silver in the image does not increase uniformly. The denser areas are built up more than lighter ones, changing the relationship between tones—the contrast. Thus, lengthening or shortening development time may have a more marked effect on contrast than on overall density. This fact means that both contrast and density must be considered when changing development time; varying it is no sure cure for improperly exposed negatives; it can only help them up to a certain point *(page 84)*.

The ability of time to control density and contrast is based primarily on the way the film emulsion is constructed. The grains of silver bromide that will develop into the negative image do not lie entirely on the surace of the emulsion, but are disseminated all through it. Consequently, when the developer goes to work, it gets at the surface grains immediately but needs extra time to soak into the emulsion and develop the grains down below the surface, as illustrated in the photomicrographs on the opposite page. The total amount of time the developer is allowed thus determines how deeply it penetrates and how densely it develops the grains of silver in various areas of the image.

Development does not occur at the same steady pace all during the proc-

ess, but changes speed up at various points, as is demonstrated in the examples above. During the first seconds, before the solution has soaked into the emulsion, activity is very slow; only the strongest highlights have barely begun to show up *(far left)*. The action speeds up for a brief spurt, then levels out at a steady, even pace for a while. During this period, a doubling of the development time will double the density of the negative, as the two center examples show. Still later the pace slows down again so that a tripling, or more, of the development time will add proportionately less density than it did before —although the negative by this time is already too heavy and contrasty to make a good print.

Temperature's Powerful Effect

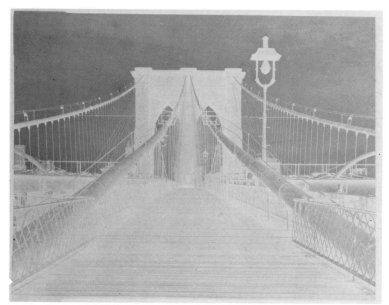

negative developed at 40° F.

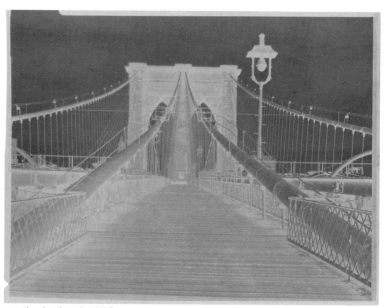

negative developed at 60° F.

Chemists have worked out an optimum temperature for developing negatives that takes into account all the factors involved, even including the comfort of the photographer. This temperature is 68° F. It is right in the center of the useful working range for the most widely used developers, it is a comfortable room temperature for an active worker, and it is a practical level to maintain in the average darkroom.

Photographic materials are finicky about temperature. Most chemicals used in developing, fixing and other processes slow down—and some quit working altogether—if the solutions drop much below 60°. Even water will hardly do its job as a cleansing fluid if the washing bath falls below 50°. All the solutions work better and faster at higher temperatures—but then around 80° the gelatin emulsion of most film begins to soften and becomes exceedingly fragile. Even the touch of a fingertip may be enough to mar it.

Another problem of high temperature is its acceleration of chemical reactions to such a fast rate that developing time must be drastically, and inconveniently, shortened—perhaps to a few seconds. Otherwise, the negative will come out badly overdeveloped. These effects of temperature on the rate of development may be observed by developing identical negatives for the same length of time but at widely differing temperatures, as was done with the examples above.

There are times, however, when it is possible, and even desirable, to deviate from the standard 68°. Some fine-grain developers, for instance, yield even finer grain if diluted. But dilution means the weaker solution would take an inconveniently long time to work. To compensate, the temperature is raised a few degrees to speed up the developer. When such a course is recommended, the instructions with the developer specify necessary time and temperature adjustments.

Similar changes may be made when it is impossible to keep the solution at 68°, as on a hot summer day. Then one of the alternate time-and-temperature combinations, listed in most developer instructions, may be used.

negative developed at 68° F. (standard temperature)

negative developed at 100° F.

The Need for Agitation

One source of trouble frequently over-looked is improper agitation of the tank while the film is being developed. As the examples at the right show, too little agitation will result in an underdeveloped negative; too much agitation will cause overdevelopment.

These problems often occur because many photographers misunderstand or ignore the reason for agitation. Its sole purpose is to move the solution inside the tank so that a steady supply of fresh developer reaches the emulsion all during the development period. If this is not done, the used-up chemicals, after doing their share of work on the emulsion, will form a stagnant pool where development activity will slow down and eventually stop completely.

Agitation must be done at regular intervals so the developer will be moved along and replaced well before it begins to be exhausted. In most cases, agitation for 5 seconds once each 30 seconds is adequate. Some fast-acting developers, however, require more frequent agitation periods.

As important as enough agitation is the kind of agitation, which depends on the motion used—the way the tank is rotated (or with some models the way the film reel is twirled). Most tanks should be turned upside down during each agitation period. Grasp the tank in a different place each time it is raised. This avoids setting up a repetitive pattern of flow across the face of the film, as might happen if the solution were set in motion in the same direction, and with approximately the same degree of force, every time. The film might be marked by the movement of the solution in the same way that steady waves create patterns on a sandy beach.

negative developed with too little agitation

normally developed negative

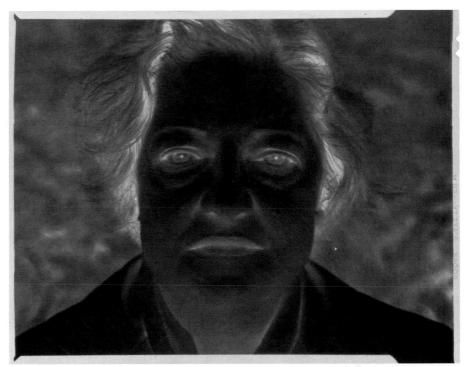

negative developed with too much agitation

Emergency Procedures: During Development

When you suspect a roll of film was wrongly exposed, but are not sure how much or whether it was over or under, the best remedy is to "develop by inspection." Under carefully controlled conditions, you quickly glance at the film and, while development is still going on, take corrective action. Development time can then be shortened or extended, and special chemical agents can be called upon. These procedures are not panaceas for sloppy technique. But they can save pictures that would otherwise come out unprintable.

To develop by inspection, follow the usual steps until two thirds of the normal development time is up. At that point, take the reel out of the tank, unwind a foot or so of film and turn on a dark-green safelight (such as Wratten 3). This light will not harm the film if you work carefully and quickly. Bring the film no closer than two feet from the safelight and keep it moving past the light. Details will be virtually invisible in the dim light. And contrast will be obscured by the milky-gray emulsion (the unexposed parts of the image, which do not become transparent until the film is fixed). What must be looked for is the relative darkness of the image compared to the milky emulsion. This degree of darkness will determine what is to be done next: continue normal development, switch to a different developer or stop development at once, as in the examples at right.

Normal: If, after two thirds of the regular development time has elapsed, the negative looks like this—there is good density in the highlights and some contrast in the shadow areas—the picture was correctly exposed. Continue development for the usual period (but allow for time the reel was out of the tank).

Underexposed: The main highlight, the snow-covered stream bank, appears to have about the right density, but the dark areas in the scene, such as the underside of the arch and the stream, are too faint. They should be a light, distinct gray by this time. To build up contrast in shadows extend development time by one third.

Severely underexposed: Even the snowbank is grayish, and shadow areas are almost blank. Normal developer will do little for such film; it must be switched to a tank of "high-energy" developer, which increases density throughout the image. If this situation is predictable in advance, have the special developer ready.

Overexposed: If the negative is dark all over with no gray tones, it is already too dense. Stop development by moving the film into the stop bath and fixer. (Note that large-sized negatives are shown here to reveal detail. To see what 35mm film looks like during inspection, stand back from the book three and a half feet.)

harsh lighting, regular developer

harsh lighting, low-contrast developer

bland lighting, regular developer

bland lighting, high-contrast developer

When you know a roll of film was correctly exposed but suspect that the contrast is likely to be off—the lighting having been either too harsh or too bland—the best remedy is to use a developer that was specifically concocted to deal with contrast problems. There are two general classes of such developers: one formulated to increase contrast, the other to subdue it.

How excessive contrast can be softened by making an appropriate choice of developer is demonstrated by the top pictures at left. Sunlight streaming directly through a window strikes the front of an armoire with blinding intensity, but leaves the side in deep shadow. A picture taken at this time, then processed with a regular developer, produces a negative with undesirably high contrast between light and dark areas *(far left)*. However, a developer that can be diluted for low contrast (such as Ethol TEC or Agfa Rodinal) will smooth out abrupt differences in brightness and produce a negative that has less harsh contrast and clearer detail *(left)*.

In the opposite situation—when the light is too uniform—the scene may appear bland and dull. The same armoire, photographed when the sun's rays are diffused *(bottom)*, is now evenly but uninterestingly lit. In a negative shot at this time and processed with regular developer, the details of the wardrobe —carved panels, drawer pulls—fail to stand out *(far left)*. But if a high-contrast developer is substituted (such as Ilford Microphen or Kodak HC-110), its vigorous action builds up the highlights and increases the overall contrast. The details then stand out in better relief *(left)* and the resulting print will be crisper and more pleasing to the eye.

Emergency Procedures: After Development

After a negative has been completely processed, and only then is found to be too dense or too light, it can still be saved. A very dense image can be thinned down by a special chemical called a reducer; a faint image can be built up with another agent called an intensifier. Both processes are relatively easy to perform since they are carried out with regular room lighting; changes in the image can be watched as they take place and they can be halted at any point. The pictures at right are examples of the results that can be obtained with the two processes.

Intensification is indicated when a negative resembles the one at near right in the upper row. The image of a cracked vase appears dark enough at first glance but a closer look reveals it is thin—it has too little density—and detail is absent from the shadow areas. This happened because the negative was not developed long enough to let good contrast build up.

Intensification strengthens contrast by adding minute particles of another metal (usually chromium or mercury) on top of the silver that is already forming the negative image. The darker areas are intensified most, so this provides a greater separation between light and dark parts of the negative—that is, greater contrast. Fine detail, such as the crazed texture of the in-terior of the vase now becomes visible *(opposite, top row)*. The image is still not as crisp as that of a normal nega-tive *(opposite, far right)* and it never can be made that good. But it will give a perfectly satisfactory print.

Reduction is indicated when a neg-ative resembles the one at near right in the bottom row. Overdevelopment has caused the density to build up too much, solidifying highlights and block-ing up shadow areas. The reducing chemicals do exactly what the name implies: They dissolve some of the dark metallic silver that forms the image. This thins down the density all over the negative but it does not interfere with the contrast. (The basic formula can be altered if it is necessary, so that con-trast too can be reduced.) After reduc-tion the densest areas of the negative are more transparent and are easier to print, the shadow areas are clearer and details such as the chip marks on the outer surface of the vase are sharper *(opposite, bottom row)*.

Both reduction and intensification procedures can be used to correct mis-takes made in exposure as well as in development, since the basic problem in either case is one of density. Nega-tives that are badly underexposed, how-ever, are beyond redemption; the image will be too faint, if it exists at all, for inten-sification to do any good.

underdeveloped negative

overdeveloped negative

intensified negative

normally developed negative

reduced negative

83

"Mistakes" Made On Purpose

Color That Heightens Reality

Perhaps the most bizarre affliction that can strike the negative during development is an effect called reticulation, a crinkling of the entire gelatin emulsion, as shown above. It occurs when the negative is abruptly moved from a very warm solution, which softens and expands the gelatin, into a very cool solution, which hardens and shrivels it up. The crinkling is so evenly textured (inset) that reticulation is sometimes done on purpose for an artistic effect. But once done it cannot be undone, and in regular work, especially with miniature images that must be greatly enlarged, reticulation is disastrous. It can be avoided by keeping all solutions, from developer to washing bath, at or very near the same temperature.

"Pushing" Film Speed

Films and Developers	to double film speed	to triple film speed	to quadruple film speed
Agfapan			
Rodinal[1]	15 min. at 68°	17 min. at 68°	19 min. at 68°
Ilford HP-5			
Microphen	8 min. at 68°	9½ min. at 68°	11 min. at 68°
Acufine	4½ min. at 70°	7 min. at 70°	9 min. at 70°
Kodak Tri-X Pan			
D-76	12 min. at 68°	—	—
HC-110 [2]	6 min. at 68°	—	—
Acufine	3½ min. at 70°	6½ min. at 70°	10 min. at 70°

[1] Rodinal must be diluted 1 part Rodinal to 25 parts water when used with the times recommended here.

[2] HC-110 must be diluted 1 part HC-110 to 15 parts water when used in this way.

When taking black-and-white pictures in poor light, many photographers deliberately underexpose the film—that is, they assume its speed rating is double or even triple the normal rating—and then compensate by giving it special treatment during development. This practice is called "pushing." Film can be pushed either by extending processing time with a normal developer or by switching to a special "high-energy" developer, which creates a heavier-than-normal deposit of silver in the image. Normal developers commonly used with three popular Agfa, Ilford and Kodak films—and the extended developing times recommended for pushing by the film manufacturers—are listed in the chart above. In addition, a high-energy developer, Acufine, can be used with Ilford and Kodak films; the time and temperature recommendations listed for it are those of its manufacturer. Because Kodak recommends that its normal developers be used only to double the speed of its film, tripling or quadrupling Kodak's popular high-speed film is best accomplished only with high-energy developer.

Pushing film is a valuable technique, but it exacts a price. It brings up the image by increasing density, and in doing so it increases graininess and contrast. This quality loss is not serious if the film speed rating is doubled. Beyond that, quality falls off, and it nears the point of unacceptability if the speed rating is quadrupled. Most photographers establish their own standards of quality by making tests when processing film at specifications other than normal ones.

EVELYN HOFER: *Enlargement from a 35mm negative,* 1969

An Image to Savor

In printmaking, black-and-white photography at last yields its prize. To many photographers, this final stage of their craft is the most pleasurable. The fleeting scene that was caught on film and elicited in reverse in the darkroom now—magically, it seems—swims into lifelike view. In contrast to the instantaneity of the actual picture taking and the rigid control usually required of film development, printmaking lends itself to leisurely creation. Here, under the yellow glow of a safelight, poor negatives can be saved and ordinary pictures transformed into something special. Here the photographer can shape and tune his image—enlarge it, endow it with tones that are warm or cool, alter the shades of light and dark in the scene, heighten or reduce the contrast between them, cut out unwanted parts and otherwise ready the picture to be mounted in the scrapbook or prepare it to be framed for hanging in the gallery.

The physical processes of printmaking basically repeat those of the first two stages of photography: recording light on film and developing the negative. Like film, printing paper is coated with a light-sensitive emulsion containing crystals of silver atoms combined with bromine or chlorine atoms or both. Light is passed through the negative, onto the paper—either directly, for contact prints, or with the aid of a lens, for enlargements. The paper is placed in a developer for several minutes so that chemical action can convert into metallic silver those crystals that were exposed to the light; it is next transferred to a chemical solution called a stop bath to halt the action of the developer, then is put in the fixer, which removes undeveloped and unexposed crystals, and finally it is washed and dried. At last there is a permanent positive image, its dark areas corresponding to the light areas of the negative, which were generated by the dark areas of the original scene. The view the camera saw has been reproduced in shades of gray in a picture.

In each step, procedures are dictated by the chemical processes involved, yet printmaking can be highly subjective. Skills of the hand and eye are crucial. For example, the proper exposure of the printing paper is usually determined visually, rather than by a light meter or another mechanical device. The photographer tests various exposures on a single piece of printing paper and develops the paper to see which, to his eye, gives the best image. His final print is made at that setting. But this is only the beginning of manual and visual control in printmaking, for the photographer is able to make a particular portion of the print darker (a procedure called burning-in) or keep a portion lighter (called dodging). At the simplest level this is done by placing the hands between the enlarger lens and the paper in order to control the amount of light reaching various parts of the print. The method may seem crude, but it can be a very effective one. And it is only one among the many manipulative techniques that permit the printmaker to adjust the positive image to match that of the negative—or to deviate from it.

Even the development of the print is no cut-and-dried operation, as it usually is with film, carried on out of sight and controlled automatically by clock and thermometer. The temperature of the print developing solution and the time allotted for the process must be held within limits recommended for the materials, but these limits vary widely; because they subtly affect the look of the final print, the result is under delicate personal control. In the past, some photographers watched the development process and decided, by the darkness of the submerged print, when it had gone far enough. Today, even expert printmakers employ a more reliable method. They fix development time in advance within the manufacturer's recommended limits, then vary exposure as necessary. If a print is unsatisfactory, another is made using the same development time but a different exposure — longer to darken the print, shorter to lighten it.

In every stage of printmaking, opportunities for influencing the final result exist and judgments based on artistic rather than technical considerations must be made. The choice of such basic equipment as the enlarger has an effect, for it can produce soft, gently modulated tones or crisp, sharp ones, depending on how its optical system spreads light over the negative. The choice of an enlarging paper also permits creative latitude. Various options of texture, finish, tint and image tone are available. And enlarging paper comes in several grades, which determine the contrast between the tones of gray.

The composition of the paper also contributes to the final look of a print. There are two main paper types: plastic and fiber-based. Plastic paper coated with resin, called RC paper, saves time in the darkroom. Because its plastic coating blocks absorption of chemicals, RC paper need be washed for only five minutes, instead of one hour for fiber-based paper. But many photographers feel that fiber-based paper produces richer images, because it lacks the layer of plastic and its emulsion contains more silver. In addition, resin-coated paper is thought to deteriorate more with age because the ultraviolet radiation of normal light will crack or cloud the plastic coating, and changes of temperature and humidity may cause the edges of the paper to curl and separate. (Fiber-based paper was used for the step-by-step demonstrations on the following pages, but instructions for RC are also given.) By manipulating all these factors — and influencing them through the choice of developer, which also affects the tones and the contrast — the photographer can control the mood and impact of his prints, emphasizing the brilliance and detail of one picture, and giving an image warmth and softness in another.

Such choices demand a steady exercise of taste. The consequences of each decision are almost immediately visible — and a wrong choice can be easily repaired by simply making another print. Small wonder, then, that printmaking is so enjoyable, for it gives the photographer an opportunity to enhance the image that the camera saw. □

The Enlarger: Basic Tool of the Printmaker

The enlarger is actually the key element in modern photography. By blowing up small negatives into prints large enough to be seen clearly, it permits the use of easily portable cameras and economical small film. And it widens esthetic horizons because part or all of a negative can be used and differing exposures can be given to separate portions of the print.

The enlarger works like a slide projector mounted on a column. Light from an enclosed lamp shines through a negative and is focused by a lens to cast an image of the negative on printing paper, which is placed at the foot of the enlarger column. Distance between negative and image sets the enlargement size.

The controls on an enlarger are simple. The distance from the negative to the paper is regulated by cranking or sliding the entire enlarger head—the housing containing lamp, negative and lens—up or down on its supporting column. The image is focused, in most enlargers, by using a knob to raise or lower the lens. The lens has a diaphragm aperture control to regulate the amount of light reaching the print; unless a great amount of light is needed to make up for a very dark negative, the aperture is normally kept small, giving the lens enough depth of focus to offset any errors in focusing.

The details of the control mechanisms vary from model to model, making some enlargers easier to use than others. But these distinctions are not so important as differences in the optical systems that distribute light. If light traveled directly from the lamp through the negative, it would be brightest at the center of the picture and dimmer toward the edges, and the final print would be too dark in the middle. To avoid this, some enlargers, known as the diffusion type, inter-pose between lamp and negative a sheet of cloudy glass. The glass spreads the light evenly but it also causes the light rays to scatter.

Consequently, some light rays never reach the enlarger lens and others overlap as they pass through the negative. This reduces contrast between tones in the print. Photographers who use diffusion enlargers prefer lower contrast—which often makes the image soft. And the scattering helps to make dust and scratches on the negative less visible in the final print.

Another optical system for spreading light uniformly over the negative employs saucer-shaped "condenser" lenses between lamp and negative (enlargers using them are called condenser enlargers). These lenses concentrate the lamp light so that it passes straight through the negative without scattering. This straight-line passage increases contrast in the final print since light rays from different points in the negative do not overlap. Many photographers use condenser enlargers, especially for small negatives, because the heightened contrast gives an appearance of greater sharpness.

Choosing between systems depends on the photographer's aim. If the goal is heightened contrast, which seems to improve sharpness and frequently adds drama to a picture, a condenser enlarger is preferable. If subtle tones and a wide range of grays are preferred, the diffusion system is best.

Although the enlarger is a simple machine, it is also a vital link in the photographic process: The best camera in the world will not give good pictures if they are printed by an enlarger that shakes when touched, has a poor lens or tends to slip out of focus. □

In the diffusion type of enlarger, a sheet of cloudy glass scatters light from the lamp in many directions so that the negative will be uniformly illuminated. But many light rays never reach the lens and others may overlap as they pass through the negative, reducing contrast in the print and lending a softness to the image.

The condenser type of enlarger uses a pair of lenses to collect light and to concentrate it directly on the negative. Most light rays go straight through for increased contrast, which gives the appearance of greater sharpness.

Combination diffusion-condenser enlargers offer a compromise solution. They have condenser lenses to collect light and focus it through the negative, and they also employ a sheet of ground glass to eliminate excessive contrast.

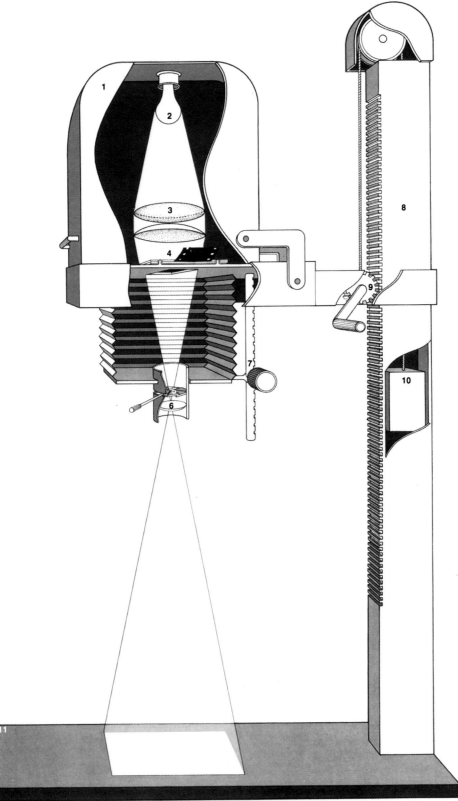

1 The enlarger head contains the main working parts: light source, a holder for the negative, and lenses. It is cranked up or down to set the enlarged image's size.

2 The lamp, which supplies the light to expose the printing paper, is usually an incandescent bulb similar to a household lamp. Some enlargers contain tubular fluorescent lamps, which give a soft light.

3 The condenser lens, a pair of convex elements, spreads light uniformly over the negative. In some types of enlargers, a different system—a flat piece of diffusing glass used alone or in combination with a condenser—serves the same purpose (diagrams opposite).

4 The negative carrier, which holds the negative flat and level, fits into an opening between condenser and main lens.

5 A diaphragm, an adjustable opening like that in a camera lens, controls the amount of light passing through the lens.

6 The lens bends light rays passing through the negative to form an enlarged image.

7 The focusing control moves the lens up or down to focus the projected image. The type shown here—a geared wheel and track shifting a bellows-mounted lens—is a common one, but other kinds are used.

8 The supporting column holds the enlarger head out over the base board and printing paper and serves as a rail on which the head can be moved up or down.

9 The height adjustment raises or lowers the entire enlarger head to set image size. Instead of the geared wheel and track shown in the drawing, some enlargers have a clamp that slides on the supporting column and is tightened to hold the enlarger head at the desired position.

10 The counterbalance compensates for the weight of the enlarger head, permitting it to be raised or lowered effortlessly.

11 The base board is the foundation supporting the whole unit; it also holds the easel on which printing paper is placed.

Processing Prints Step by Step

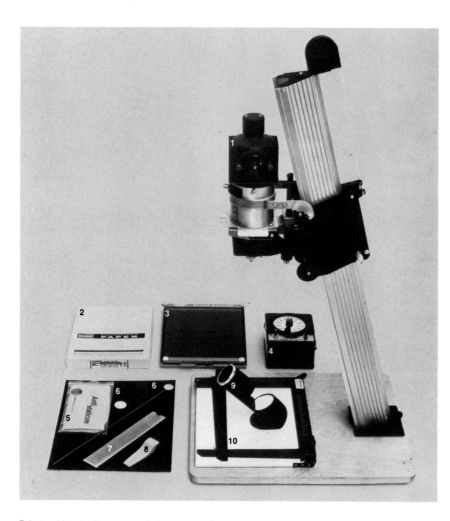

1 enlarger

2 printing paper

3 contact printing frame

4 enlarger timer

5 cleaning cloth

6 dodging and burning-in tools

7 protective envelopes

8 cleaning brush

9 magnifier

10 printing-paper easel

Printmaking is like assembling a watch: orderliness is vital. There is a considerable inventory of equipment—negatives, an enlarger, a contact printing frame, paper, a timer for the enlarger, dodging or burning-in devices *(above)*, plus at least three kinds of chemicals with trays, a separate timer for developing and associated materials *(opposite)*. The first step is to set things up conveniently. This should be done with the room lights on, but even the later steps do not require total darkness. The fairly bright illumination of a yellow-green or amber safelight causes no harm to printing materials.

Printing one negative, from beginning to end, actually involves the processing of three separate prints. First, all the negatives in a roll are printed on

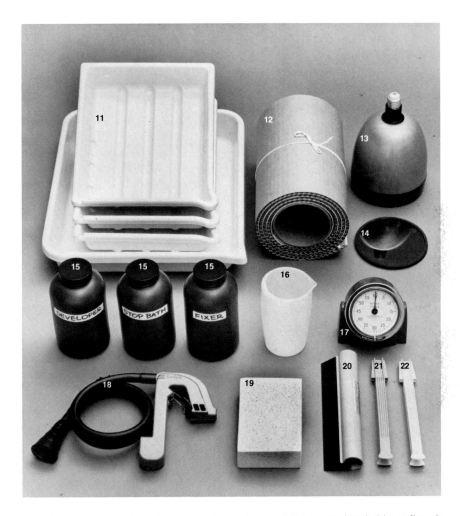

one sheet in a contact printing frame, in order to make—without enlargement —one "proof," or "contact," sheet. From this assemblage of 12 to 36 pictures, the best negative is chosen to be blown up. Then a test enlargement determines exposure. And finally the third print is made for exhibition.

Even a very experienced photographer proceeds carefully through these steps. Mistakes are inevitable at first. It takes time to learn that little things are important—how the exposed paper is slipped into the developer, the use of a magnifying glass for focusing, the way a print appears less contrasty when it dries. But none of the operations are difficult to master, and the creation of a beautiful print becomes possible after relatively little experience.

A Whole Roll at Once on a Contact Sheet

When they first begin to process their own prints, many amateurs are tempted to skip the contact printing stage and select the negative to be enlarged by looking at the film itself. But in the negative state, pictures are often difficult to judge, and in the case of 35mm negatives small size compounds the difficulty. Even experts insist on making their choices by studying contact prints.

The prints are fairly easy to make. If the film size is small, an entire roll (36 negatives of 35mm or 12 of 2¼ x 2¼ inches) can be fitted onto a single sheet of 8 x 10 paper. The contact sheet then becomes a permanent file record of negatives on that roll, as well as a guide for later preparation of enlargements. It should therefore be made carefully enough to permit comparison between similar pictures.

It may be necessary to try several different exposures before arriving at a satisfactory contact sheet *(pages 96-97);* once a satisfactory time is determined—usually by means of trial and error—it can serve for all contact sheets made with negatives of similar density and the same enlarger and printing materials.

Both for contact sheets and for final prints, exposure times will vary depending on the enlarger and materials used. Processing times will also vary; consult manufacturer's recommended times for the paper and chemicals being used.

The procedures demonstrated on this and the following 11 pages were carried out with a condenser enlarger and fiber-based Kodabromide grade 2 paper, Kodak Dektol developer diluted 1 to 2 and Kodak stop bath and fixer.

1 prepare the solutions

After mixing the developer, the stop bath and the fixer, and adjusting their temperatures to 65° to 75° F. (Step 1, pages 58-59), fill the trays.

2 assemble the negatives

The negatives, which must be stored in protective envelopes, are now collected. Handle them by the edges.

3 dust the negatives

With a cleaning cloth, remove fingerprints and dust. Even a small speck can cause a white blob in the final enlargement.

4 identify the emulsion side

Film curls toward the emulsion, which has a duller sheen than the film base. The emulsion side must face the paper during printing.

5 clean the contact frame

Clean the printing-frame glass, using plain
water or cleaner sold specially for this purpose.
Do not use household glass cleaners.

6 prepare to insert negatives

Now open up the cover of the contact frame
all the way, taking care to keep fingers from leaving
any marks on the glass; they may show.

7 place the negatives in the frame

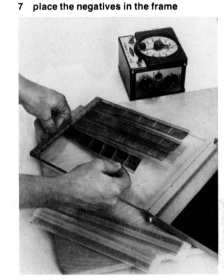

Strips of negatives are snapped under clips
on the glass cover. The emulsion side must face
away from the glass, toward the paper.

8 position the enlarger head

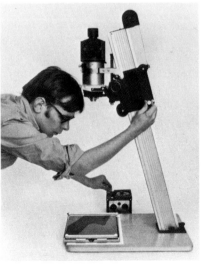

Switch on the enlarger lamp and raise the
enlarger head until the light that is projected
covers the contact frame. Switch the lamp off.

9 check solution temperatures

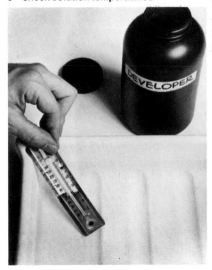

Measure temperatures of the solutions again so
that processing times can be adjusted according to
manufacturer's instructions.

10 take a sheet of paper from the box

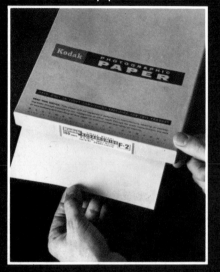

With the room lights shut off and the safelight
turned on, remove one sheet of printing paper
from its box. Take care to close the box.

11 identify the emulsion side

Fiber-based paper curls toward the emulsion.
Resin-coated paper does not, but the emulsion
side is usually glossier.

12 insert the paper into the frame

Slide the paper under the hinged glass lid, making
sure that the emulsion side of the paper and
the emulsion side of the negative face each other.

13 close the frame lid

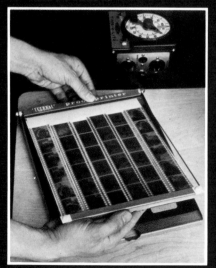

Holding the printing paper in place with a finger,
close the glass lid of the frame. Its weight
holds it shut and presses negatives against paper.

14 adjust the lens aperture

Open the diaphragm on the enlarger lens to its
largest aperture (usually f/4.5) so that the
maximum light can reach the printing frame.

15 set the timer

For negatives of average density, start with the timer
pointer set at 5 seconds. Check the resulting print to
see if a longer or shorter exposure is needed.

16 make the exposure

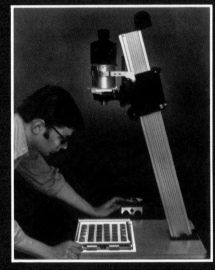

After placing the frame under the enlarger, press the timer button; the timer shown automatically shuts off the lamp after exposure.

17 withdraw the paper

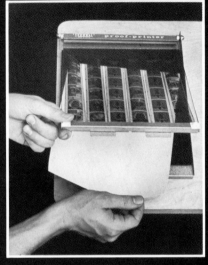

Take the printing paper out of the frame, but leave the negatives in place, ready for another attempt if the first print does not turn out.

18 begin processing

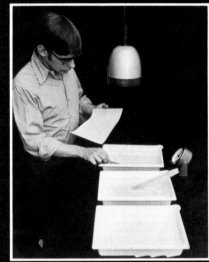

Holding one edge, slip the paper smoothly into the developer, immersing the surface quickly. Agitate the print with the developer tongs.

19 conclude development

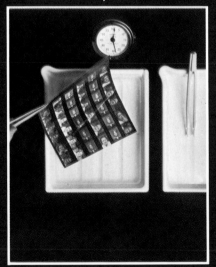

Develop for the recommended time—in this case, 2 minutes. Lift the print out by a corner and let it drain into the tray.

20 transfer to the stop bath

With developer tongs holding a corner up, use stop-bath-fixer tongs to pull the print into the stop bath. Leave it there for 5 to 30 seconds.

21 transfer to the fixer

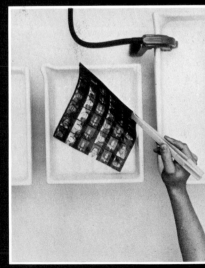

Move the print into the fixer for 5 to 10 minutes (2 minutes for resin-coated paper). Agitate it constantly, then wash and dry it.

Preparing the Negative for Enlargement

When selecting one negative from many for enlargement, sharpness is a most important consideration. With a magnifying glass examine all parts of the contact prints of similar negatives to check for blurring caused by inexact focusing or movement by the camera or the subject. Look for distinct and minute details— an eyelash, for example, or twigs on a tree—that quickly betray any fuzziness.

If the negative is 35mm, even faint blurring in the contact print is cause for its rejection, since so much enlargement is needed for a useful print. Minor faults of underexposure or overexposure of the negative can be remedied during enlargement *(pages 100-103)*. While studying the selected contact print, mark the area to be included in the enlargement. This "cropping" is best done now, as a guide for later steps.

22 select a negative for printing

Under a white light, examine the processed contact sheet with a magnifying glass to determine which negative you want to enlarge.

23 extract the negative carrier

Tilt up the lamp housing of the enlarger and lift out the negative carrier—two sheets of metal that hold the film between them.

24 insert the negative

Place the chosen negative in the carrier and center it carefully. The emulsion side must be facing down when the carrier is replaced.

25 clean the negative

Before printing, hold the negative at an angle under the enlarger lens with the lamp on so that the bright light reveals any dust; brush it off.

26 replace the negative carrier

Tilt the lamp housing and place the negative carrier in position. Switch off room lights so that the image can be seen clearly for focusing.

Insert a piece of white paper under the masking slides of the easel. Paper shows the focus more clearly than even a white easel surface.

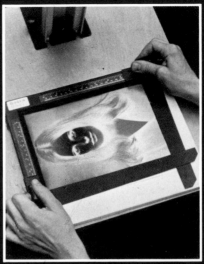

Referring to the inch marks on the masking slides of the easel, adjust the slides to frame the print to the desired size — in this case, 8 x 10.

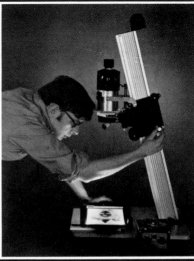

Raise or lower the enlarger head to get the desired degree of image enlargement, moving the easel as needed to compose the picture.

30 check the aperture

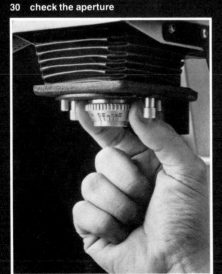

31 focus the image

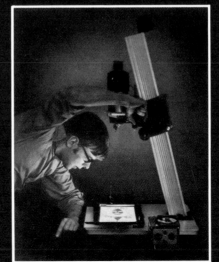

32 refine the focus

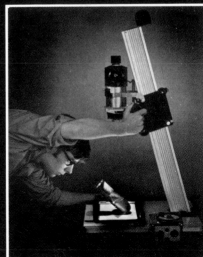

A Test Print to Determine Exposure

The best way to tell how long to expose an enlargement is to make a test print as shown on these pages. It looks like a striped version of the final print *(Step 43, opposite)*. The strips are sections of the print, each strip exposed under the enlarger 5 seconds longer than its neighbor to the left. By comparing strips it is easy to pick out the one with the best rendition of tones; that exposure is correct for the final print. Time, rather than aperture setting, is the factor generally employed to set exposure for enlargements.

A small aperture, such as f/11, is preferred because it maintains sharpness of image. With an average negative, this setting usually permits an exposure just long enough for convenient manipulation. If the negative is badly over- or underexposed, change the lens aperture to avoid impractical exposure times.

33 close down the aperture

When focus is sharp, reduce the aperture of the enlarger lens to a small f-stop, about f/11. The small opening offsets slight focusing errors.

34 insert printing paper

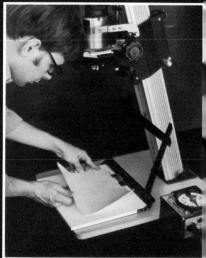

With room lights and enlarger lamp turned off, slip printing paper, its emulsion side up, under the masking slides of the easel.

35 set the timer

Turn the pointer of the timer to 5 seconds, so that the test print will receive a series of exposures in 5-second increments.

36 first exposure

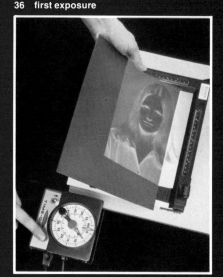

Cover four fifths of the printing paper with a piece of cardboard and press the button to expose the uncovered section for 5 seconds.

37 second exposure

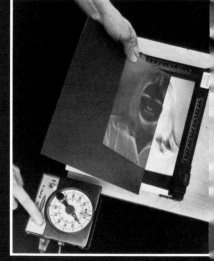

Slide the cardboard to cover only three fifths of the paper and press the button. The timer makes another 5-second exposure automatically.

38 third exposure

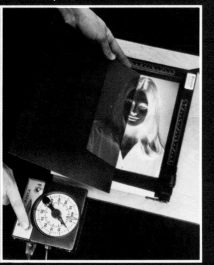

Move the cardboard and expose again. The first section has now been given 15 seconds' exposure, the second 10 and the third 5.

39 fourth and fifth exposures

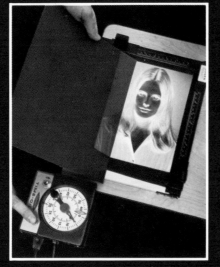

Make two more 5-second exposures in the same manner, first revealing four fifths of the paper, then exposing the entire sheet.

40 remove the exposed paper

Take the paper from the easel for development. It will now have strips bearing five different exposures that range from 5 to 25 seconds.

41 develop the test

Develop for the recommended time—in this case 2 minutes. Various degrees of darkening—due to the different exposures—are clearly visible.

42 transfer to the stop bath

Using developer tongs and stop-bath-fixer tongs (Step 21, page 97), immerse the print in the stop bath, agitating it for 5 to 30 seconds.

43 select the best exposure

After fixing for about 2 minutes (washing is unnecessary), turn on room lights and select the best exposure—15 seconds in this case.

The Payoff: A Print to Show

After making a test print, the production of the final print would seem to be a mechanical operation. But it is this stage that demands the most skill and judgment. Choice of printing paper *(pages 106-113)* and precise regulation of exposure can remedy deficiencies in the negative—or transform an ordinary picture into an outstanding one.

Some prints will need control of exposure in bright and dark areas—dodging and burning-in—to get maximum detail. For dodging, a wire-mounted disk (or a finger) blocks light from a shadow area that might be so overprinted that detail would be lost. For burning-in, cardboard (or a hand) shields most of the picture as one section gets longer printing time to register detail in a highlighted area. Even chemical steps are not routine; washing, especially, should not be rushed.

44 expose the print

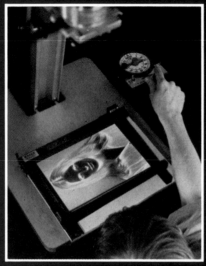

After setting the timer to the exposure indicated by the test and inserting fresh paper in the easel, press the button for final exposure.

45 dodge the shadows

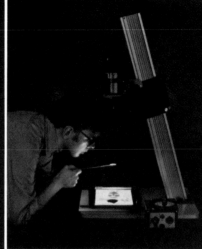

Block some light from shadow areas to prevent darkening and loss of detail. Keep the tool moving or lines will appear in the print.

46 burn in the highlights

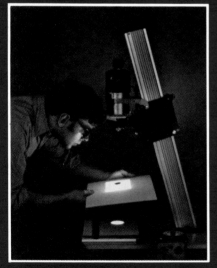

With a cardboard shield, block light from all parts of the print except highlight areas. Give them extra exposure to register their detail.

47 develop the print

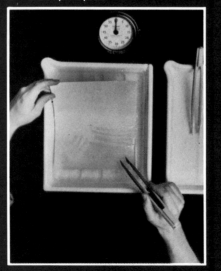

Slip the paper quickly into the developer tray, pressing it down with the developer tongs to make sure it is entirely immersed in the solution.

48 agitate gently

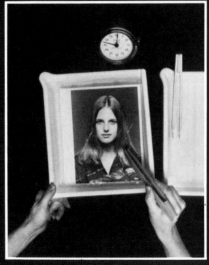

Holding the print under with the tongs, rock the tray throughout the development period to keep fresh developer flowing over the picture.

49 complete development

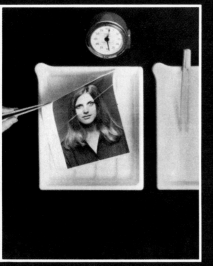

When the print is fully developed — in the example shown here, 2 minutes — lift the print out by gripping a corner of it with developer tongs.

50 drain off developer

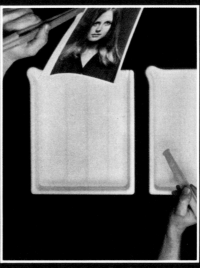

Hold the print above the tray for a few seconds so that the developer solution, which contaminates stop bath, can drain away.

51 transfer to the stop bath

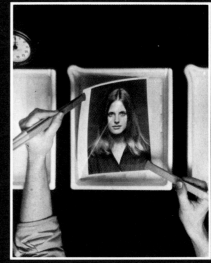

The stop bath chemically neutralizes the developer on the print, halting development. Keep developer tongs out of stop bath.

52 agitate

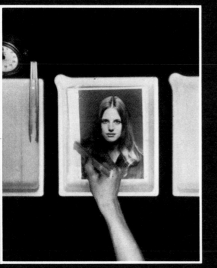

Using the stop-bath-fixer tongs, keep the print immersed in the stop bath for 5 to 30 seconds, moving it back and forth in the solution.

53 drain off stop bath

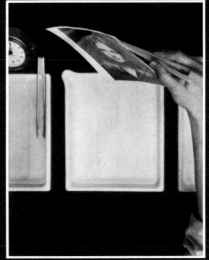

Again lift the print so that solution can drain into the stop-bath tray. This prevents the stop bath from altering the fixer's composition.

54 transfer to the fixer

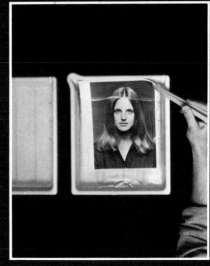

Slip the print into the fixer and keep it submerged. The same tongs are used for stop bath and fixer — the solutions are compatible.

55 agitate

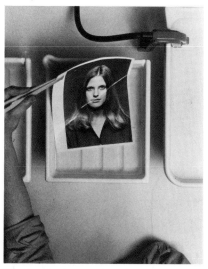

Move the print about occasionally while it is in the fixer. Room lights can be turned on after a minute or two and the print examined.

56 remove the print

After 5 to 10 minutes in the fixer (2 minutes for resin-coated paper), transfer the print to the washing tray.

57 wash

The print must be washed for at least 60 minutes (4 minutes for resin-coated paper) in running water to remove all traces of fixing solution.

58 remove the surface water

Place the print face up on an overturned tray and squeeze off most of the water. Moderate pressure will not harm the print.

59 dry

Roll a fiber-based print face down in a blotter roll and leave it to dry overnight. Resin-coated prints should be hung to dry.

Every photographer works out his own repertoire of refinements to the basic steps of printmaking. Here are some, suggested by the Time-Life Photo Lab, that will help the beginner.

Enlarger lens focal lengths. *For best results, the focal length of the enlarging lens should be approximately the same as that of the normal lens for the camera making the negative. Too short a lens will produce a sharp, evenly illuminated image only from the center of a negative that is too large for it. Too long a lens may produce too little magnification. A lens with a focal length of 50 to 75mm is best for 35mm negatives, use a focal length of 80 to 105mm for 2¼ x 2¼ or 2¼ x 2¾ sizes, and one of about 150mm with 4 x 5 negatives.*

Cropping. *Two pieces of cardboard cut in the shape of an "L" can be arranged to form an open rectangle of variable size. Placed over a contact print, the pieces can be moved to show how the picture changes as degrees of "cropping" include or leave out portions of the scene.*

Selective development. *Part of a print can be darkened during development by increasing the temperature at that spot. Breathing on it while holding it will warm it enough; so will rubbing the front with your finger. To darken a large area, pull the partially developed print out of the tray, rinse it with water and swab the area to be darkened with cotton dipped in concentrated developer.*

Prolonging the life of fixer. *Rather than one tray of fixer, use two trays side by side. Prints are passed from the stop bath to the first tray, left for about 5 minutes, then transferred to the next for 3 or 4 minutes more. Most of the fixing action takes place in the first tray; the second tray ensures that the last undeveloped, unexposed emulsion crystals are dissolved. The fixer in the first tray will be chemically exhausted first; it can be replaced with the lightly used solution from the second tray.*

Reducing print washing time. *Using a hypo-clearing agent with prints is just as important as it is with film (pages 70-71). It cuts washing time and water consumption by at least 50 per cent and helps prevent eventual yellowing of the print. Hypo-clearing agent, however, can only be used with a print on fiber-based paper. Resin-coated papers require no solution to help remove fixer since the paper's plastic coating makes it liquid-resistant. One precaution: Never leave resin-coated paper in any solution for longer than the recommended time—eventually solutions will seep in through the edges, ruining the print.*

Drying. *A heat dryer is one device used to dry fiber-based prints quickly. It consists of an electric heating element, a smooth metal plate or drum, and a cloth belt. After the temperature of the metal is raised to between 120° and 170°, a print is held securely against the metal by the cloth belt; an 8 x 10 print takes from 2 to 10 minutes to dry. But chemical residues—usually fixer—can contaminate the belt if all prints have not been thoroughly washed. A simpler drying device, the rack, avoids the possibility of contamination, which can be a problem not only with the heat dryer but also with the blotter roll normally used (page 104). The rack, which serves for both fiber-based and RC paper, need be nothing more than a fiberglass window screen supported horizontally so air can circulate around it. Lay fiber-based prints face down on the screen; resin-coated face up.*

Storing printing paper. *Keep the paper in a light-tight box in a cool, dry place. Stray light "fogs" paper—gives it a gray tinge that shows up most noticeably in the unexposed margin of a finished picture. Time and heat do the same. Most paper will last about two years at room temperature. Stored in a refrigerator, it keeps considerably longer.*

Printing the entire frame. *Negative carriers that come with most enlargers have openings that are slightly smaller than the full 35mm frame; they cut off about 15 per cent of the total image. To print the entire frame, or to include a black border around the picture, enlarge the opening of the carrier with a file, checking progress against a negative. Smooth the filed edges with fine sandpaper, then wash the carrier thoroughly.*

Brightening fogged paper. *If a print comes out fogged, add commercial antifog solution or a few drops of 10 per cent potassium bromide solution to the developer before using any more of the same batch of paper.*

Reducing. *A solution of potassium ferricyanide crystals—about one eighth teaspoon to eight ounces water—causes a chemical reaction that removes some of the silver in an image, brightening it. Take the print out of the fixer after about a minute and swab the part of the print that is too dark with cotton dipped in reducer. To stop the reducing action, reimmerse the print in fixer and then wash it thoroughly.*

Toning. *Special toning agents can improve prints by substituting a subtle color for the usual gray. The print is dipped into a tray of liquid toning solution after the print has been washed but while it is still wet. The most common tones are the rich browns called sepia, which add warmth to a picture. Selenium toners enrich the dark tones of the print and protect the image against fading.*

The Paper's Palette of Gray

Two prints of Wells Cathedral taken by Dmitri Kessel demonstrate the difference between warm and cold image tones. The enlargement on the left was printed on silver bromide paper, which produces cold, neutral tones. The enlargement on the right, warmer in tone, was printed on paper with an emulsion that contained a mixture of silver bromide and silver chloride.

Making a black-and-white print is like painting with one color: gray metallic silver. This can be a challenge rather than a limitation, for printing papers come in a wide variety of shades of gray. The paper base can be manufactured in numerous textures, tones and surface finishes. And the emulsion coating can make silver images look warm or cool, sharply contrasted or softly modulated.

Even color variation is possible, since not all gray is simply gray, as the pictures reproduced here show. The silver may appear to be neutral black, blue-black, warm black, brownish, reddish or greenish. These variations reflect the size and structure of the developed silver grains.

The coldest tones are generally produced by an emulsion composed almost entirely of either silver chloride or silver bromide. Warmer tones are produced by an emulsion that contains a mixture of both. Emulsions in which silver chloride predominates are not very sensitive and are mainly used for contact printing.

The surface qualities of the paper are no less important than its emulsion in creating a print with a tone appropriate

to its subject. The term "surface" actually refers to two properties—texture and finish. Both can influence the amount of light reflected from a print. Textures are generally categorized as "smooth," "fine-grained" or "rough" (there are also surfaces that resemble silk, tweed and suede). Finish refers to shininess and is distinct from texture (smooth papers, for example, come in several degrees of shininess). Commonly available finishes are glossy, luster and matte. Extra glossiness (for pictures to be reproduced in papers or magazines) is obtained by us-

ing glossy resin-coated paper or, if fiber-based paper is used, by pressing a wet print onto a chromed metal sheet.

A very smooth surface (in terms of both texture and finish) looks bright since it reflects most of the light falling on it. Also, it reveals maximum detail. The rougher surfaces scatter light and obscure detail; the scattering effect not only dims highlights, but also makes black parts of the picture look grayish. However, such surfaces are less harsh than smooth ones, and often add atmosphere to pictures in which precise detail is not important.

The difference between matte and glossy surfaces is revealed in two prints of the interior of a modern building in Germany, also by Dmitri Kessel. The picture at right, above, reproduced to show a matte effect, scatters reflected light and produces less-dense blacks in the stair steps than the glossy print next to it.

Emulsions That Modulate Contrast

One of the most crucial characteristics of a photograph is also the simplest to control through the choice of printing paper. This is contrast, the difference in shade between one tone and a slightly darker or lighter one. Tonal differences can be exaggerated by the response of the paper emulsion to make the print more contrasty than the negative, or they can be diminished to make the print less contrasty. Most papers are made in numerical grades of contrastiness ranging from 0 (very "soft," or low contrast) through 2 (normal) to 5 (very "hard," or extremely high contrast).

The paper grade exerts a powerful influence on the appearance of a picture, as shown in the series of photographs opposite. It can create an image that has a gentle sweep of tones, the shades of gray delicately distinguished one from another. At the other extreme, it can virtually eliminate gradations in shade, leaving an image composed almost entirely of dazzling whites and opaque blacks.

Contrast is affected not only by the print emulsion but also by numerous factors throughout the photographic process—the lighting of the scene, exposure, type of film, development of the film and print, even by the kind of enlarger used. Furthermore, contrast as a characteristic cannot be entirely separated from another key property of a photograph: the number of distinct shades of gray. Contrasty paper, by increasing the difference between tones, eliminates the subtle variations in tone; with fewer variations visible, fewer separate tones can be seen. At the same time, the loss of the slight variations emphasizes extremes of tone.

In this way, high-contrast paper may be used to produce whites and blacks that will add "snap" to a dull negative. Conversely, low-contrast paper can reproduce more of the tonal variations that exist in the negative, increasing the number of distinct shades. It can be used to bring out detail in shadows or highlights that might otherwise be visible only after much dodging and burning-in. Low-contrast paper does not eliminate extreme tones if they exist in the negative, but neither does it emphasize them.

The choice of contrast grade is often dictated by the subject of the picture. Portraits may be best served by a low-number grade, for the subtle gradations of gray produced on such paper cause shadings to indicate facial contours very pleasantly and make wrinkles and lines less conspicuous. A picture with striking geometrical design generally calls for high contrast. And increased contrast, by sharpening distinctions in tone, may make detail stand out.

Most often the choice of a grade of paper is dictated by contrast deficiencies in the negative. The paper may be selected to add lifelike sparkle to a picture that had to be shot in dull light, to correct imbalances introduced by underexposure or overexposure, or to soften harsh shadows and highlights.

grade 0 printing paper

grade 1 printing paper

grade 2 printing paper

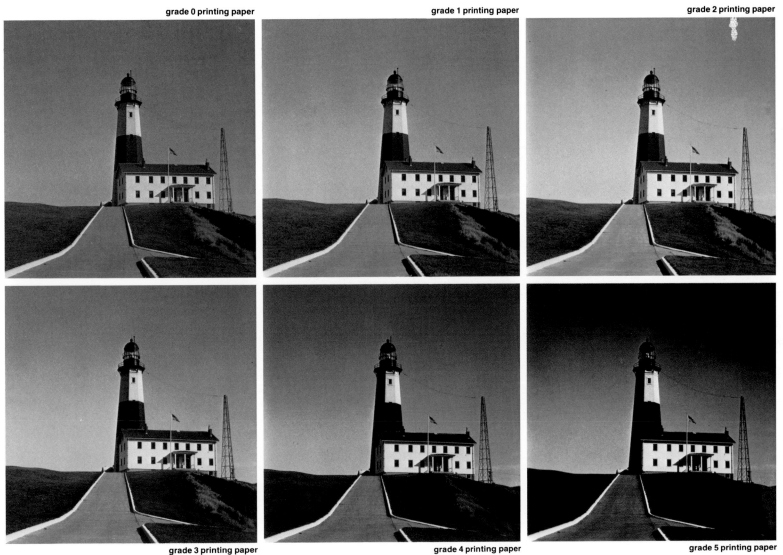

grade 3 printing paper

grade 4 printing paper

grade 5 printing paper

The Montauk Point, Long Island, lighthouse, photographed by Jules Zalon, is shown in six degrees of contrast. On grade 0 paper the long range of gray shades in the picture makes it look flat, but fine tonal gradations in the grass show up. With grade 5, the pale porch shadow and the dark shadow of the window it overlaps are almost indistinguishable, and the print is almost wholly dense blacks and glaring whites.

109

Matching Contrast Grade to the Negative

It's no trick to get a satisfactory print from a nicely balanced negative; paper of normal grade will duplicate the negative tonal gradation exactly. But an assortment of contrast grades comes in handy when the not-so-nicely balanced negatives must be printed.

Lack of contrast—usually from underexposure—is the most common problem. The silver image is so faint that no part of it is much denser than any other part, and even the densest parts are too thin to block all light from passing through. The resulting print will have an overall gray muddiness—unless high-contrast paper is used to increase the difference between tones and to exaggerate the extremes. A similar grade of paper will also improve the print from a negative shot outdoors on an overcast day. Excessive contrast, generally from harsh lighting or overdevelopment, is remedied by low-contrast paper.

To judge the tonal qualities of a negative, look at it against a uniformly lighted white background—a white wall or a sheet of paper, not a bare bulb. Examining the tones in a test print also helps suggest which paper will produce a final print of the desired contrast.

Co Rentmeester's low-contrast negative of an army camp in Vietnam (bottom) was photographed at dawn directly into the sun, making highlights and shadows seem similar in tone. However, contrasty grade 5 paper (top) creates a scene in which both night and day appear dramatically opposed.

Alfred Eisenstaedt's picture of a group of circus performers yielded an "average" negative (near right, bottom), having both dense and transparent areas, with a good range of tones in between. To preserve normal contrast it is printed on a normal grade of paper.

John Hanlon's shot of a basketball game — the New York Knickerbockers playing the Boston Celtics — gave a contrasty negative (far right, bottom). The harsh lighting on the court made the images of the background and dark uniforms unusually weak, the brighter areas unusually strong. But natural tones are restored to the picture if it is printed on low-contrast paper.

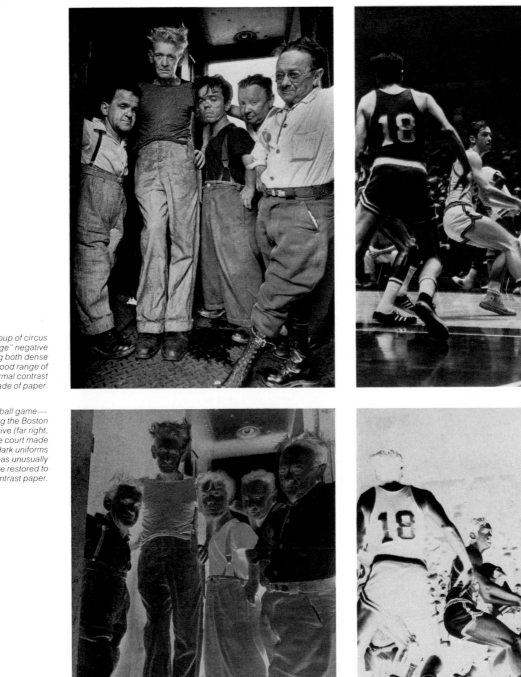

The Fine Art of Dodging

In many pictures, an imbalance of tones is caused not by the overall contrast of the negative but by the camera's inability to make ideal exposures for individual portions of the image. The remedy is dodging and burning-in to adjust printing exposure from area to area *(page 102)*— but in a more complex fashion than that ordinarily employed.

Frequently these twin techniques are used to increase the detail registered in shadows and highlights. But a test print may indicate that broad areas of a picture should be individually controlled for a pleasing result.

In the test *(right)* of a picture of a Maine inlet the exposures used range from 3 to 18 seconds. The dark rock acquires the best tone from a short exposure, the water demands an intermediate exposure and the sky needs the longest exposure of all. These various requirements are met by using fingers and a specially cut cardboard mask to shield part of the picture from exposure during enlargement, so that rock, water and sky each gets just the exposure it needs.

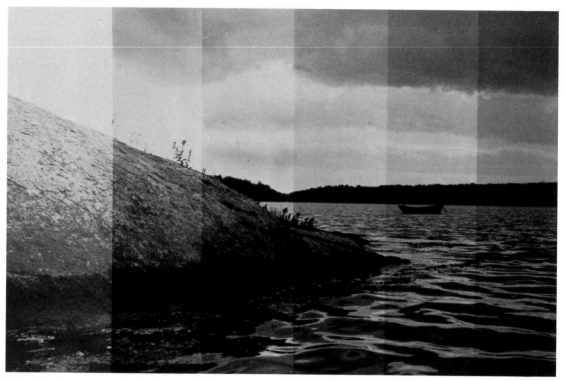

The test print of a scene of a Maine inlet demonstrates the effects of six exposure times, ranging from 3 (left) to 18 seconds at 3-second intervals. Clearly, a single exposure for the final print would sacrifice the detail of either the rock, water or sky. But the results of the test indicated that three different exposures, one for each of these pictorial elements, would give the desired balance of tones and detail.

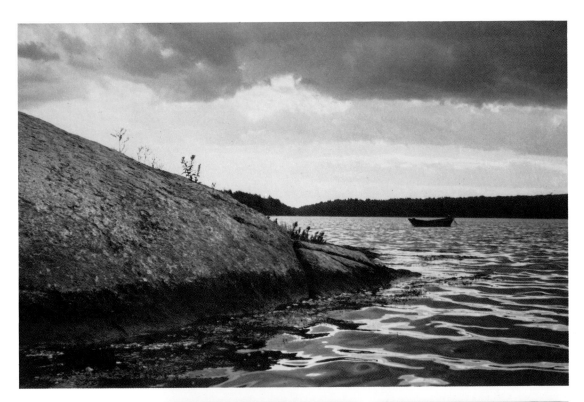

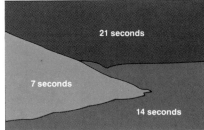

21 seconds

7 seconds

14 seconds

The final print (left) was made by rationing out exposures, estimated from the test-print exposures, according to the scheme shown above. The detail of the dark rock was brought out by a 7-second exposure. The water received 14 seconds. To darken the sky, the printmaker used a longer exposure than any on the test print — 21 seconds.

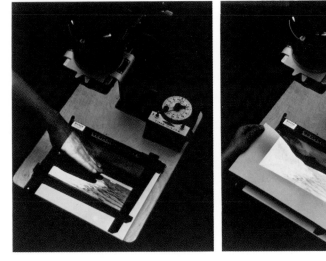

The exposure balancing act for this picture was performed by the dodging and burning-in techniques shown at left. After setting the timer for a series of 7-second exposures, the printmaker gave the entire print an initial exposure of 7 seconds. He shadowed the rock with his hand for the second exposure (far left). Then he employed a shaped cardboard mask to shield both the rock and the water from light during the last exposure (left).

The Versatility of Variable-Contrast Paper

number 1 filter

number 1½ filter

number 2 filter

number 2½ filter

Instead of stocking a number of different contrast grades, many photographers today prefer to use a single type of paper that has adjustable contrast. Most such papers are coated with two emulsions. One, sensitive to yellow-green light, yields low contrast; the other, sensitive to blue-violet light, produces high contrast. The degree of contrast is varied simply by inserting appropriately colored filters in the enlarger *(far right)*. The filter governs the color of the light that reaches the printing paper—and thus controls contrast.

With only one type of paper and a set of filters, the photographer can attain finer gradations of contrast than might be possible with papers of different contrast grades. Furthermore, he can control the contrast of localized sections of the image. This is done by masking the paper so that the sections can be printed separately, each with the contrast filter its tones call for. A low-contrast part of the image, for example, could be enlivened by printing it with blue-violet light; a harsh part could be softened by printing in yellow-green.

The three versions at right of a Manchester, New Hampshire, mill show how several degrees of contrast in one print can improve a picture. In the version made with a Number 3 filter (upper right), the water and sky seem washed out and lacking in detail; in the version made with a Number 1 filter (bottom right), the mill is too dark and low in contrast. The final print (opposite page) was made by exposing the mill with the Number 3 filter and the water and sky with the Number 1 filter, achieving a tonal balance impossible with paper having a single degree of contrast.

number 3 filter

number 3½ filter

number 4 filter

Variable-contrast paper can produce seven different degrees of contrast, as shown at left, with a set of seven filters. The contrast range is equivalent to paper grades 1 through 4—rising by half steps. The contrast that is given by a Number 2 filter is generally considered to be "normal." Two ways of inserting filters in enlargers are shown below. A filter holder can be attached to the lens of the enlarger by means of rubber-tipped screws. One of the filters from the numbered set that comes with this attachment is then slipped into the holder (below, top), and can be easily changed if another grade of contrast is desired. Some enlargers have a special filter drawer (below, bottom) located between the lamp and the negative. A filter—which has been cut to the appropriate size from an acetate filter sheet—is inserted, the drawer closed and the print made.

Delicate Shades with Special Developers

Although changing printing paper is the simplest way to alter contrast in a print, contrast can also be controlled with the use of special developers. The modifications they introduce may be more delicate than when switching paper grade.

In these developers special combinations of chemical compounds reduce or increase contrast, most noticeably in the shadow areas of the print. A low-contrast developer, for example, brings out detail in shaded areas. A high-contrast developer, on the other hand, deepens the blacks in the print and increases the apparent sharpness of the image.

The chemical composition of these developers is similar to that of high- and low-contrast film developers *(page 81)*. Most low-contrast developers use Metol or Phenidone as the primary developing agent and contain little or no hydroquinone. High-contrast developers contain a high proportion of hydroquinone and a minimal amount of Metol or Phenidone. Both types work best with certain fiber-based papers. They are particularly useful in extending the range of papers that are manufactured in only one contrast grade such as Kodak Ektalure.

The two pictures at right were both printed on double-weight grade 2 Kodak Medalist paper, which is available only in grades 2 and 3. The bottom print was developed in Kodak Selectol-Soft, a low-contrast developer containing a high proportion of Metol. The top print, which has noticeably darker shadows with less detail and sharper contrast, was developed in Edwal G, a developer with a high proportion of hydroquinone. The difference between the two prints is equivalent to about one grade of contrast.

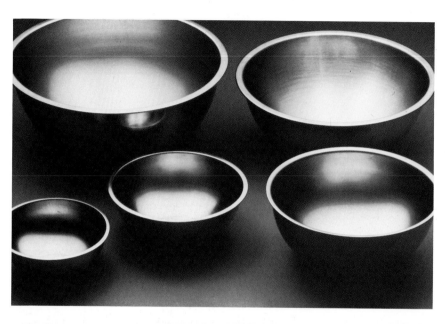

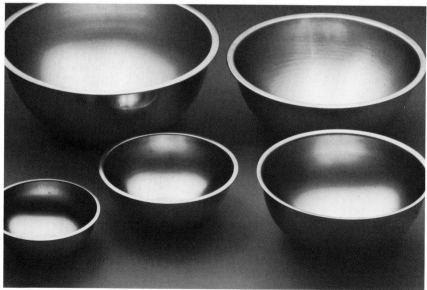

BRETT WESTON: *A contact print from an 8 x 10 negative of Garapata Beach, California,* 1954

Methods of the Masters

They have been only a handful. Among the millions of amateur and professional photographers around the world at a given time, the master printmakers may total no more than a few hundred. Yet their influence is out of all proportion to their size: It is they who carry photography into museums, galleries and salons, where their pictures are matted, framed and hung to be savored in much the same way a painting by Rubens, Rembrandt or Picasso would be. The heritage upon which the master printmaker builds is, in photographic terms, a long one. For these photographers are the artistic descendants of Stieglitz, Käsebier, Coburn, Edward Weston and other creative photographers who, in this century's first decades, led the fight for photography's acceptance as a medium of art *(Chapter 1)*.

There are several characteristics that bind creative photographers together into a recognizable group. Among these is an almost fanatic attention to detail at every level of the photographic process—from composing the picture right through to the selection of a particular grade of enlarging paper. Perhaps even more characteristic, however, is the fact that every successful printmaker has developed a faculty for what photographers call "prevision"—that is, the ability to look at a three-dimensional scene and see in the mind's eye how it would appear in the two-dimensional format of the photographic print. This is no simple trick, for it requires not only creative imagination but also a complete and sure familiarity with all the equipment, the materials and techniques available for bringing an idea to fruition. There are literally thousands of variables. Each camera, each type of film, of developer, of printing and enlarging paper has its own special characteristics, and the interplay of these variables, together with the photographer's choice of aperture, shutter speed and other elements of timing, determines in large measure whether or not his print will be a success. Upon the photographer's calculations of such mechanical factors depends the outcome of his artistic intentions.

Every master printmaker has evolved a style of his own that is best suited to portray his unique vision of the world through the medium of photography. To the collector of photographic prints, a picture by Harry Callahan *(pages 150-151),* Brett Weston *(page 119)* or Frederick Sommer *(pages 146-147)* needs no written signature, for the photographer's personality infuses the print itself. Still, for all the personal quality that each brings to his work, most can be classified in a general way as sharing with other printmakers one of three broad philosophical approaches to photography. There are those like Bill Brandt *(pages 152-153)* for whom the negative is merely a starting point toward the creation of a print. They will use any photographic means they have at their disposal, radically altering reality as necessary to produce the pictures that they have imagined. The result may have little apparent relationship to the

negative—or, for that matter, to anything else except an artist's idea. Other photographers such as Jack Welpott (pages 142-143) aim to reproduce the scene as they saw it. They use such darkroom tactics as dodging and burning-in not to alter reality but to make the print reproduce the reality they had seen in front of the camera.

Finally, there is a group of master printmakers who stand at the opposite pole from those who create their pictures with the enlarger, for they eschew even the slightest deviation from the image captured in the camera. Some will not even use enlargers, but instead rely on 8 x 10 contact prints. To them, the challenge lies in reproducing in the print exactly the image recorded in the negative. This requires painstaking attention to the details of print-making techniques—the choice of paper and developer, the regulation of printing exposure. One among them goes so far as to measure, with a laboratory instrument, the density of each part of a negative before he decides the best way to print it.

A leader of this purist school of printmaking is Brett Weston, whose reputation as an artist-photographer now rivals that of his famous father, Edward. Weston considers the print used as the frontispiece of this chapter as among his finest. His recollections of how it was made reveal his method of working. Early one foggy morning on a beach near his home in Carmel, California, he was studying close-ups of rock formations with his 8 x 10 view camera. Suddenly the rising sun topped the coastal hills and burned into the blanket of vapor. Like a print in a tray of developer, the image of the beach began to emerge from the dissipating blanket of mist. Weston, realizing that he must work with unaccustomed speed, hurriedly positioned his tripod and camera as he saw forming on the ground-glass viewing screen the scene he later would print. The faint shapes of distant hills appeared and grew dark and massive; sharp shadows etched the forms of beach rocks and bluffs deeper and deeper against the contrasting white sand. At the precise moment when the three elements—light, mist and shadow—were all exquisitely balanced within the format of his ground-glass screen, Weston exposed his sheet of Isopan film.

Later he made exactly the same kind of judgment when, working in his darkroom under the dim glow of a yellow safelight, he seized the moment of perfection to stop the development of the contact print, plunging it into a tray of stop bath just as the visual impression he had glimpsed on the beach was reborn on richly toned Azo grade 2 printing paper.

On the following pages, each of the three approaches to printmaking is represented by the work of some half dozen of the most highly rated modern photographers. They are a diverse group—from four continents; what they share is a devotion to fine printing and the skill to execute their intentions. □

Imogen Cunningham

It was in 1901 that the International Correspondence Schools received $15 from a 17-year-old girl in Seattle, in exchange for a 4 x 5 view camera, a course of instructions and a box in which to return glass plates to the school for criticism. The girl was Imogen Cunningham, and she grew up to be one of America's leading portrait photographers and printmakers.

Among her favorite portraits was this picture of her father, taken in his apple orchard in California when he was 90 years old. The portrait illustrates Cunningham's preference for simple darkroom procedures, for her only manipulation of the print was slight dodging: She held back exposure of the shadow

under the woodpile in order to prevent darkening of the details in that portion of the picture. The paper on which she printed the portrait was a variable-contrast type, whose tonal gradations are controlled by filters that are put over the light source *(pages 114-115)*. Cunningham employed no filter, and this caused the paper to produce average contrast and great detail.

Much more intricate treatment was necessary for some of Cunningham's most famous pictures. She was so often asked to print them that she kept an explicit record of the procedure each required. She filed a master print on which each area was marked with the exposure time it needed. The file print

of one of the most renowned of her photographs, a portrait of the American painter Morris Graves, is covered with so many separate exposure notations it looks like a topographical map.

Even in her last years, Cunningham remained a portraitist and printmaker of extraordinary creativity. Just about her only concession to age was her unwillingness to deliver personally the portraits of her subjects. She explained that she could no longer bear their expressions of dismay when confronted with their own images. "So many people dislike themselves . . . that they never see any reproduction that suits," she said. "Give me a homely man. He has no illusions about himself."

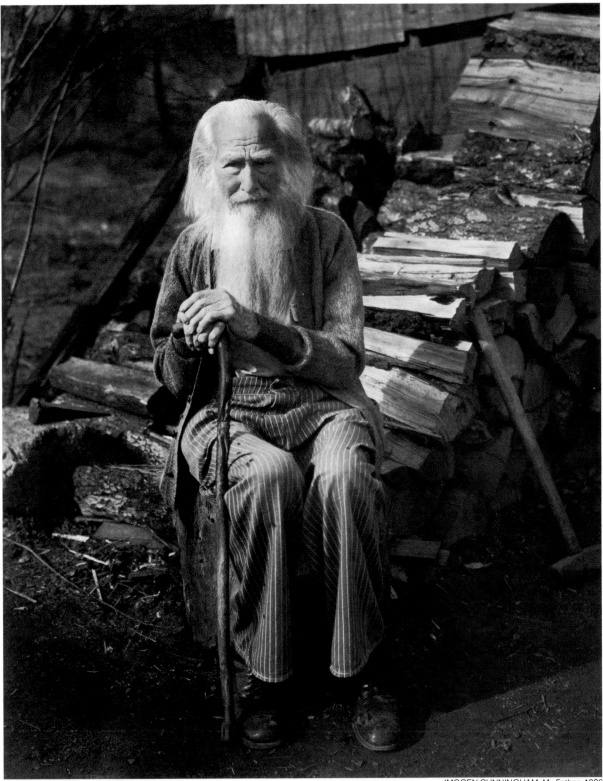

IMOGEN CUNNINGHAM: *My Father,* 1936

Paul Caponigro

In 1967, Paul Caponigro began taking pictures of Stonehenge, the prehistoric monument set in the plains of southern England. At first, he recalled, "I was carried away by the mystery and power of the stones," but he came to know them so well that they seemed to speak and even gesture to him. "The stones have let me in," he said. The observation is typical of Caponigro, a Massachusetts-born photographer renowned for his expressive landscapes, reproduced in magnificently detailed prints.

The picture at right is of four lintel-topped pairs of columns that constitute the most striking feature at Stonehenge. The print conveys both the roughhewn sculptural force of the pillars and the aged density of their rock. At the same time, the viewer is given a glimpse—through one pair of columns—of the flat, unpopulated landscape beyond.

Caponigro used a 5 x 7 view camera to capture the monumental quality of the stones and chose a 150mm wide-angle lens because it provided great depth of field and kept the foreground and background in a relative scale he considered harmonious. He took the photograph just as day was breaking, before the site became crowded with tourists. "Everything you need for a picture was there," he notes, "the light, the time, the situation. I didn't have to be fancy."

In making the print, his problem was to show the varied surface of the stones in sharp detail, yet keep the overall quality of the print as soft and subtle as the early-morning light in which he shot the picture. To do this he selected his printmaking materials from among available products—and some not so available—so that the distinctive characteristics of each could be exploited.

Kodak HC-110 was picked as the film developer because it enhances detail by producing sharp-edged grains of silver; other types of developers tend to give softer edges to the grains, slightly blurring the image. Then, he chose an appropriate printing paper. Choice of paper, Caponigro believes, is such an important step in the printing process that he keeps six brands on hand, including, carefully stored away, several favorites that have been discontinued. To make this print, Caponigro reached into his reserves for Varilour, a warm-toned variable-contrast paper that the Dupont Company stopped making in 1975. Variable-contrast paper can approximate different grades of paper contrast with the use of colored filters. Caponigro used no filter at all for this print, a technique that produces the equivalent of grade 2 paper.

Equally important to the final result was the paper developer, Ansco Ardol, a formula noted for its soft, warm tones. Finally, the print was bathed in a selenium toner, which combines with the silver in a print to form metallic compounds that enrich blacks in the image and also protect it. Caponigro always judges toning time by eye, rather than by the clock, and prefers short times in the toning solution. "A long toning can destroy the soft atmosphere I put in a print," he says. For this print, Caponigro left the print in the toner so briefly—about 1 minute—that the toner deepened only the darkest parts of the picture and left other areas unaltered.

PAUL CAPONIGRO: *Stonehenge, Wiltshire, England,* 1970

Manuel Alvarez Bravo

The elements of this romantic study of a pensive young girl leaning over a shaded balcony appear to be carefully worked out. The strong modeling of light and shade, the repeated patterns of intersecting lines, and the subtle shades of gray combine to make a masterful photograph. Yet it is a candid shot, taken on the spot with an early 20th Century press camera designed to take action pictures.

The picture was made in 1931 by Manuel Alvarez Bravo, who is now regarded as Mexico's greatest photographer, but who was then a 29-year-old hopeful who had recently quit his job as a typist to try freelance photography. Sitting late one afternoon in the hall of a house in Mexico City, he glanced through an open door and caught a glimpse of the girl as she stared down dreamily over the railing. "I felt the sudden shock of reality," he recalls. "I thought she embodied a universal theme, which is what I always try to portray—not just a specific event or a purely Mexican situation." He rushed out, grabbing his camera. Then, holding it close to his body to prevent shake, he made an exposure of 1/10 of a second with the aperture set at f/8.

The print reproduced here, made especially for this volume of the LIFE Library of Photography, is somewhat different from the ones Bravo produced in 1931, when he used developers and papers that are no longer on the market. The modern result, he believes, is somewhat better. He chose a standard fiber-based paper and paper developer, but gave the print a 3-minute bath in selenium toner, diluted 1 to 9 with water, which made the blacks richer, and "produced a print that is more mature." He rarely ever uses burning in or dodging, and employed neither to make this print.

MANUEL ALVAREZ BRAVO: *Daydream*, 1931

GREGORY CONNIFF: *Wildwood, New Jersey, 1978*

"I practiced law, after my fashion, for a number of years," said Gregory Conniff of Madison, Wisconsin. "It nearly drove me mad." So Conniff quit the profession to concentrate full time on photography, which had been his hobby since he was a teenager. Only after changing careers, however, did he teach himself to print.

Conniff is best known for his studies of small-town backyards, homely locations from which he creates artful compositions. The photograph at left, for instance, derives its force from the stairs and posts, which have become crisscrossing diagonals climbing up out of the picture frame.

The ultimate appearance was planned before the negative was shot. Conniff took the picture in the late afternoon of a bright day, when the light created extremes of contrast—deep shadows beneath the porch, strong highlights on the stairs and doorway. He deliberately overexposed by about one stop—setting exposure as if the speed rating of the film were ISO 50/18° instead of the actual 125/22°. Then he cut development time 25 per cent. This combination of overexposure and underdevelopment produces rich details in both highlights and shadows, but reduced contrast.

To ensure that these details were retained in the print, he followed a complex development procedure. He used a diffusion enlarger *(page 90),* which produces lower contrast than does a condenser type because the light from its lamp is scattered, or diffused, by a sheet of cloudy glass before it reaches the negative. He printed the negative on Number 2 Ilford Ilfobrom paper.

To control contrast still further, he used two developers. First, he immersed the print for 45 seconds in a low-contrast developer that produces warm tones and reduces the contrast of printing paper by almost one paper grade. This step increased the number of distinct tones of gray so that every fine detail became visible as a separate shade; however, such a low-contrast development cannot produce the heavy deposits of metallic silver needed for total black.

Conniff then switched for 2¼ minutes to a normal-contrast developer that produces cold tones. It caused the deposition of just enough additional silver to make the darkest gray appear black but not so much that distinctions between the gray shades were lost. The combination produced a print that was somewhat lower in contrast than normal, but revealed all the details in the shadows in rich tones.

Conniff was able to come up with a good print after a test strip and one or two tries. "I don't feel that a print should be agonized over," he says. "People who struggle all day for a single print may not be sure of what they want—or they're trying to imitate a level of perfection defined by someone else."

David Vestal

One of the most influential teachers, critics and editors in American photography today is David Vestal, whose own prints testify to his sure command of the medium. The picture that is shown here, one of Vestal's favorites, was made when he was teaching at the Center of the Eye, a school of photography in Aspen, Colorado. It also posed a series of problems whose solutions, though routine for Vestal, are most instructive for less experienced printmakers.

The woodland scene presented subtle variations in tone. The time was morning and the light level was low. The idea Vestal had in mind was to convey what he called "the tenderness of the aspens" as they appeared in the soft, early-morning light—"representing both light tones in the sky and dark tones in the ground clearly without lowering contrast in the tree trunks to the point where they die."

The exposure was made with a Canon L1 camera on 35mm Tri-X film, and Vestal first printed the full negative on glossy, doubleweight, grade 2 Spiratone paper, developing it in the Ansco 120 solution he ordinarily uses with Spiratone paper. He had aimed for some increase in contrast, but the result seemed still a little bland and even in tone. Usually the next step would be to try a more contrasty grade of paper, but this, Vestal thought, might change tones too much. He chose instead to switch developers, using the stronger D-72 in a normal concentration for another test print. It added contrast yet did not quite give the tonal balance Vestal demanded.

He decided against attempting to vary exposures over the print. "Burning and dodging in such a picture," he explained, "would tend to throw tonal relationships off so much that the feeling would be killed." Instead he gave the print a relatively short exposure—6½ seconds. This allowed him to develop the paper longer than usual—5 minutes—to bring out the palest tones. Then, to intensify the areas in shadow without losing their detail, he treated the print in a dilute solution of selenium toner. The result is a picture of delicacy and restraint that gently draws the eye into the scene.

DAVID VESTAL: *Untitled*, 1969

Minor White

When Minor White was chosen by the Massachusetts Institute of Technology to head its new department of photography in 1965, the appointment came as no surprise to White's fellow photographers. It seemed wholly logical that a prestigious center of scientific learning should seek out the man whose eminence not only in his profession but as teacher, critic, and editor had made him what one critic called "the most influential photographer to reach creative maturity since World War II."

White was also a poet, and he often accompanied his pictorial material with poetic imagery offering his own interpretations of what seemed to be pure abstractions. Of the picture at the right he said, "The image may be compared to a detail of the Christmas story. The detail of the animals in adoration of the Birth. The tiny black and white stones in the left signify a birth of something in myself that adores the cosmic force."

The picture is actually a close-up of a stone formation at low tide on the beach of Point Lobos, California. It was taken with a 4 x 5 view camera, the lens set at f/45 to provide maximum depth of field and precisely rendered detail. The sheet film White often used, Super Panchro-Press, and the developer, D-23, also helped maintain resolution of detail, as does the fact that the enlargement is only 4 x 5 to 8 x 10.

This evocative picture is number seven in what White called a "sequence," a group of pictures that he considered esthetically related. When he created a sequence, he often gathered his negatives and printed at white heat, one after the other, sometimes for days at a time. In that process, the quality and nature of each print were subtly influenced by the one preceding it. Some sequences may cover many years of his life, some only brief periods, but each represents an artistic unity, as if every picture in it were carefully selected to hang in one room of a gallery.

MINOR WHITE: *Moment of Revelation*, 1951

WILLIAM CLIFT: *Sheep and Petroglyphs*, 1975

134

William Clift, a New Englander transplanted to Santa Fe, New Mexico, is best known for his panoramic landscapes in a tradition that reaches back to the mid-19th Century. Full of complex detail delineating the play of sunlight and shadow over rising and falling land masses, and monumental geologic formations, his pictures are the result of much hard work—in and out of the darkroom. Clift struggles in the darkroom, laboring to recapture, in his print, the mood of the original scene. Clift admits that his faculty for "prevision"—the ability to make the imaginative leap between a three-dimensional scene and a two-dimensional print before the picture is taken—is not well developed. "I definitely have a feeling when I take a picture, but I do not know how it will turn out in the print," he says.

It took Clift two or three days to make a successful print of this picture, which was taken in Canyon Del Muerto on a Navajo reservation in northeastern Arizona. An obliging shepherd brought his flock to graze in the canyon, a place sacred to the Navajo.

Clift made the photograph 50 feet from the cliffside with a 12-inch telephoto lens on his 5 x 7 view camera. His original negative was low in contrast because the sunlight was diffuse during exposure, and also because he ordinarily overexposes (deliberately rating ISO 400/27° film at ISO 250/25°) to record detail in the shadows, a technique that reduces contrast. To add some contrast in the print, Clift used a condenser enlarger *(page 90)* and Kodak Polycontrast Rapid paper with a filter, which produced the equivalent of a grade 3 paper—one grade more contrasty than normal.

During a 60-second enlarging exposure, Clift burned-in and dodged extensively, seeking to brighten the sheep and make tones in the rocks and cliffside appear more even. Four hours of spotting followed, during which Clift added liquid dye to the areas of the print he wanted darker. For example, he added an outline of dye to individual sheep. To protect the print from fading and staining, Clift used a final bath of gold toner compounded from the so-called Nelson formula, which coats the silver image with a thin plating of metallic gold but does not alter the cold tone of the silver as much as other gold toners do.

Philippe Halsman

Between 1940, when he arrived in the United States, and 1979, the year he died, Latvian-born Philippe Halsman established an international reputation as one of the world's foremost portrait photographers. One hundred of his studies of the world's famous graced the covers of *Life,* three of his portraits were put on United States postage stamps and three were used by presidential candidates as campaign pictures.

In addition to his great skill with camera and darkroom equipment, Halsman had a genius for establishing quick and easy rapport with his subjects—whether it was an aging actress worried about her wrinkles or a prime minister impatient with posing. Once they were engaged by Halsman's informed conversation, his camera was forgotten, the mask of self-consciousness dropped and the photographer went to work.

Halsman told a story about the accompanying portrait of Albert Einstein that has become almost as well known as the picture itself. The photograph was taken in 1947, seven years after Einstein had helped Halsman to escape from Nazi-occupied Paris. As Halsman was preparing his equipment, he and Einstein were discussing the atomic bomb. Einstein, caught up in the ideas they were talking over, reflected in his expression sorrow over the destructive uses of his theories—and just at that moment Halsman tripped the shutter. The picture won immediate acclaim and became the most popular likeness of the famous physicist.

In making the print Halsman faced the problem of registering the details of the scientist's snowy hair while preventing the skin tones from becoming too dark. To do this he slightly overexposed and underdeveloped his negative, thus reducing contrast. He printed the picture on variable-contrast paper, using it without a filter so that it gave medium contrast overall, and he gave the whole picture an exposure of 12 seconds. He then exposed the hair and the background for 4 more seconds. This extra exposure, provided to those areas alone while Halsman held his fist over Einstein's face, was necessary because, despite the precautions taken during development of the film, the hair would have turned out too light and the objects in the background would have become distracting.

Though he often found that normal gradations of variable-contrast paper used without a filter produced a pleasing effect, this technique did not always suit all parts of a picture. By employing a filter while burning-in or dodging portions of the negative, Halsman could control contrast to an exact degree and also could vary that contrast from one part of the print to another.

With the Einstein portrait, however, he burned-in the hair and background without a filter, since reducing the contrast with a soft, low-contrast filter would have made the hair become a dull gray, while increasing the contrast with a hard filter would have made it look like straw.

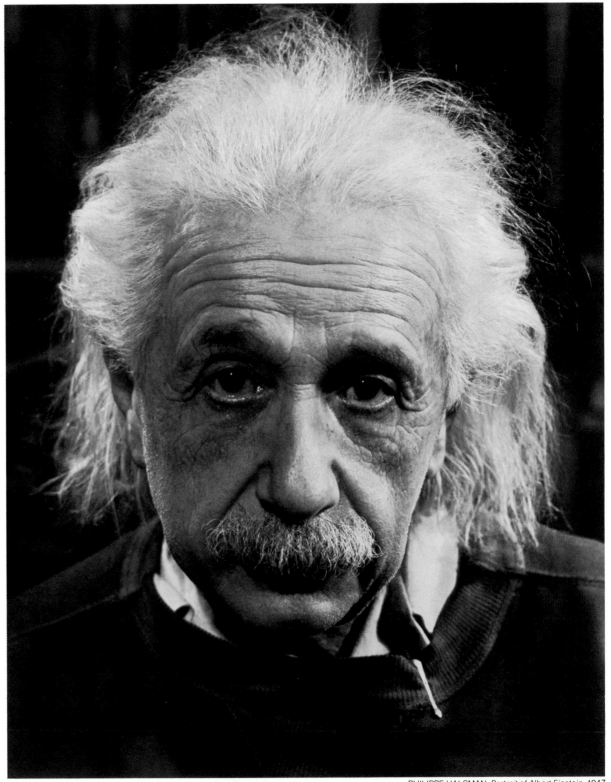

PHILIPPE HALSMAN: *Portrait of Albert Einstein*, 1947

LEWIS BALTZ: *West Wall, R-OHM Corporation, 16931 Milliken, Irvine, California, 1974*

The industrial and residential buildings that increasingly clutter the once-open expanses of the American West are the subjects of Lewis Baltz's photographs. His studies of garages, warehouses, factories and tract homes in his native state of California, and in Nevada and Utah, show what he called "one of the most common views our society has of nature: landscape-as-real-estate."

Most of the buildings that Baltz photographs are so new that they are not yet inhabited; some of them are not even finished. The absence of people contributes to the sense of desolation often evident in his pictures.

Baltz considers himself a documentary photographer, and titles his pictures with their exact locations, inviting the viewer to visit the scene and judge how faithfully it has been recorded. "I want my pictures to be seen as factual statements," Baltz has said, and his darkroom technique is aimed at ensuring that the photographs describe their subject matter as accurately as possible.

This photograph was taken as the light was fading on a late-spring evening. To make the exposure, he used a tripod-mounted Leica M-4 rangefinder camera and a moderately wide-angle 35mm lens. As usual, Baltz shot with the camera at eye level so that the viewer feels as if he is standing before the scene. Although Baltz generally positions his camera for a head-on view, here he set the camera slightly to the side of the building to get added depth.

To get the detail that he likes, Baltz does not use ordinary black-and-white film. He shoots with Kodak High-Contrast Copy, a special type of film made for copying documents in the microfilming process. It produces a very sharp image with virtually no grain. When developed normally, the image is only black and white with no tones of gray, like type on a printed page. But Baltz develops his microfilm in low-contrast developer that gives a wide range of grays.

Once satisfied with his negative, Baltz aims to reproduce in the print exactly the image recorded in the negative. Using Agfa Brovira, a cold-toned paper, to make this print, he manipulated only to the extent of burning-in the interior of the building to show detail in that bright area. He developed the print in Printofine, a developer he chose also because of its cold tones. A 5-minute immersion in a hypo-clearing agent that contained selenium toner, diluted 1 to 9, protected the image from fading.

George Tice

Through producing—and selling—limited editions of his pictures, each printed by his own hand and loosely bound in portfolios, George Tice has had as much as anyone to do with shaking the art-minded public awake to the value of fine photographic prints. Best known among these portfolios are a series he did on trees and another on the Amish of Pennsylvania.

The print at the right was made in 1961 at the time that Tice was shooting in Pennsylvania. There had been something about the way the late afternoon light fell on the country road that had drawn him to the spot again and again. But his results had not pleased him. This time he had been waiting 20 minutes; the light was nearly gone. Then —in place of the Amish horse and buggy he had hoped would come by— the automobile appeared, backlighted by the dying sun. Sensing the drama of the scene, Tice swung into action. With the aperture of his twin-lens camera at f/6.3, he set the shutter at 1/250 second to stop the motion of the car. In the fading light he knew this combination would produce an underexposed negative in which the fields bordering the road would hardly show up at all.

If Tice had sent the resulting nega-

tive to the local drugstore for printing, the outcome would have been a small car on a country road toward sunset—a fairly literal representation of what he saw when he tripped the shutter. But instead of that Tice made a picture of haunting mystery and apprehension by an elaborate printing technique. The square, 2¼ x 2¼ negative was cropped to a horizontal format, more in keeping with the shape of the road. To intensify the contrast between the highlights and the shadows, he printed the picture on very contrasty grade 5 paper. The basic printing exposure for the car and road was 5 seconds. Additional exposures of 15 seconds each were used to make the upper and lower areas of the fields almost solid black. Small, irregular areas around the car were darkened for an additional 20 seconds. To add depth to the image, the developed print was treated in a chemical bath, a selenium toner that intensified the dark areas. Finally, a sunspot on the road was removed with spotting dye.

To Tice, the end result becomes "a combinaion of what I saw and how I felt about it. The road is narrowed at both ends. To each side lie unfathomable depths. The driver is not sure where he is going. He is alone."

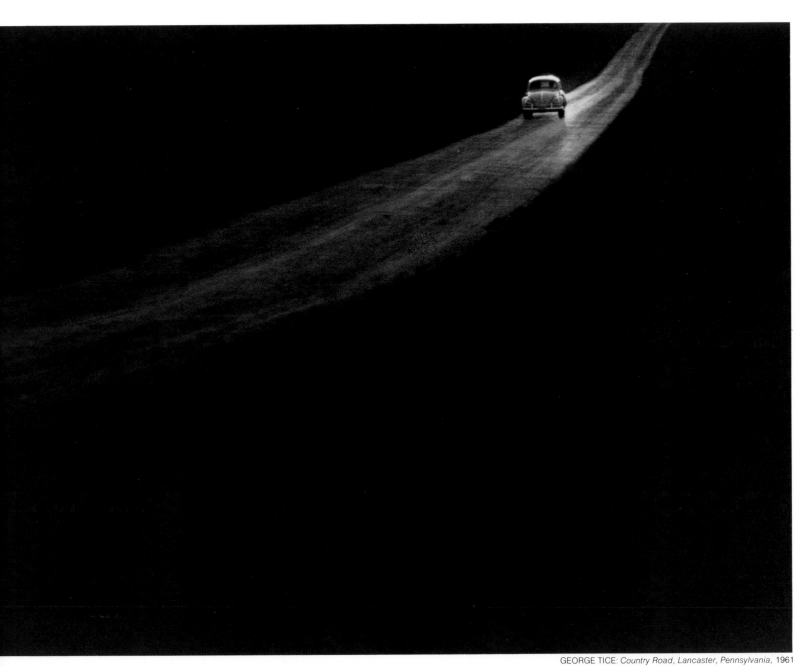

GEORGE TICE: *Country Road, Lancaster, Pennsylvania,* 1961

Jack Welpott

A large-paned window in a room in an old house, a round oak table set with the remnants of breakfast, a Victorian mirror, a sketch pinned to the wall, a lumpy couch, a young girl—the random elements of a random morning make up the photograph at right. At first glance it appears to be nothing more than a lucky snapshot. In reality its complex balancing of lights and darks was meticulously created in the darkroom. Its creator is a photography teacher who has exhibited his work in numerous galleries and museums, including the George Eastman House in Rochester.

Jack Welpott took the photograph with a 4 x 5 view camera. He placed it high on a tripod "to emphasize the position of the objects—each in its place and in relationship to every other object." The girl is

the picture's center of attention. Her image appears three times—on the couch, as a reflection in the mirror and as a sketch on the wall—her pensive expression and lowered head in all three manifestations helping to establish an atmosphere of brooding tension. "The round table stabilizes these conflicts," Welpott says. "The image is filled with commonplace objects which react to each other in uncommon ways—it becomes a sort of dialogue between objects."

In order to get maximum detail despite the relatively dim light—the only illumination came from the room's single window—Welpott closed down his lens to f/32 and made an exposure that lasted 4 seconds. "I exposed for the shadows and then underdeveloped the negative by 45 per cent to reduce contrast. Had

the negative been fully developed, all of the surface texture in the highlights—particularly around the window—would have been lost."

Close scrutiny of this picture reveals a secret of the printmakers' art. Notice the relative brightness of the seated girl and her reflected image. The reflection is brighter than the girl herself, though ordinarily a mirror reflection is darker than the object it shows. The explanation is that Welpott, in making his enlargement, held back the exposure in the dark, right-hand side of the picture to keep detail in the mirror frame and in the deep shadows around the right-hand side of the table. By doing so, he lightened the reflected image of the girl as well, calling attention to it and at the same time underscoring the tension that is the picture's theme.

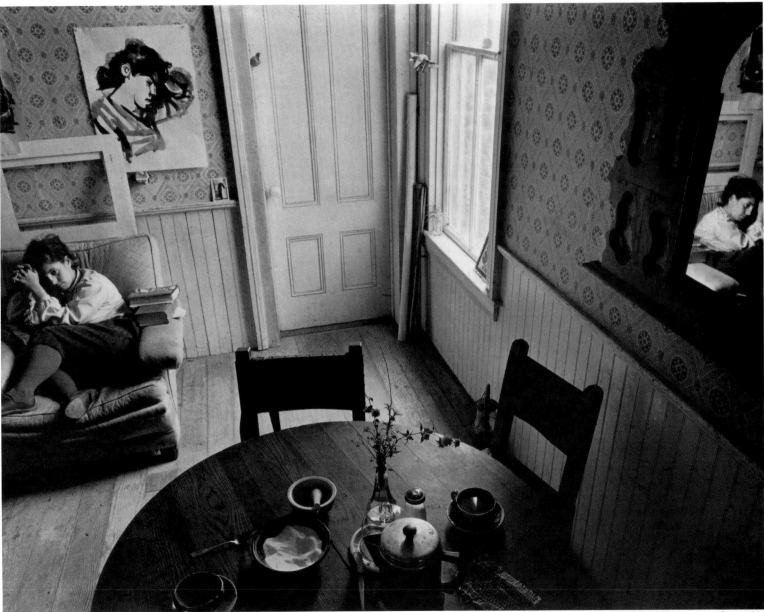

JACK WELPOTT: *Anna in Her Room*, 1964

George Krause

"My purpose is not to mirror what is happening in the world, but to interpret what I find," says George Krause. A young photograpner who lives, works and teaches photography in Philadelphia, Krause employs a 35mm reflex camera for most of his picture taking, later transforming the negatives into statements of his interpretation with carefully planned darkroom treatment.

In the print at right, Krause has succeeded in turning what might have been a commonplace seascape into an uncommonly lovely composition. His interpretation of the scene he came upon in the harbor at Wedgeport, Nova Scotia, early on a foggy morning is an intensification of reality. Ordinarily, pictures taken in such a diffuse light show only a middle range of grays and tend to produce rather bland prints.

To avoid this, Krause printed on the grade of paper with the highest possible contrast. The gray fog separated into tiny dots of grain, becoming itself a visible entity rather than simply an overall tone. Krause also gave a significantly longer printing exposure to the shadow of the dory on the water, turning it into a concentrated patch of black that was strong enough to balance the diffuse weight of the rest of the photograph—the ghostly gray tones of the sheds, the docks, the water and the fog.

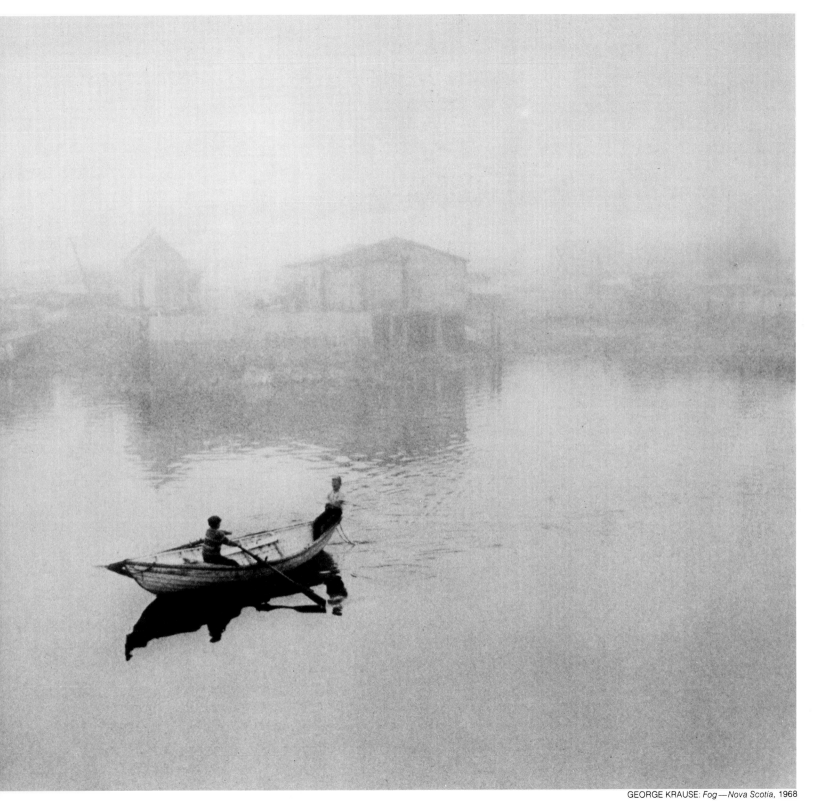

GEORGE KRAUSE: *Fog — Nova Scotia,* 1968

Frederick Sommer

A casual favor for a friend led Frederick Sommer to create this arrestingly ambiguous portrait, which has become one of his best-known images. The friend, who was building a house in Sommer's hometown, asked the photographer to take a few pictures of two little girls who often played near the construction. Sommer used his friend's snapshot camera to make the portraits.

The resulting prints so intrigued Sommer that he made arrangements with the parents of one of the children to rephotograph her with an 8 x 10 view camera. This time Sommer carefully arranged the picture to illustrate his theory that a good composition consists of a core element surrounded by subordinate elements that echo it. So he posed the child —the core—against an unfinished wood wall that, with its exuberant patterns and contrasting tones, repeated the luminous tones found in the girl and her dress.

It took Sommer several years and repeated printing sessions to achieve the effect that he wanted. He first made a contact print that was darker than normal on low-contrast paper that was somewhat aged—old paper gives less contrast than fresh. After fixing it, he dipped it briefly in a selenium toning bath, which helps increase contrast in the darkest areas. When the print was dry, he studied it carefully, then immersed it in a bleach made of a highly diluted solution of potassium ferricyanide and fixer, and washed it thoroughly. This lightened the print, but affected highlights more than shadows, slightly increasing the contrast. Then, using an artists' brush, he painted bleach into small areas he wished to brighten even more, and washed again.

Sommer is unabashedly proud of his work. "Children are rarely photographed effectively," he once noted. But this picture is more than simply an unusual portrait of a child. Sommer sees his subject, with her strangely glowing eyes, Cupid's-bow mouth and chastely folded hands, as representing women of all ages.

Haunting though she is, the image is considerably less startling than many of Sommer's other pictures. Believing that the artist must cultivate a total awareness of the world around him, Sommer has often depicted disturbing subjects, among them chicken embryos, coyote carcasses and the decaying corpse of a horse; many of them he photographed in the parched desert landscapes of his home state, Arizona. Bewildered when critics complained that such pictures are merely celebrations of the bizarre, Sommer replied, "These things exist, and you might say my pictures are homage to existence as it is."

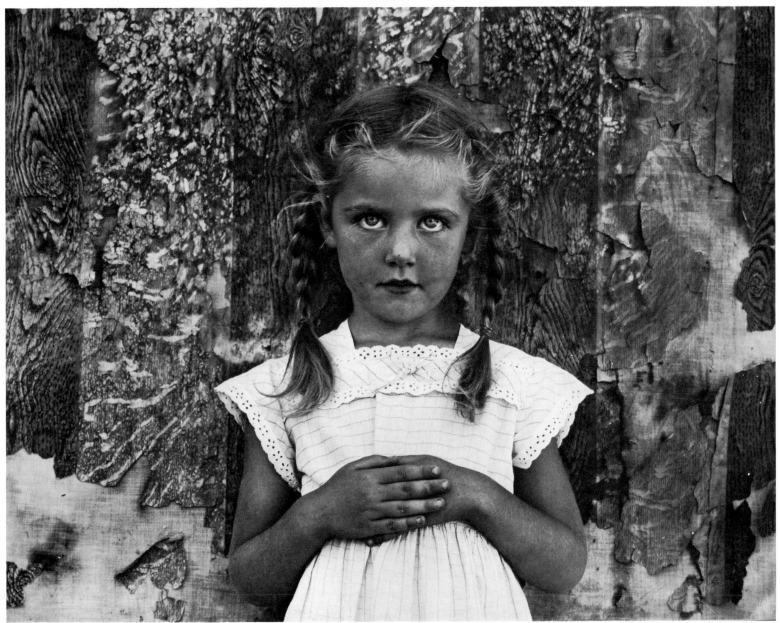

FREDERICK SOMMER: *Livia*, 1948

147

Roger Mertin

Roger Mertin undertakes complex pictures that require virtuoso control of darkroom processes. The picture at right is one that Mertin counts among his finest. It shows a television screen floating in a black void over a reclining female nude, and was taken by aiming his 35mm Nikon camera, equipped with a 28mm wide-angle lens, into a mirror. Reflections from the mirror can be seen along the model's leg, in the foreground, and buttocks.

"When I made this photograph," said Mertin, "I was interested in exploring the possibilities of pictures within pictures." He employed this approach to express, with powerful visual impact, confrontations that perplex modern man: between female and male, between nature and artifice, between the sensual and the cold.

With a picture like this, depending so heavily upon intellectual interpretation for its impact, meticulous care in printing was of primary importance. Mertin used Brovira grade 4 paper for high contrast. He stopped down his enlarger lens to f/11, so that he could give a total exposure of 18 seconds, time enough for burning-in and dodging.

After Mertin exposed the print enough to bring the flesh tones of the model to the desired degree of darkness, he gave the television-screen portion of the print extra exposure. This made it stand out strongly, in sharp contrast to the delicate delineation of the girl's form and the velvety, rich black of the detailless background, so that the model and television image seem to hang in space.

ROGER MERTIN: *From "Plastic Love-Dream,"* 1968

HARRY CALLAHAN: *Weeds in Snow, Detroit*, 1943

Beginning in the late 1930s, Harry Callahan gained a reputation for sophisticated prints of stark simplicity. Sharp lines and brilliant contrast between blacks and whites are strongly stressed while form, shadings and texture are deliberately ignored. The result is an abstraction that frequently seems to be totally divorced from the original scene that had inspired the photograph.

Abstractions in black and white were not always the mark of a Callahan work. When he began making photographs his goals were realism, a wealth of detail faithfully reproduced, and a full range of tonal values and textures. He continued to make striking pictures of this kind, but the picture at left, taken in Detroit in 1943, revealed a new avenue for his art. Callahan was peering into the ground-glass viewing screen of his Linhof camera and focusing on a snow-covered field from which the dried-up stalks of the previous summer's weeds protruded; suddenly he perceived a strange, compelling beauty in the pattern of the scene rather than in its form or texture. "This was a great discovery for me," Callahan was later to say, "and it led me to search for the same beauty in similar subjects."

To enhance the contrast of his composition, he underexposed one step and overdeveloped his film by approximately 50 per cent. Even so, his negative revealed some texture of the snow, and to recapture the effect that had intrigued him, Callahan found himself working in the darkroom to get greater and greater contrast between the dark stalks and their white setting.

He hesitated at first to break completely with his previous realistic style, and settled on a slightly contrasty grade 3 paper for his original print. A hint of the snow's texture came through. Later, after his style changed, Callahan reprinted the same picture on a very high-contrast grade 5 printing paper, which turned the background into a shadeless and textureless mass of white. This is the version reproduced at left.

Bill Brandt

"I try to convey the atmosphere of my subject by intensifying the elements that compose it," said Bill Brandt, one of the most inventive and successful British photographers of the 20th Century. How well he managed to achieve his aim through his deliberate control over both negative and print can be seen in the darkly foreboding photograph at right.

One of a series that Brandt did to illustrate the architecture and landscape of Britain's literary past, this picture has as its subject Haworth, where the Brontës lived. In 1945 it was nothing but a sheepfold and a plaything of the winter wind. To convey the atmosphere of the wild Yorkshire moors that had inspired Emily Brontë to write *Wuthering Heights,* Brandt deliberately chose to shoot his picture on a dreary February day following a storm.

The wind was blowing so hard that, in order to avoid the blurring of camera movement, Brandt had to shoot at 1/100 second, even though his twin-lens reflex was mounted on a tripod. High-speed film (Tri-X) made up for the relatively brief exposure in dim light, and let him stop down the lens to a fairly small aperture, f/11, so that he could get the great depth of field that he needed.

Brandt printed his 2¼ x 2¼ negative on a glossy grade 4 paper so as to achieve sharply defined contrast. This gave deep blacks and brilliant whites to suggest the gloom and mystery Brandt was after. But such contrasty paper seldom registers delicate differences in tone; the black house could turn out as deep a shade as the dark clouds and disappear from the scene completely. To register the house, he carefully dodged the sky, keeping it light enough so that the bulk of the house is clearly defined, yet not so light as to dissipate the power of the storm clouds rushing over the snow-patched hillside. Such a delicate operation requires time; Brandt stopped his enlarger lens down to a small aperture, f/18, so that the printing exposure became extraordinarily long—7 minutes—giving him plenty of time to dodge the clouds as much as was necessary.

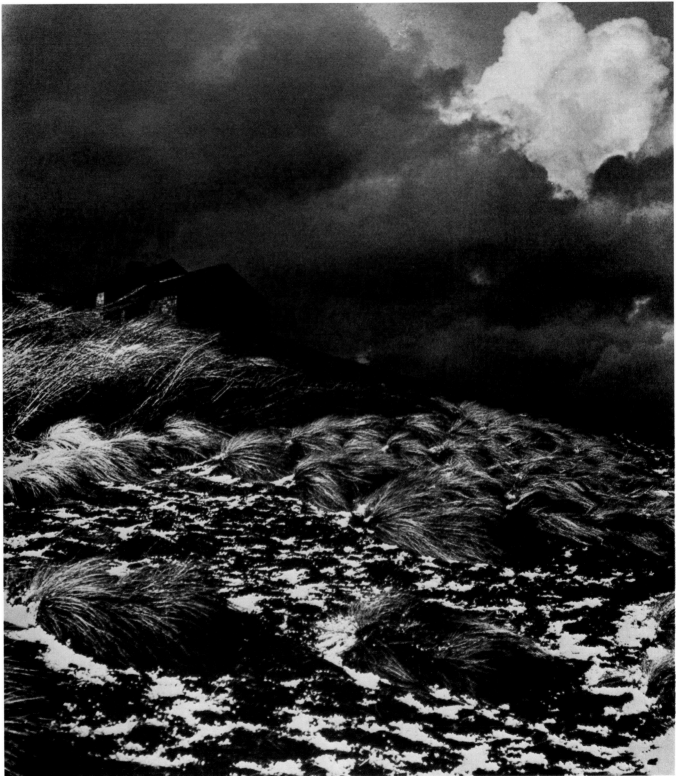

BILL BRANDT: *Wuthering Heights*, 1945

153

Eikoh Hosoe

Eikoh Hosoe, a photographer who is represented in museums around the world, learned his craft at the Tokyo College of Photography, where he became a teacher. Asked once to describe his printing technique, he used a metaphor from the kitchen. "The negative," he said, "is raw. You must cook it."

Two of Hosoe's favorite methods of preparation are classics—dodging and burning-in. For dodging, he attaches cutout shapes to a piece of piano wire. For burning-in, he uses photographic paper with holes cut in it. One side of the paper is black, the other white. When the negative is dark and projects a dim image on the enlarger easel, Hosoe turns the white side of the paper up, using it as a screen on which to view the image projected by the enlarger light. Otherwise, he follows the normal practice of burning-in with the dark side up.

Hosoe used both burning-in and dodging to make the print at right, one of a series of close-ups of men posing with women; the pictures were deliberately left headless in order to concentrate attention on the models' bodies. Here, the striking contrast between the dark and light skin tones is a photographic parallel to depictions found in 18th Century Japanese woodcuts in which the women are pale, the men dark.

To emphasize the difference in the color of his models' skin, Hosoe first exposed the picture on Plus-X film, which is a medium-speed film that gains in contrast what it loses in speed. Then, to exaggerate the differences in skin tones even more, Hosoe dodged the white of the woman's skin and burned-in the dark of the man's, while printing with a condenser enlarger on Gekko single-weight grade 5 glossy paper.

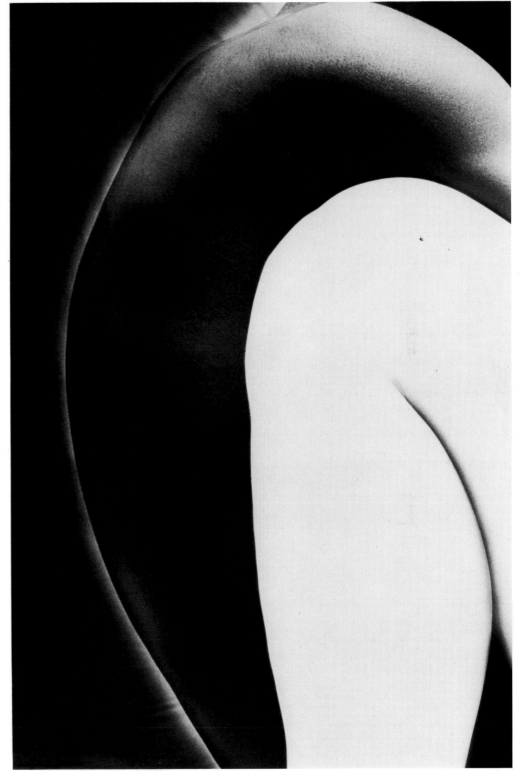

EIKOH HOSOE: *EMBRACE No. 15*, 1970

Mario Giacomelli

So startling are the tonal contrasts in this print by Italy's Mario Giacomelli that many photographers who have seen the original believe it to be a composite of at least three negatives. It is not. It is made from a single negative, but each of the principal figures in it was exposed separately during printing. Giacomelli concedes that "it is the most difficult print I have ever made."

Giacomelli, a printer of books who still considers photography an avocation, shot the picture in a small hill town in Italy's Abruzzi district. He saw the women of the village, dressed in traditional black, hurrying home after early mass, while strolling casually among them was the discordant, strangely disquieting figure of a boy in long pants. The contradiction of a happy-go-lucky youth surrounded by downcast, black-clad women inspired Giacomelli's vision: "I wanted the boy to be the main theme of the photograph and to come forward clearly while the others should be like characters on a stage set, and appear uncertain, blurred and out of focus. The boy must appear to be projected into the scene from above as in a surrealist painting, while a whiteness around him transports him forward on a path of light."

Achieving this vision from the reality of the negative required painstaking control of the print. For one thing, Giacomelli had used a flash when making the picture and the strong light from alongside the camera had caused the face of the woman in the foreground to be much more brightly illuminated than that of the boy or those of the women in the distance. Moreover, this problem was greatly accentuated by Giacomelli's choice of printing paper, an Italian brand with extra-vigorous contrast.

The printing exposures that would provide the relationships that Giacomelli envisioned were arrived at only after much trial and error. The entire print was given an exposure of 30 seconds. But the face of the boy was exposed for an additional 2 minutes to darken it somewhat, that of the woman at left 4 minutes more and that of the woman at right 3 minutes more, to bring out detail in their faces. Giacomelli also darkened the black skirts of both women in the foreground by exposing them for an extra half minute. Finally he dodged the center section with his hands for half a minute, creating a white area around the boy—"to bring him forward on a path of light."

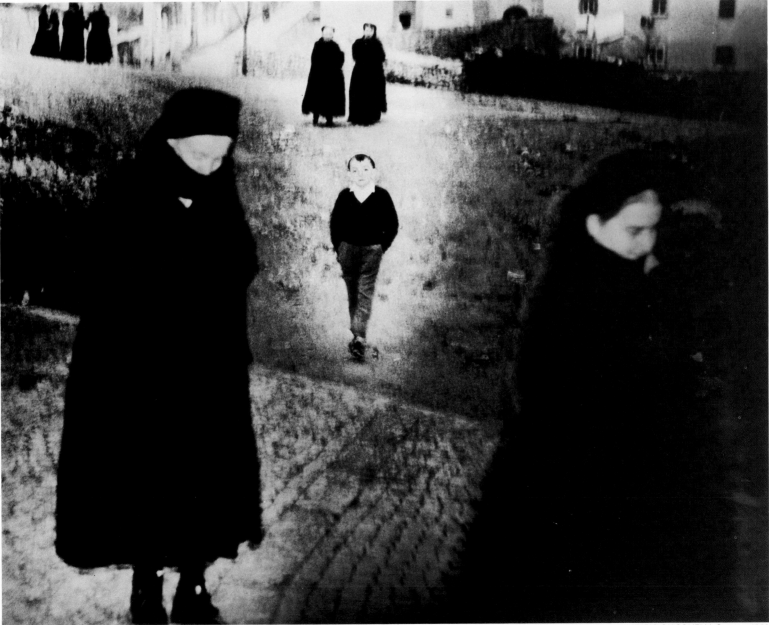

MARIO GIACOMELLI: *Scanno*, 1962

Duane Michals

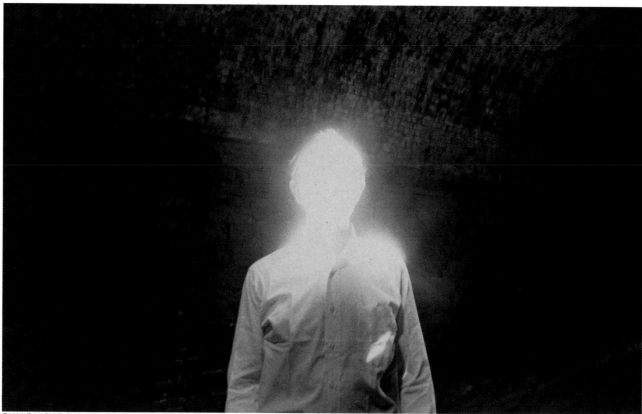

DUANE MICHALS: *The Illuminated Man,* 1969

"I wanted to do a photograph of a man whose head would dissolve into pure light—as if his spiritual energy or aura could be seen, while his features were obliterated,'' is the explanation that Duane Michals gives for this deliberately unbalanced photograph. Michals posed a friend in the automobile tunnel just south of Grand Central Station in New York City, standing him where his head was spotlighted by a shaft of sunlight that penetrated from the street above. Michals mounted his 35mm Nikon F camera on a tripod, loaded it with Tri-X film and made a long exposure calculated to capture the mottled texture of the dim tunnel wall. But the face, in full sun, was at the same time greatly overexposed.

Michals, one of the few creative photographers who do not choose to develop their own black-and-white film, had his laboratory develop the roll normally. Then he printed the picture on the most contrasty grade of paper, using an exposure of 20 seconds. The very high contrast of this paper emphasized grain, produced deep black tones and made the light area an aureole of white.

The extreme overexposure in the negative of the highlighted face caused the streaked aura of white in the print. This effect, accentuated by graininess, makes the light appear in particles that suggest a sunburst, just as Michals had intended it should. Only in the subject's shirt—which was given a few seconds' extra exposure—is there any great amount of detail, its re-creation of texture a foil for the featureless face. ☐

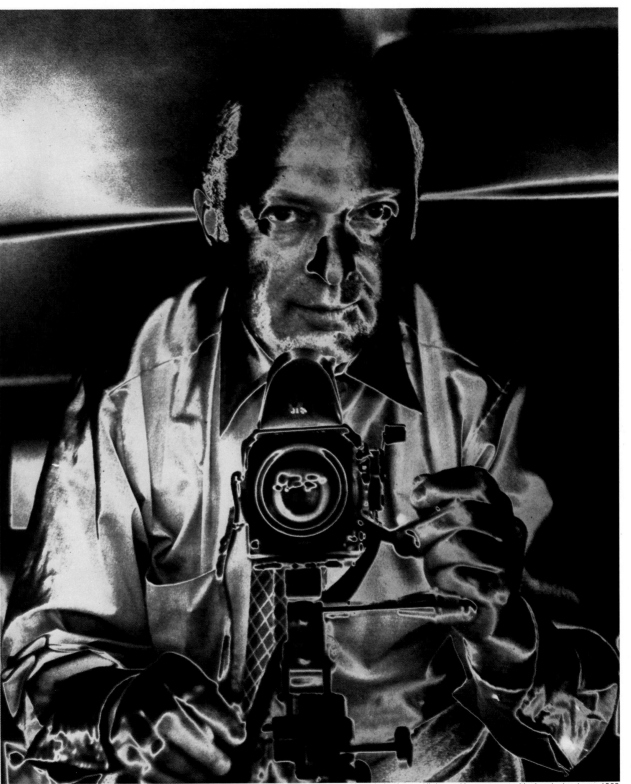

YALE JOEL: *Self-portrait, some of its tones reversed by solarization and lightened by treatment with chemical reducer,* 1969

What the Camera Never Saw

Prints that radically transform the image captured by the camera—or are made entirely without a camera—can start a heated argument in almost any gathering of photographers. Some insist that any manipulation of the print —even such routine practices as trimming edges off the scene, or adjusting exposure by dodging—violate the integrity of the photograph and are to be avoided. Other photographers disagree, usually vehemently. They argue that any technique should be used if it makes a print more interesting or exciting, or expresses a personal viewpoint that could not be conveyed by conventional methods.

The dispute has been going on since photography was invented, and it is yet to be resolved. The early photographers retouched and hand-colored their pictures—some even applied thick paint to the images to suggest the textures of the original subjects. William Henry Fox Talbot, the father of modern photography, made beautiful shadow pictures without a camera by laying a leaf, feather or piece of lace on a sheet of sensitized paper *(page 195)*. After he had discovered how to make pictures with a camera he often achieved a soft, diffused quality in his prints by inserting nonsensitized, heavily textured paper between the negative and the positive sheet during the printing process. The photographers who followed him continued to be fascinated by the artistic freedom available to them when making prints.

But it was not until the years during and after World War I, when radical modes of expression were being pursued in the Dada and Surrealist art movements, that the esthetic potential of the transformed, or experimental, black-and-white print was seriously explored. Adventurous artists then showed how deliberate manipulation of the printing process could convey powerful ideas and a feeling of otherworldly beauty *(pages 196-210)*. Their techniques have in recent years been refined and greatly broadened by a number of artist-photographers who are making the image in the darkroom a significant and increasingly popular art form.

Thanks to the great versatility of the usual working material (printing paper) and the principal tool (the enlarger), the processes used in making the transformed black-and-white print can be simple. If printing paper is viewed not as merely something that makes an opaque positive out of a negative transparency, but as a light-sensitive substance in its own right, its potential as a medium becomes apparent. It is fairly slow in speed compared to camera film, and this attribute permits the photographer to take his time working with it. He can change the character of its tones in many ways, bleaching away parts of a picture or reversing blacks and whites with the technique called solarization. (Both of these techniques were employed in making the frontispiece picture for this chapter.) He can coat his own paper with an emulsion of light-sensitized gum arabic to introduce color into prints from black-and-white neg-

atives *(pages 184-192),* or he can use printing paper alone, as though it were a canvas, and "paint" pictures on it with light. Abstract patterns, for example, can be created with nothing more than a carefully shielded point of light, such as that from a pen type of flashlight, which is used like a brush to make black lines of varying shades and character.

When printing paper is used with an enlarger and negative, it is in effect taking a picture (the print) of a picture (the negative). The enlarger then serves as a sort of darkroom camera—one that permits easy manipulation of both sides of this process of taking a picture of a picture. Many changes can be worked on the negative side. Two—or more—negatives can be used to print their images on a single sheet and create an evocative multiple picture. If a transparent positive copy of the negative is made, the positive transparency can replace the negative in the enlarger; it then produces a negative print, in which all tones are reversed. A negative and positive are sometimes printed side by side to make a fascinating contrast in tones. And if the positive and negative transparencies are combined, one practically on top of the other, they make a print that gives a strange illusion of depth *(page 170).* The print side of the picture-of-a-picture process lends itself to even more simple manipulation. Flash light on it during development and some tones reverse *(pages 166-169).*

Prominent among the outstanding professionals who have exploited these techniques is photographer Yale Joel. "I began experimenting with printing almost as soon as I became seriously concerned with photography," Joel says, "and the work has been not only exciting but rewarding. Even an uninteresting negative will often produce a picture with great vitality and bizarre charm when printed in an unorthodox manner. And often you don't need a negative to get fascinating results."

The series of pictures on the following pages shows Joel at work in the darkroom. The scenes are real rather than staged; as they were shot Joel was actually using sensitive paper and film to make the very prints shown. This could be done because the sequence steps were photographed on special infrared film, which is sensitive to electromagnetic radiation—infrared waves that have no effect on ordinary photographic materials. If the scene is flooded with infrared waves, the special film takes pictures by this invisible light, which does not harm the light-sensitive paper or film being worked on. The infrared radiation was provided by a battery of standard flash units that were tightly covered with infrared filters—very deep red plastic that blocked the flash's ordinary, visible light but permitted its infrared waves to pass. Thus the darkroom seemed dark but was actually illuminated with infrared, making it possible to record even the images of Joel's prints as they were formed in the developer tray. □

The Photogram's Shadow Picture

To record the delicate image of a stalk of marsh grass, Yale Joel employed a technique used at least 40 years before practical photography was invented. The result is a photogram, a shadow picture made without a camera. An object is placed on a sheet of printing paper, and the paper is exposed to light from an enlarger *(opposite)*, then developed, fixed and washed in the usual manner.

For all its simplicity, the photogram offers the adventurous photographer great latitude. It can create fascinating patterns with bulky, transparent or translucent objects, like a pitcher or a plastic bottle, that bend the light rays.

The print is developed in ordinary developer (above) until the background is a rich deep black while most of the shadow image remains bright and clear. In this instance, the developing time was approximately 3 minutes.

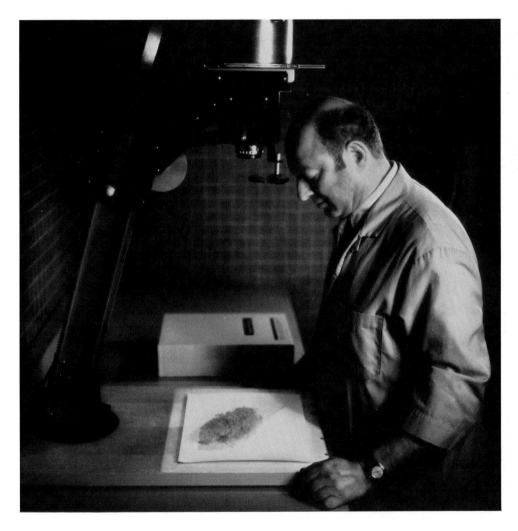

Joel creates a photogram by placing a stalk of marsh grass on a sheet of high-contrast paper on the easel. He then positions the head of the enlarger about three feet above the easel, sets the lens aperture wide open and turns the enlarger on for an exposure of 1 second.

A Print That Is Both Positive and Negative

Simply by turning on an ordinary light bulb while the print of a winter woodland scene was being developed, Yale Joel produced the striking image on the opposite page. This procedure, commonly (and somewhat incorrectly) known as solarization, gives the print both negative and positive qualities. It also adds halo-like bands known as Mackie lines (after Alexander Mackie, who first described them) between adjacent highlight and shadow areas.

The eerie appearance of the solarized print results from a combination of chemical actions. The print is prepared in the usual manner, except that the bright light is turned on for an instant about three fourths of the way through the development period. The flash of light has little effect on the dark areas of the print because at this stage of development most of the crystals there have already been exposed and converted to black silver by the developing process. The opposite, however, is true of the bright areas; little affected by printing exposure or developer, they contain many sensitive crystals that can still respond to light and further development. The bright areas therefore turn gray, but they remain somewhat lighter than the shadows.

Between the light and the dark areas, parts of the crystals interact to retard further development; those border regions remain almost white, forming the halos of the Mackie lines. The Mackie lines, which contribute greatly to a solarized print's fascination, are most pronounced when the picture has strong contrasts between light and dark areas. For this reason, the best results are obtained with contrasty negatives and high-contrast paper.

Strictly speaking, this printmaking technique is not solarization at all. True solarization takes place when film, not printing paper, is greatly overexposed. The excessive exposure generates a strange and complex reaction in the sensitive crystal that actually reverses the usual photographic mechanism; the image comes out as a positive rather than a negative. The correct name for the phenomenon shown here is the Sabattier effect, after the French physician, scientist and photographer, Armand Sabattier, who first described it in 1862. His discovery was an accident. Daylight happened to fall on a plate while he was developing it, and the negative image was partly converted into a positive one.

There can be no precise rules for solarization. "Every print is an experiment," Joel says, "and, for me, that's part of the reward.

"I turn on a 25-watt bulb for an instant—as fast as my fingers can turn the switch on and off. Obviously errors occur. If I develop too little before turning on the light, the entire print is likely to go black. If I develop too long, the solarization effect may not take place. If the light is on too long, I may wind up with a black piece of paper. But the remarkable results that can be obtained make the experiments well worth the occasional failures."

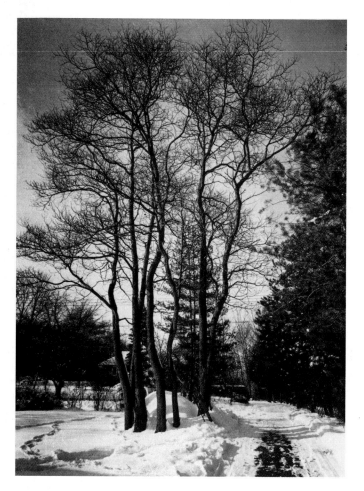

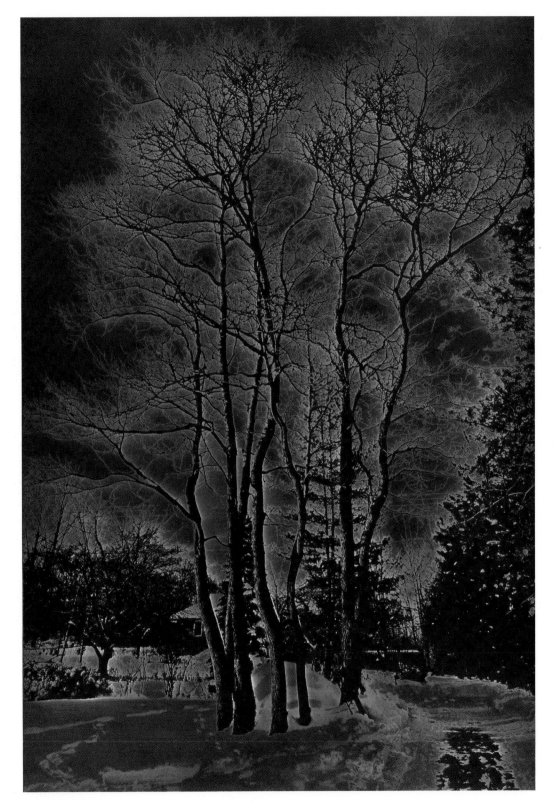

Joel inserts the carrier containing the negative
into the enlarger. He will make the solarized print
on extremely high-contrast paper.

The enlarger is turned on to expose the paper
just as it would be for an ordinary print. For this
negative the aperture setting of the lens was
f/11 and the exposure was made for 10 seconds.

In the developing solution (above), the exposed sheet begins to form a conventional print. But this process will be interrupted after three fourths of the usual developing period.

After a minute and a half of development, Joel solarizes the print while it is still in the developer, briefly turning on a 25-watt lamp that is suspended about four feet above the tray.

The partially reversed solarization appears as the print is left in the developer for the last quarter of the developing cycle. This picture required approximately 30 seconds of additional development after solarization. It was then fixed and washed in the usual way.

An Extra Dimension with Bas-relief

The marked three-dimensional quality of the buildings and crane at right, their appearance of having been molded in clay, was created with the technique known as bas-relief. This unusual effect depends on an artificial emphasis of the shadows in a scene and is basically an optical illusion.

Human vision has come to interpret shadows as evidence of three dimensionality. For example, shadows tell us a distant round object is a sphere, not a circle. Bas-relief exaggerates existing shadow lines and introduces artificial ones by printing a negative and a positive together. This requires a transparent positive copy of the negative as well as the negative itself, and producing the positive is simplest to accomplish if the original negative is moderately large—say, 4 x 5. The transparent positive is made by printing the original negative on a sheet of slow-speed high-contrast copying film such as Kodalith. If the original negative is small the positive must be produced by enlargement; in that case a duplicate negative in the same large size can then be made by contact printing the transparent positive onto another sheet of copying film.

To combine the positive and negative for the final bas-relief print, one special piece of equipment is required. This is a light box—a box with a top of diffusing glass that is illuminated by a bulb underneath (a substitute can be jury-rigged with the glass mounted on wooden blocks above an illuminated paper sheet). With the negative and positive combined on top of the light-box glass, they can be positioned so that their images do not quite coincide. The slight deviation creates the exaggerated shadows in the print.

171

Under a red safelight, Joel places a sheet of 4 x 5 copying film, emulsion side up, on the easel in preparation for making a positive transparency of his 4 x 5 negative.

The negative, with the emulsion side down so that it will face that of the copying film, is put on top of the unexposed film to make a positive.

To hold negative and film together, Joel covers them with glass. He then exposes them for 1 second with the lens at f/8 and the enlarger head three feet above the easel.

After developing the positive film like an ordinary print, Joel places it and the negative on a light box, emulsion sides together. A magnifying glass aids proper misalignment.

The transparencies, taped together, are placed in the negative carrier with the negative film on the bottom. The carrier is then put into the enlarger.

Because the light must pass through both the negative and the positive before reaching the paper, a long exposure is needed. It was 20 seconds at f/8 for this picture.

The bas-relief effect appears during development. If it had not, Joel would have shifted the transparencies and printed again.

Two Pictures in One

Combining images from two or more negatives on a single sheet of printing paper produces startling effects not easily created in the camera. Such composites can be made very simply—by pasting together parts of several prints into a collage and rephotographing the result, or by sandwiching several negatives together and making a single print from them. For some effects, however, it may be necessary to print several negatives, one at a time, onto the same sheet of paper. Two popular techniques for creating striking composites in this way are demonstrated on the following nine pages by Yale Joel.

The first method, used to create the picture of the young man and the skyscrapers at right, superimposes images from two negatives in separate exposures; the size and position of each image is carefully adjusted, but the overlap between the two is not concealed. The resulting print can be strongly symbolic—here conveying a message of human dominance. The second technique, used for the picture of the diver in the snowbank on page 179, also superimposes two images in separate printings. However, this time Joel used a sophisticated masking technique that blends the two images so seamlessly that, at first glance, the print appears to have been made from a single negative. The deception, however, is quickly revealed by the unreality of the scene: A scuba diver can hardly surface on a snow-covered suburban lawn.

Multiple printing, even more than other forms of darkroom experimentation, requires that the final appearance of the picture be fully worked out in advance—previsualized, in the photographer's jargon. Yale Joel said, "In many instances, I take the pictures with the composition of the multiple print in mind. At other times, I merely come across a couple of negatives in the file that suggest interesting possibilities for combination into one unit."

Even after the multiple print has been planned, further preparation is necessary—principally to get around the fact that the photographer cannot see the images actually in combination until the print is all finished. After the first negative is printed, therefore, the partly exposed paper is set aside—undeveloped, its image invisible—while the second negative is readied for printing. The second print will be made on the same (apparently blank) sheet, without interfering with the latent image already there. Since visual adjustments of the two images are impossible, it is necessary to make a diagram that will show where on the sheet the separate images are to fall and that will indicate which part of the sheet to expose and which to shield from exposure at each succeeding step.

This procedure sounds more complicated than it is. The diagram is merely a tracing of the images projected by the enlarger. It serves as a guide in making masks to shield one part of the printing paper while exposing another part. If the steps outlined on the following pages are followed in sequence, multiple printing can be accomplished simply, and becomes a rewarding avenue to good picturemaking.

After he has determined the correct exposure for the skyscraper negative with a test print, Joel makes a print of the skyscrapers on a fresh piece of paper.

Joel marks the back of the print with a soft grease pencil to indicate the top of the scene. He stores the undeveloped print in a light-tight box.

With the first negative still in the enlarger, Joel places on the easel a piece of ordinary, nonsensitized paper and traces on it the projected outline of the skyscrapers.

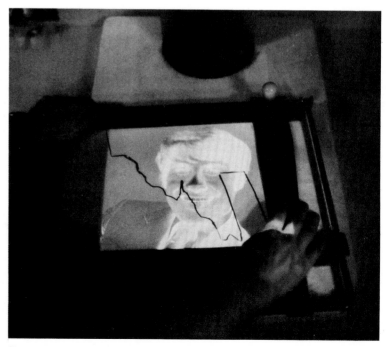

The negative of the man's head is put in the enlarger and projected onto the tracing. Joel adjusts the enlarger head and easel until the image falls where he wants it.

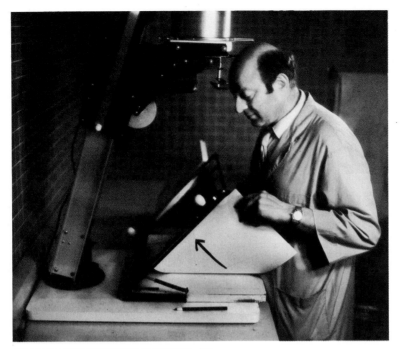

After making a test print of the second negative, Joel takes out the exposed but undeveloped skyscraper print. The marked arrow indicates its position on the easel.

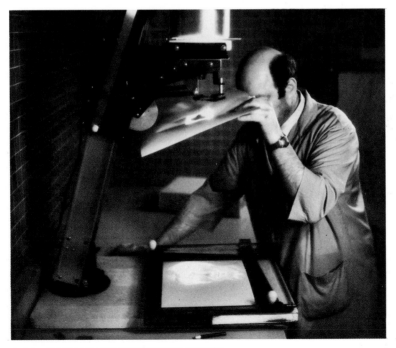

A piece of cardboard with a small hole masks all but the man's face as Joel prints the second image. The mask is moved slightly during exposure to blur the image outline.

After the second exposure, the print is developed and the multiple picture appears: The images are distinct but overlap slightly.

A Subtle Blend of Unexpected Elements

A diver appears to emerge from the middle of a snowbank in the arresting image at right—startling in its realistic presentation of a scene that could not possibly exist. Unlike the composite print that has been reproduced on page 175, in which overlapping forms are tolerated, a print such as this one must hide all evidence of manipulation to be successful.

The scuba diver was put into the snow by a form of multiple printing that requires a special masking technique and negatives that have compatible images. The subjects of both pictures must have been shot from about the same angle and illuminated with light of comparable intensity coming from about the same direction. Otherwise, the images will fail to blend convincingly.

In the picture at right, this blending was accomplished with two printing exposures and two masks, one mask the reverse of the other. For the first exposure the mask was a cutout in the shape of the diver. It was used to dodge part of the background so that a blank space would be left in the background print. For the second exposure, the mask was the paper from which the first mask had been cut. It was used to burn in only the image of the diver's head. When these operations are as carefully done as they were by Yale Joel, no darkroom legerdemain will be revealed, and the final print conjures up a world that never was—and never could be.

After making a test print of the background snow scene to determine proper exposure, Joel traces the outline of the snow scene on ordinary, nonsensitized paper (as on page 176). He then marks the position of the enlarger head with a piece of tape on the enlarger column, inserts the second negative and moves the enlarger head to position the diver's image correctly. He marks this second position on the enlarger column and makes a test print of the diver.

To make his first mask—a cutout in the shape of the diver's head—Joel focuses the image of the diver on the top of a box whose height is equal to about one half the distance between the easel and the enlarger lamp. This point is approximately the position at which the mask will be held during the first exposure, when Joel must keep blank the area that will later receive the diver's image.

Rather than merely sketch the outline of the diver
for the mask, Joel makes a print of the diver negative
on paper placed on top of the box. This print will
give him an exact outline for his mask.

He carefully cuts the diver out of the print to form
the first mask. Next, he will cut a piece of backing in
the identical shape from the middle of a sheet
of thin cardboard to give the mask extra support.

Joel uses a wire coat hanger to support the cutout mask of the diver above the easel. He tapes the cutout to one end of the hanger and bends the wire so that it will suspend the mask at the proper height but will project over as little of the background image as possible.

He tapes the free end of the hanger securely to the enlarger head. With the enlarger lamp on and the sketch of the snow scene on the easel, he carefully positions the mask, using a pair of long-nose pliers to make fine adjustments.

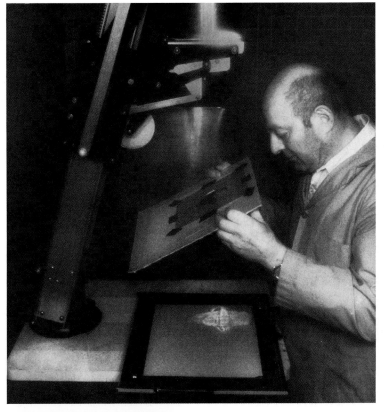

With the mask in place, Joel proceeds to print the negative of the snow scene. During an exposure of 18 seconds at f/8, he taps the wire to make the mask quiver, thus blurring its outline and keeping sharp divisions from appearing in the print. After exposure, he draws an arrow on the back of the paper with a grease pencil to indicate the top of the print, then puts the paper in a light-tight box.

For the second exposure, Joel uses a reverse mask, the cardboard from which the diver's silhouette was cut. For extra support, he has taped it to a sheet of cardboard. He puts the negative of the diver back in the enlarger and positions the enlarger head, using the second mark he made on the column. He then prints the diver image for 15 seconds at f/8 onto the sheet retrieved from the light-tight box, holding the reverse mask to block out everything but the diver. He jiggles the mask slightly to blend the borders of the two images.

After the second exposure the print is developed. The overlapping elements in the two pictures have been successfully masked out and the diver is seen surfacing in a snowy suburban backyard.

Gum Prints: Coating Colors by Hand

The technique that turned the black-and-white cityscape at right into the richly colored design on the opposite page is known as gum printing. Much favored around the turn of the century, gum printing was revived during the 1980s by photographers who prized its soft tones and the control it gives over shading. Black-and-white negatives can be gum printed in any color or, with repeated printings, in several different colors, and images from several negatives can be superimposed on a single print. To create the picture on the opposite page, Yale Joel used a single negative, but he needed five separate exposures and five coatings of gum-bichromate emulsion.

A viscous and light-sensitive material, gum-bichromate responds to light rays not by darkening, as silver compounds do, but by hardening, the degree of hardening being determined by the amount of light striking any given area. Before exposure the substance is dyed with watercolor pigment. After exposure the print is simply washed thoroughly in water and the still-soluble parts of the emulsion—those not exposed to light—are washed away. The image remains, a sort of bas-relief in a hardened jelly.

Since no gum-bichromate printing paper is available commercially, the photographer must prepare his own. Most gum printers start with artists' watercolor paper because it holds up well through the repeated soaking that the process requires. To ensure that the paper size and shape will not change after printing begins, they preshrink the material by immersing it in very hot water for 10 or 15 minutes and then hang it up to dry.

Though most watercolor paper is sized by the manufacturer—treated to control absorbency—additional sizing is advisable to make sure that pigments remain on the surface of the paper and do not penetrate the fibers, where they cannot be washed out during development and may stain the finished print. A light application of household spray starch serves well as sizing.

Once the paper has been prepared, it must be coated with homemade emulsion: a mixture of potassium dichromate (the sensitizing agent), gum arabic and pigment. For multicolored prints, a separate emulsion is prepared for each color, and even for single-color prints two or more coatings of emulsion are commonly used. After an exposure, the print is developed and dried before the next emulsion is applied.

Compared with ordinary photographic emulsions, gum-bichromate is relatively insensitive to light. Exposures must be long—from a few minutes to a few hours, depending on how much potassium dichromate sensitizer is in the emulsion mixture and on the type of illumination; a powerful light source—sun lamp, photoflood or the sun itself—is needed. No enlarger light is bright enough to harden the emulsion in a reasonable length of time.

Only contact prints can be made, for to produce display-sized prints, large negatives must be made with sheet film in a view camera or by enlarging small negatives onto special duplicating film *(page 187)*. The image itself should be one with prominent shapes, for multiple printings generally obscure fine details.

To aid in aligning negative and print for multiple exposures, a light box like the one described on page 192 is useful.

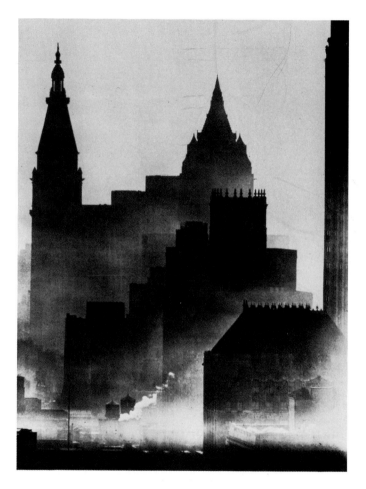

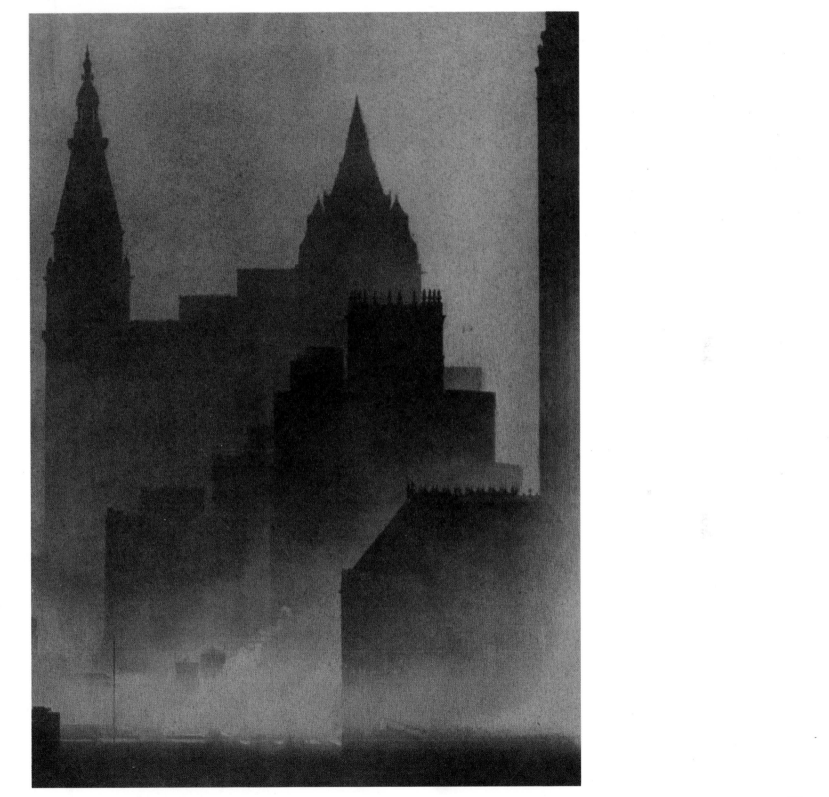

Most chemicals and equipment needed for gum-bichromate printing can be found at photographic, art, drug or hardware stores. But gum arabic is available only from art stores that carry supplies for lithography and etching.

The gum arabic is easier to use if purchased in liquid form rather than as a powder, which must be mixed. The liquid is sold in several grades of viscosity, designated in degrees Baumé; bichromate printing requires gum arabic of viscosity between 12° and 14° Baumé.

Several kinds of more commonly available artists' supplies are also needed. The paper should be 100 per cent rag paper of the sort used for watercolors. It should have a slightly rough or toothy surface and should be an inch or two larger on each side than the negative to be printed on it. The pigments are standard artists' watercolors in tubes (27). Three brushes are used: a fan brush (7), a wide polyfoam brush (6) and a small artists' brush (19).

A standard 275-watt sun lamp (8)—together with protective goggles (5)—will be needed for exposing the print. Also necessary are plastic gloves (28), which must be used when handling the sensitizer, potassium dichromate (13); they are also advisable when working with other chemicals involved—some can irritate the skin.

The potassium dichromate and sodium bisulfite (11), which clears the final print of any trace of sensitizer, are available from large camera stores. This source can also supply the special duplicating film, Kodak SO-015 (3), needed to make enlargements of small negatives, as well as a balance (21) that can accurately weigh pigment to within .1 gram (approximately .0033 ounce).

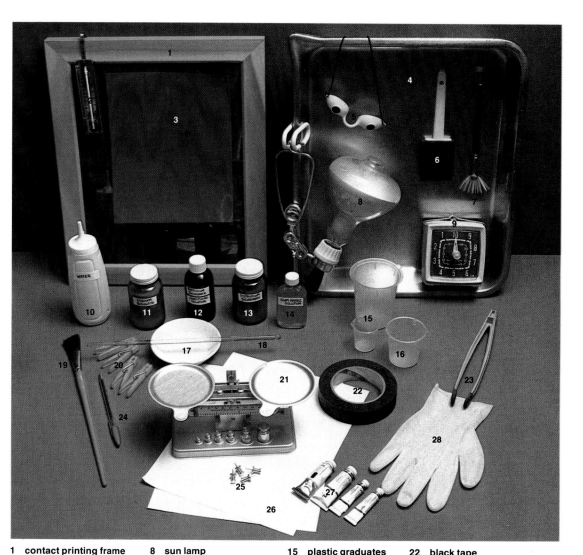

1	contact printing frame	8	sun lamp	15	plastic graduates	22	black tape
2	thermometer	9	timer	16	measuring cup	23	tongs
3	duplicating film	10	plastic bottle	17	mixing dish	24	ball-point pen
4	processing tray	11	sodium bisulfite	18	stirring rod	25	pushpins
5	goggles	12	sensitizing solution	19	watercolor brush	26	watercolor paper
6	polyfoam brush	13	potassium dichromate	20	clothespins	27	watercolor pigments
7	fan brush	14	gum-arabic solution	21	balance	28	plastic gloves

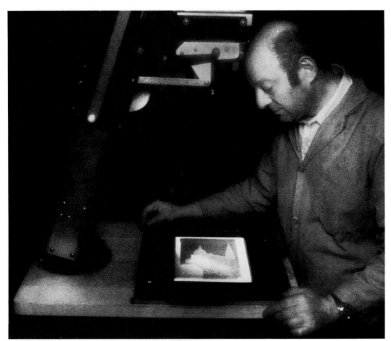

Joel makes an 8 x 10 negative for contact printing by enlarging his 35mm original onto an 8 x 10 sheet of Kodak SO-015 reversal film that produces another negative with no intermediate positive. This film is processed just as an ordinary print would be.

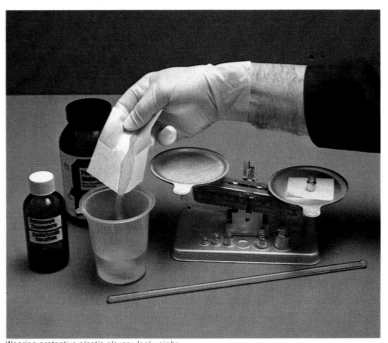

Wearing protective plastic gloves, Joel weighs out 11.7 grams (.4 ounces) of potassium dichromate crystals for the emulsion and pours them into a graduate containing three fluid ounces of warm water. Then he stirs the mixture until all crystals dissolve—20 minutes may be needed. The solution is now sensitive to ultraviolet light and must be placed in a protective brown bottle.

After pouring .7 fluid ounces of gum-arabic solution into
a plastic graduate, Joel weighs out 1.2 grams (.04 ounces)
of blue pigment on the laboratory balance.

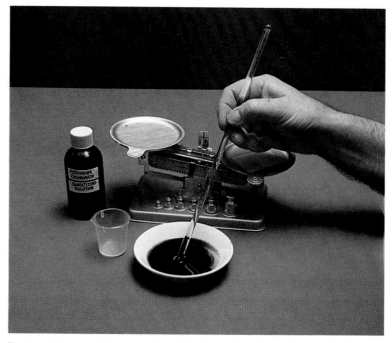

The pigment is mixed with the gum-arabic solution in a
small dish. Pigment concentrations can be varied to create
the density of color desired.

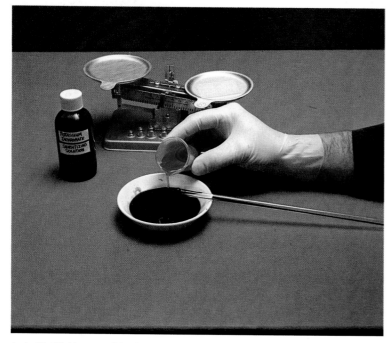

Joel adds .7 fluid ounces of the dichromate sensitizer to
the pigment-gum mixture. The sensitizer's orange color will
wash out during the remaining processing steps.

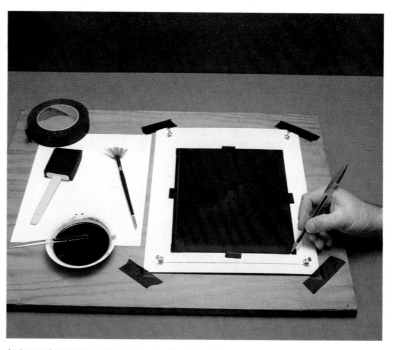

Joel tapes the negative to his paper and, with a ball-point
pen, marks its corners to help him position the negative for
each exposure. He then removes the negative.

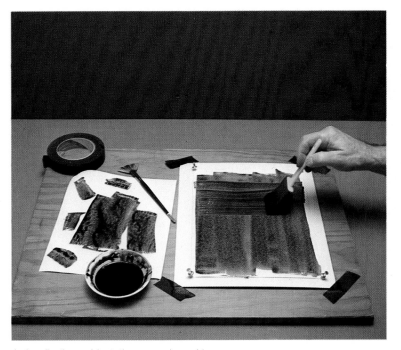

Joel applies the emulsion to the paper, using a wide
polyfoam brush to ensure an even coating. The mix gets
sticky in about 45 seconds, so he works fast.

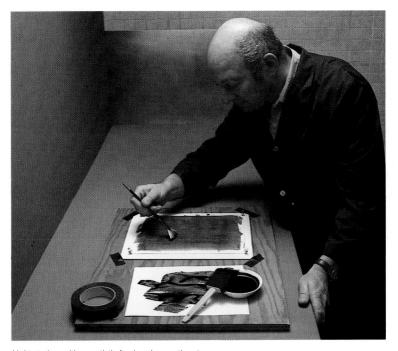

Light strokes with an artist's fan brush smooth out any
irregularities in the coating. Joel places the coated paper in
the dark for an hour to dry.

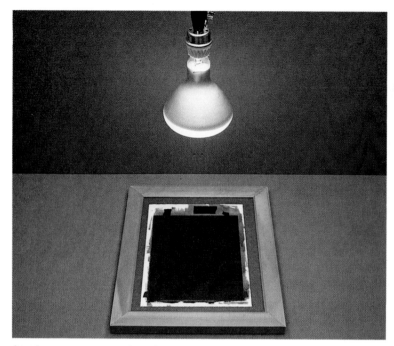

A sun lamp exposes paper and negative, taped together with emulsions facing in a printing frame. Tape outside the image area gives an unexposed strip for comparison.

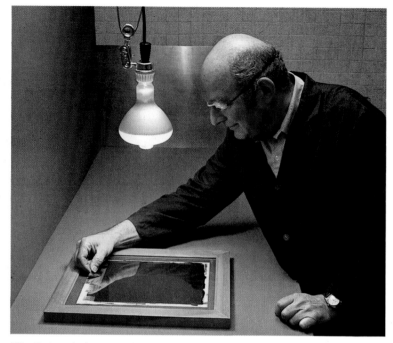

Lifting the tape, Joel compares the color underneath with that around it. When the surrounding area is substantially darker, exposure is about complete.

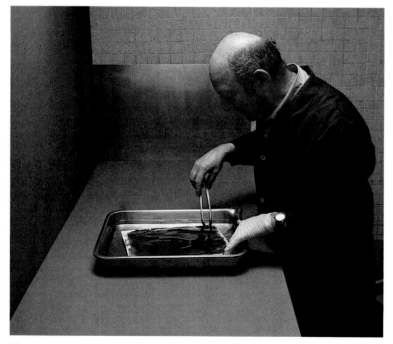

After an exposure of 10 minutes, the print is removed from the contact printing frame and inserted, face up, into a tray of 70° F. tap water. The paper quickly becomes limp.

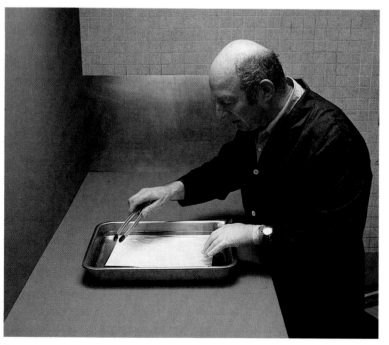

Five seconds later, Joel turns the print over so that unexposed emulsion does not settle on the image surface. The emulsion is now extremely soft.

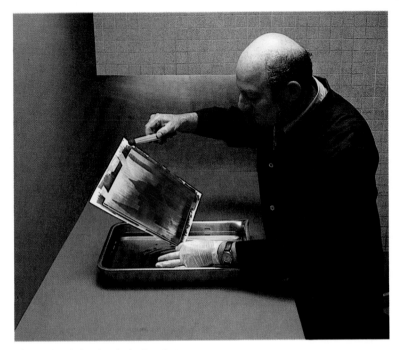

After gently agitating the print for five minutes,
Joel examines it to see if detail is clear in the highlights.

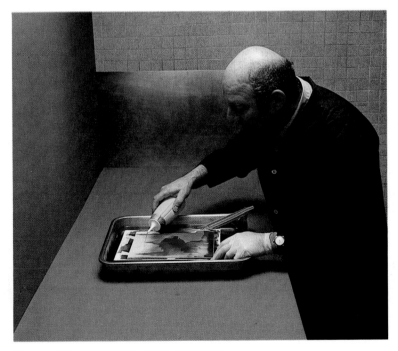

When overall development is satisfactory, Joel lightens
certain highlights by squeezing water on them from a plastic
bottle. Brushing the areas would serve the same purpose.

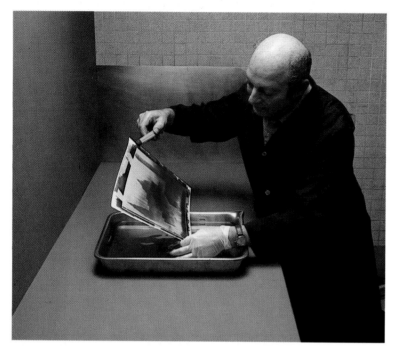

When development is complete, Joel removes the print from the water and hangs it up to dry before applying another coating of emulsion.

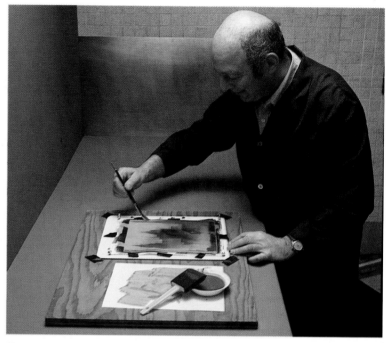

When the print is dry, Joel applies an emulsion coat of burnt umber, prepared in the same way as the blue emulsion, for a second exposure.

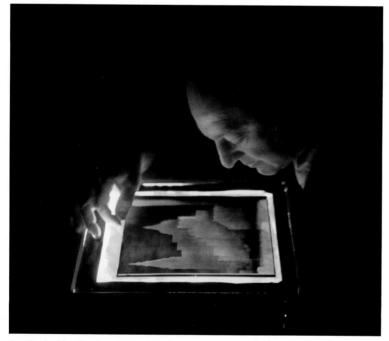

Double-checking that the print and the negative are in exactly the same position, Joel uses an improvised lightbox. He repeats these steps for each exposure.

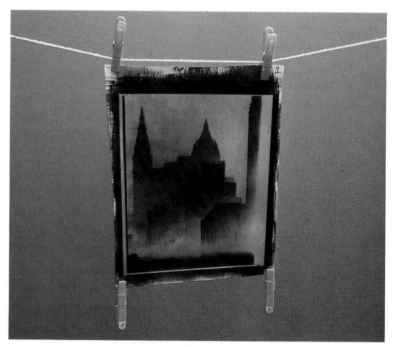

The completed print is bathed for 5 minutes in a 5 per cent sodium bisulfite solution to remove any traces of orange dichromate. Finally, it is washed for 15 minutes and dried.

The Cult of the Absurd 196

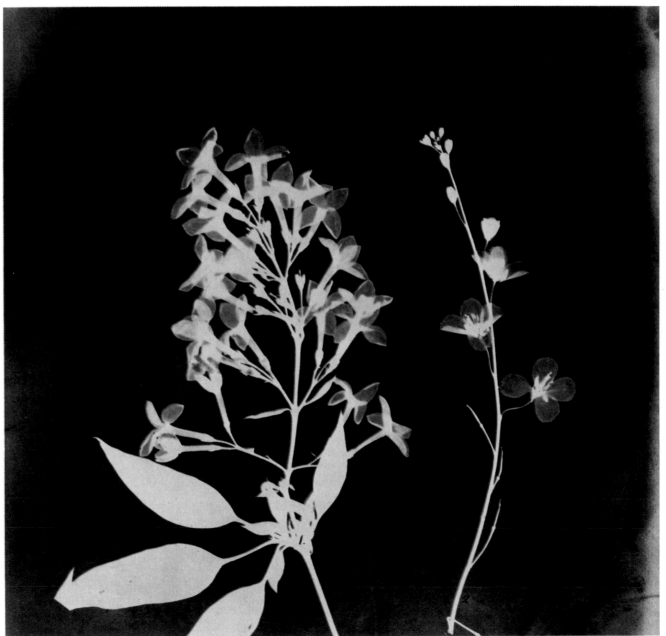

WILLIAM HENRY FOX TALBOT: *Cameraless shadow picture of field flowers,* 1839

The Cult of the Absurd

The shattering impact of World War I had a profound effect on photography. For more than half a century photographers had concentrated on picturing the appearance of the world about them—not always as a literal copy, but generally as a recognizable one. Now the horrors of the War made appearances seem meaningless and put traditional ways of viewing the world into question. A few daring photographers sought to express their doubts by creating prints that ignored the real world. Some were simply shadows, flat, featureless, often blurred *(page 209)*. Others reversed the normal tones of images, substituting black for white, or combined several seemingly unrelated images in a single print *(pages 199, 209)*. Such transformations of the print were not actually new, for they had often been produced in experiments or as tricks. But during and after World War I the transformed print became far more than an amusement. In the hands of such talented practitioners as John Heartfield, Man Ray and László Moholy-Nagy it evolved into a new form of photography, an art of its own.

Heartfield, Ray and Moholy-Nagy all started out as painters, emerging from the international community of artists that, in the first quarter of the 20th Century, altered forever man's view of himself. Their photographic approach grew out of the wild experimentation that was then causing a reassessment of traditional concepts of art, principally in two lively movements centered in Germany, Switzerland and France: Dada and Surrealism.

To the general public, the works of both of these movements seemed ridiculous—one artist copied the *Mona Lisa,* but added a mustache and goatee; another showed a tiny castle on a big rock in mid-air. To many artists, however, they showed how pictures that broke up, distorted and rearranged the images of the real world could reveal more about that world than could straightforward reproduction.

Dada was a wacky footnote to the history of man's efforts to convey his ideas. A philosophy rather than simply an art movement, it spawned poems and stage shows as well as paintings and photographic prints. Even the name of the movement was absurd (a French child's word for hobbyhorse, it was picked from a dictionary because, one Dadaist explained, "the child's first sound expresses the primitiveness, the beginning at zero, the new in our art"). Dada's aim, however, was clear and purposeful—an expression of outrage at the senseless horrors of World War I.

In 1914 the gilded and complacent civilization of Europe had gone up in flames. Kings and statesmen who had played at diplomacy as though it were a game of chess suddenly found that their delicately balanced power structure, their gentlemanly assurances of an approaching millennium of well-being for all people, had been a terrible self-deception. The orderly chessboard of nations was transformed into a quagmire of mud and blood. In

the first year of the War, half of the families in France lost a husband, a brother or a son. Artillery blasted the lovely countryside into a smoking wasteland. Tanks rumbled across the devastated farms and poison gas was carried on the breeze. On the home front, posters continued to trumpet the old themes of glory, bravery and national greatness, but they sounded increasingly hollow with every passing month.

The irrationality of the War revolted artists in Europe and drove some of them to seek neutral ground in Zurich, Switzerland. But they were not running away; they were looking for a means of expression appropriate to an age of insanity, and they found it in Dada. "Our work had, from the very beginning," recalled one of the first members of the group, "an antimilitaristic, revolutionary tendency. Friends came to visit from the various belligerents — from Italy . . . from Paris . . . from Germany. All of them loathed the senseless systematic massacre of modern warfare." At first this loathing was expressed in a theater of the absurd in a Zurich inn, where in 1916 the Cabaret Voltaire was founded by the German poet Hugo Ball. As Ball put it in his diary, "Our cabaret is a gesture. Every word spoken or sung here says at least one thing, that these humiliating times have not succeeded in wresting respect from us."

The words spoken or sung hardly even qualified as language, in the ordinary sense. Several texts or poems would be read simultaneously; plain noise was sometimes presented as music; weird dances were performed to the accompaniment of someone banging on a tin can or yapping like a dog.

The performers shouted obscenities at the audiences. They invented "static poems," which consisted of large printed cards placed on chairs and changed every so often. They created nonsense verses, such as: "indigo indigo/ streetcar sleeping-bag/ bedbug and flea/ indigo indigai/ umbaliska/ bumm Dadai." One Dada poet, Tristan Tzara, wrote a work called "Roar," which was simply the word "roar" repeated 147 times. Public reaction was predictable. During the intermission of one performance, the audience went to a nearby food market and bought missiles, which they proceeded to use. A member of the group later wrote proudly: "For the first time in the history of the world, people threw at us not only eggs, salads, and pennies, but beefsteaks as well. . . . The audience were extremely Dadaist."

Photography was a tempting medium for Dada, simply because it ordinarily portrayed the surface reality the Dadaists sought to ridicule. The challenge to twist its images to serve the nonrealistic ends of Dada was irresistible. John Heartfield first met this challenge with the multiple-image prints that came to be called photomontage (pages 174-183). Heartfield started with individual prints from each negative, cut them up, pasted them onto a backing (or held them down under a sheet of glass), and then rephotographed the

assemblage. This composite negative gave a print of its own that, especially when retouched by hand, could be made to look as if it came from a single camera shot—even though the component parts of the picture shouted out that something was wrong. Such trick prints have been made since photography was invented. Often they were passed off as accurate records of reality to pursue some political end. During the Second Empire in France, opponents of the government circulated a picture that ostensibly showed Empress Eugénie in the nude; actually it was her face pasted onto someone else's body. Another scurrilous montage had the Pope appearing in a Freemason's costume. No such fraudulent aim was served by the Dada photomontages that Heartfield introduced. They sought simply to explode the conventional logic of vision.

Heartfield had been born in Berlin in 1891 as Helmut Herzfelde, and the way his name came to be changed says much about his character: He switched to an Anglicized version to demonstrate his opposition to the Kaiser's policies. His antimilitarism did not prevent the German Army from drafting him. (After demobilization, he continued to wear his uniform, but he allowed it to become dirty and ragged in order to "dishonor" it.) It was during the War that photomontage came to be developed out of necessity. Heartfield and a fellow artist, George Grosz, began to exchange postcards on which were pasted odd scraps from advertising illustrations, picture magazines, labels and fragments of printed words. Such jumbled commentary on the chaos of the times could get through the censors of the mail more easily than logical prose. These postcards—collage rather than photomontage, because the result was a pasted-up assemblage rather than a photographic print—were to set the course of Heartfield's career.

Back in Berlin, he became a leader among Dada artists, and the technique for evading censorship matured into a versatile medium of expression. He began to employ his cut-up designs for book jackets, calendar pictures, the covers of Left-Wing magazines, stage sets and wall posters, which were pasted up along the streets of the city. His friend Grosz pronounced him, with mock pretentiousness, a *monteur* (French for builder), and by extension his creations became photomontages, the term that has endured.

John Heartfield was particularly effective at photomontage not because he was so good with a camera—he never took a picture himself—but because he possessed great imagination as a designer and an encyclopedic memory for images he had seen in newspapers and magazines. Many of the ingredients of his prints were cut directly from these sources, but if he wanted a certain kind of picture that was not available, he would have a friend go out and shoot it for him. He had little trouble in getting assistance in his endeavors because everyone recognized him as a genius. Although he was

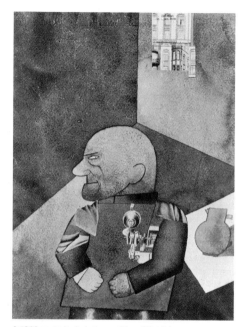

A 1920 portrait of photographic satirist John Heartfield by his friend George Grosz shows the short, determined artist in the tattered German Army tunic that he continued to wear for years after he was demobilized in 1916—its scruffy state proclaiming his contempt for everything related to militarism. Grosz gave Heartfield's type of print its name; he called Heartfield a builder or assembler—"monteur" in French and German—and a photographic collage like those shown at right came to be called a photomontage.

Photomontage, the combining of images of several photographs into a single print, became in the hands of German artist John Heartfield a powerful new weapon of political satire — which he courageously raised against the rise of Nazism in the '20s and '30s. He was not a photographer himself, relying for the raw material of his art on picture agencies, clippings from newspapers and periodicals, and occasionally asking a photographer friend to execute a particular shot that he could find nowhere else. After these snippets of images were pasted up, they were rephotographed to become book covers, wall posters or magazine illustrations. In the two top prints at the right Heartfield combines money with Hitler to attack the rich German capitalist industrialists who backed Nazism. The man in the Nazi uniform in the lower left, printed to appear standing over a bloody corpse, is Julius Streicher, whose promotion of racism is suggested in the title's quotation of a poem by the playwright Bertolt Brecht, a close friend of Heartfield's. The church in the fourth picture is built up from several prints of a photograph of a cannon shell, a satirical monument to the military-industrial forces that Heartfield opposed.

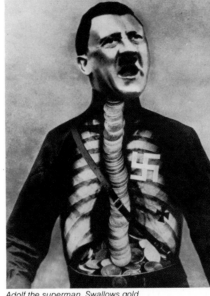

Adolf the superman. Swallows gold and spouts junk, 1932

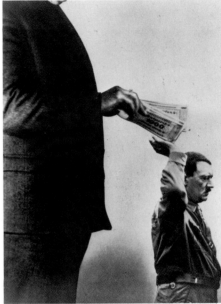

Millions stand behind me. The meaning of the Hitler salute, 1932

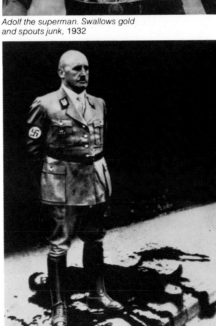

A Pan-German. 'The womb is fruitful yet from which he crept,' 1933

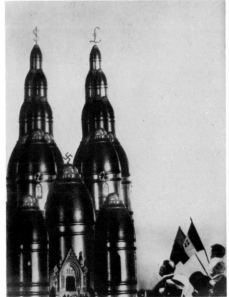

Hymn to the forces of yesterday: We pray to the power of the bomb, 1934

only a bit over five feet in height, he possessed the energy of a giant; his effervescent personality and great talents attracted many followers from the lively colony of artists then working in Berlin. One of his helpers later described how Heartfield worked: "The photographs which I made for Heartfield, in accordance with an exact pencil sketch . . . often took hours, many hours. . . . In the darkroom he would stand by the enlarger until the prints were ready. I was generally so tired that I could no longer stand or think; all I wanted was sleep. But he hurried home with the photos still damp, dried them, cut them out, and assembled them under a heavy sheet of glass. Then he would sleep for one or two hours, and at eight in the morning he would be sitting with the retoucher. There he would stay for two, three, four or five hours, always fearing that the retouching would spoil it. Then the photomontage is finished, but there is not much relaxation: new tasks, new ideas. He burrows in the photo-libraries for hours, for days. . . ."

The early photomontages had been made up of fragments of almost anything—not just pictures but bits of headlines and text as well—put together to suggest absurdity in the best Dada tradition. They emphasized chance and odd juxtaposition, and they attacked rationality with the very imagery by which rationality was usually expressed. The goal—as Heartfield's brother later put it—was "to present disorder as the principle of bourgeois order." But later compositions dispensed with printed matter, using only pictures, and also lost their apparent irrationality. By the late '20s the juxtaposition of images was still absurd, but it conveyed a clear message—a political one. Heartfield was no longer content to mock the militarism and totalitarianism that was brewing in Germany. He attacked it directly.

His photographic invective was devastating. In one photomontage, he created a print in which a church seemed to be made out of bombs (page 199). As the brutal policies of the burgeoning Nazi movement gained followers, he showed German judges taking the shape of swastikas. In still another bitter photomontage, he joined one photograph of a bloodied murder victim with a second photograph of a German officer to produce a print showing the officer standing on the corpse of the victim.

No one else could create images that were quite so horrifying. Cemeteries, skulls, bayonets, piles of coins and snakes were combined in fiercely accusing compositions. Because of his pictorial attacks on the Nazis, Heartfield had to flee his homeland soon after they came into power, but he continued to work at photomontage until his death in 1968.

In his use of bizarre images to suggest a reality beyond that normally seen, Heartfield was exploiting the precepts of Dada's successor art movement, Surrealism, a style well suited to photomontage. Surrealism sought to create a super meaning, based on the workings of the unconscious. It was largely

inspired by Sigmund Freud's exploration of the urges that lurked below the rational levels of the mind. In the words of André Breton, the principal spokesman for the movement, Surrealism was an attempt to find "the future resolution of these two states, dream and reality, which are seemingly so contradictory, into a kind of absolute reality, a surreality, so to speak."

The Surrealists' techniques were as strange as those of Dada. To free themselves from the chains of conscious reason, they shut themselves up in dark rooms and wrote down all the words or images that flickered through their minds. They wrote or drew pictures while under hypnosis. Sometimes several artists would collaborate in the creation of what they called "exquisite corpses": Each person drew on a piece of paper, folded it so that the next man could not see what had been done and handed it on for additions.

Among the Surrealists who seized upon photomontage as a medium, one of the most inventive was Max Ernst. Like Heartfield he had been a member of the Dada group (and like Heartfield he was a thoroughly rebellious spirit — he had been courtmartialed several times for insurbordination while serving in an artillery unit in the German army). Ernst collected photographs and took some himself, then combined them with printed matter, engravings and his own painting. "It is now possible," he wrote, "to [illustrate] the amazing graphic appearances of thoughts and desires." Breton agreed, saying that Ernst had achieved "a true photography of thought." Thus, in one Ernst creation, classical nudes appear amidst ordinary city dwellers; in another, two strange columnar shapes seem to grow in a stark, rocky landscape. Following Ernst's lead, Surrealists photographed such incongruous photographic images as a rotting donkey's head on a grand piano, or a man who seemed to be wiping his mouth off his face.

While Heartfield and Ernst were exploring the potential of the photomontage, their fellow artists were trying other techniques of transforming the photographic print. For example, shadow pictures, now called photograms, were made as early as 1916 by a Dada pioneer, Christian Schad, who produced abstract designs by laying objects on sensitized paper and exposing it to light. Such pictures, made without a camera, had been produced by early experimenters, including modern photography's inventor, William Henry Fox Talbot *(page 195),* but this did not deter Schad from naming them after himself — Schadographs (an unintentional pun, since the German Schad knew no English). Yet it remained for an American to exploit the full range of printing effects: multiple exposures, photograms, distorted enlargements, reversed tones and their many variations.

Philadelphia-born Man Ray, one of the most versatile and imaginative of modern photographers, seemed to have been destined for Dada. Even shorter (five feet) than the diminutive Heartfield and absolutely irrepressible, he

came to be called the court jester of modern art. In 1916 he produced an odd assemblage of hardware and graphic design that he called a self-portrait: it consisted mainly of two electrical bells, a push button not connected to either bell (or to anything else) and a hand-print by way of a signature. Several years later, he turned out one of the most memorable of all Dada works — a flatiron with a row of tacks glued to the bottom. Even his pseudonym was a put-on. He steadfastly refused to explain its significance, if any, or to acknowledge his real name. He once snapped at a persistent reporter, "My schoolmates frequently kidded me about my foreign name. My first name was Emmanuel and I changed it into 'Man.' My second name is nobody's business. If you are really that keen about it you can try and find out for yourselves." (Despite considerable digging, no one did find out until the artist's death in 1976 when the secret was revealed: His last name was Rudnitsky.) As a child he had made clear that he would shape the world to suit himself. At the age of seven, when he produced a crayon drawing of the battleship *Maine,* he used every color in the box. Told that it did not look real, he said that since the newspaper picture he had for a model was in black and white, he was free to follow his imagination.

Although he was a poor boy, son of an immigrant laborer, his talent for drawing was admired by his high-school teachers, and they helped him get a scholarship to Columbia University to study architecture. He turned it down. He worked as a commercial artist by day and studied painting at night. And he also began to frequent 291, Alfred Stieglitz' gallery for the avant-garde in photography and other forms of art *(Chapter 1).* A meeting with Marcel Duchamp, a French Dadaist then residing in New York, helped to focus his outlook on life. Duchamp was one of the most playful spirits in the art world, and he and Man Ray hit it off immediately — even though they did not speak each other's language. They ignored the language problem, improvising a game of tennis without a ball and calling scores back and forth by way of making conversation, each in his own tongue.

In 1921 Man Ray joined the flood of American expatriates going to Paris. He arrived in France on Bastille Day, carrying, among other things a work called "New York 1920" — a jar filled with ball bearings in oil. Five months after his arrival in Paris, he had his first show. In the announcement he wrote, "Monsieur Ray is incommunicado. After having been successively a coal dealer, a millionaire several times and chairman of the chewing gum trust, he decided to accept the invitation of the Dadaists and to exhibit his latest canvas in Paris." One creation was a photograph of an eye attached to a metronome with a paper clip.

If Man Ray could be said to have a profession, it was that of photographer. He had acquired his first camera back in 1916 to reproduce his paintings for a catalogue. To earn a living in Paris, he offered to perform the same service

CHRISTIAN SCHAD: *Schadograph,* 1918

Using a safelight and printing paper, the German painter Christian Schad produced photographic abstractions by arranging on printing paper scraps of newspapers (upper left), bits of string and any other relatively flat objects that struck his fancy, and then exposing the composition to a bright light. Such cameraless photograms, called Schadographs, were among the first of the transformed prints that signaled a wave of photographic experimentation after World War I.

for fellow artists. "I had to get money to paint," he later said. "If I'd had the nerve, I'd have become a thief or a gangster, but since I didn't, I became a photographer." He became an exceedingly good one. Celebrities ranging from the Aga Khan to Ernest Hemingway sat for him. Soon French fashion magazines, as well as *Vogue, Harper's Bazaar* and *Vanity Fair* in America, were after him for contributions to their pages, and he no longer had to worry about where the next meal would come from. He eventually compiled one of the most brilliant and complete photographic records of the personalities who made Paris the world's cultural center in the '20s and '30s.

While many of the pictures were straightforward portraits, some involved unorthodox transformation of the prints. One of the most famous is a study of his mistress, Kiki *(page 204)*. The picture turned out to be a kind of girl-violin hybrid, for when Man Ray noticed the similarity between Kiki's shape and that of a violin, he capitalized on the resemblance by painting a violin's "f-hole" sound openings on the print.

Such photographic daring brought him more and more clients, and improvisation became his trademark. He had no compunction about charging the Marquise Casati a stiff fee for a portrait so blurred by movement that she appeared to have three pairs of eyes (she liked it so much she ordered dozens of prints). He once forgot to take his camera lens when he had to photograph the great Matisse. Rather than return to his studio, he simply taped a spectacle lens to the camera; for a shutter he used the black cloth that normally shielded the ground-glass focusing screen from light. On another occasion, he shot a racing car at 1/1000 second to freeze its motion, but when the film was developed he decided the picture looked too static. During printing, he tilted the enlarging easel, giving the car a blurred, stretched-out appearance that suggested its speed.

With photographic equipment, Man Ray was irrepressibly experimental. He bought a movie camera for amusement during a holiday and filmed the countryside from a car traveling at 80 miles an hour. The car had to come to a sudden stop when a herd of sheep crossed the road — and Man Ray suddenly had an idea for creating a photographic impression of a collision. He got out of the car, started the movie camera, then threw it 30 feet up into the air and caught it again. The resulting film showed a dizzying swirl of landscape and sky, as if the observer were tumbling through the air himself.

Later in life, he wrote, "A certain amount of contempt for the material employed to express an idea is indispensable to the purest realization of the idea." He so emphasized this casual approach that he tried to make it seem that some of his most significant innovations were only accidents. This, for example, is his description of the discovery (or rediscovery) of the technique for reversing a picture's tones, black for white: "One day in the darkroom I

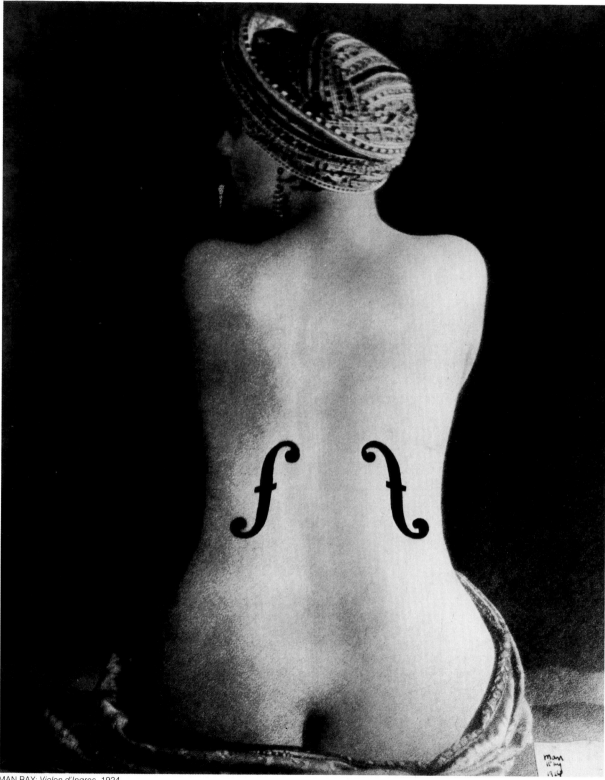

MAN RAY: *Violon d'Ingres*, 1924
204

Man Ray's own favorite among the pictures he transformed during printing is a study of his one-time mistress, Kiki, the famed Parisian model of the '20s (opposite). Like many of his works it combines outlandish ideas to make a sophisticated in joke. The shape of Kiki's bare back suggests a violin, so Ray painted a violin's f-shaped sound holes in the appropriate places on the print. The pose recalls the nudes painted by the 19th Century French artist Ingres. And the punning title suggests Ray's whimsical intent: "Violon d'Ingres" literally means Ingres' violin, but—because Ingres was an amateur violinist—the phrase has become French slang for someone's hobby.

was developing some portraits which were not especially important and after a few minutes turned on the white light to examine them more easily and see if I had properly judged the time. I then leisurely stuck the negative into the hypo and was astonished the following day on re-examining the negatives to see that they were partially reversed with a clear zone which would form a black line separating the most contrasting values."

This process, most often used on prints rather than negatives, is usually called solarization although it is more accurately termed the Sabattier effect, after the French scientist Armand Sabattier, who discovered it *(pages 166-169)*. To solarize a print, it is partially developed, but not fixed. It is then exposed to white light before development is continued. The highlights of the picture are unaffected by the first development, whereas the shadow areas are at least partly developed during the first stage. The second development makes the shadows of the print become even darker and the highlights become varying shades of gray. The partial reversal produced by this method gives images an eerie, sometimes nightmarish quality. The results he obtained so intrigued Man Ray that subsequently he solarized many of his portraits and still lifes.

Encouraged by his experience with solarization, Ray experimented further with printing, trying, he claimed, "to provoke accidents, examine the results closely and utilize them with more or less control." One day he placed a sheet of unexposed printing paper in his developing tray. He placed a small glass funnel, a graduate and a thermometer on the paper and then turned on the light. "Before my eyes, an image began to form, not quite a simple silhouette of the objects as in a straight photograph, but distorted and refracted by the glass. . . ." With the egotism characteristic of many Dada artists, he called his photograms Rayographs. But they were unlike the Schadographs that Christian Schad had made with opaque objects and snips of paper, for Man Ray's photograms looked almost three dimensional.

Ray began to strew every sort of object on printing paper—bottles, scratched glass plates, beads, hairpins and chicken wire. Sometimes he exposed the print under a stationary light; on other occasions he played a flashlight over it for a few moments. The opaque objects made images with sharp contours; the translucent ones added a variety of textures. Floating in the void of the print, the images often had a strange beauty.

Later he applied his Rayograph technique to motion pictures. He described the process as follows: "Acquiring a roll of a hundred feet of film, I went into my darkroom and cut up the material into short lengths, pinning them down on the work table. On some strips I sprinkled salt and pepper, like a cook preparing a roast; on other strips I threw pins and thumbtacks at random, then turned on the white light for a second or two, as I had done for my

still Rayographs. Then I carefully lifted the film off the table, shaking off the debris, and developed it in my tanks." He spliced the lengths together to form a short subject that would run about three minutes. Entitled *The Return to Reason,* the film was presented in a theater for public viewing. "It looked like a snowstorm," wrote Ray, "with the flakes flying in all directions instead of falling, then suddenly becoming a field of daisies as if the snow had crystallized into flowers. This was followed by another sequence of huge white pins crisscrossing and revolving in an epileptic dance, then again by a lone thumbtack making desperate efforts to leave the screen. There was some grumbling in the audience, punctuated by a whistle or two." Then the film broke, not once, but twice. According to Man Ray's account, a riot ensued: "A cry for the lights arose, the theater lit up disclosing a group locked in a struggle preventing the participants from striking any blows. Small groups in other parts of the theater were seen, divided into two camps, engaged in similar activities. A group of police stationed outside in anticipation of trouble rushed in and succeeded in emptying the theater."

In the hands of the Dadaists and Surrealists the transformed print was undisciplined, its wildness deliberately employed to express either the external chaos of the world or the internal chaos of the individual. Heartfield used photomontage to attack the political tendencies of the times, Max Ernst used it to suggest the currents of the unconscious, and Man Ray used various sorts of transformed prints to expose the absurdities of convention. These artists lived for the emotions and regarded the intellect with wariness. It took a very different sort of photographic artist, László Moholy-Nagy, who stressed the analytical more than the emotional, to establish a rationale for the transformation of prints. While he employed the same techniques used by these other men—photomontage, photograms, solarization—his approach was an intellectual one.

Moholy-Nagy was born in 1895 in a small town in Hungary. His father ran up such gambling debts that the family lost its wheat farm; he then disappeared. Schoolmates teased László because his father had left his mother, and he endured what he later called a "silent childhood," but throughout these difficult years he nourished a sense of mission. In a note to his mother when he was 14, he wrote, "I shall be great and good—I promise—and if I don't fulfill this promise you may take my life." He grew up to be a tall, forceful, but inherently shy man. At the age of 19, he was called into the Austro-Hungarian Army and sent to the Russian front. Hospitalized in 1915 with what was then called shell shock, he made his first drawings.

He determined to become an artist and after the Armistice worked his way across Europe to Berlin as a letterer and sign painter. There, his theories about art began to take shape. He was deeply drawn to the abstract and also

to technology, which he saw as a liberating force that had to be expressed in art—and used in art. "Everyone is equal before the machine," he said. "There is no tradition in technology, no class-consciousness. Everybody can be the machine's master or its slave."

His conviction that art could be both mechanical and creative made the camera and the enlarger natural instruments to work with, but one of his early attempts to forge an alliance between creativity and technology employed, of all things, the telephone. He called the technique telephone art. He ruled off a paper in a graph-like pattern and had it delivered to the foreman of a paint factory. Then he telephoned the man and, referring to a color chart and the paper grid, told him where to place the paint for the picture. In this way Moholy-Nagy had separated the artist from physical contact with his art, interposing a machine that, he believed, guaranteed an objectivity otherwise impossible.

Moholy-Nagy's concern for the relationship between art and technology led him to a revlutionary school of design called the Bauhaus (literally "build house" in German). By embracing the industrial age with genuine enthusiasm, the students at the Bauhaus helped create the international style of the 20th Century, establishing enduring fashions for metal chairs, glass-walled skyscrapers, hard-edge paintings and the modern layout in magazines, newspapers and advertisements. Moholy-Nagy contributed to all of these fields—but his particular concern was photography.

Moholy-Nagy was a man who began at the beginning—and, in photography, this meant studying all the effects of light striking a light-sensitive material. The starting point was the shadow picture, to which he gave the name now commonly used, photogram. He spoke of it in the terms of science. "Cameraless pictures are . . . direct light diagrams recording the actions of lights over a period of time, that is the motion of light in space." The photogram, he said, "is the real key to photography." It had no real relationship to subject matter. Its only content was the elements of its design, the play of light in space. Where Man Ray had sought to unhinge reality with photograms, Moholy-Nagy was not trying to prove anything; he was simply utilizing light and film to make beauty.

The photogram remained his first love, because it was "the most completely dematerialized medium which the new vision commands." But he was interested in every aspect of photography. He experimented with fast shutter speeds and long time exposures, X-ray photography and photomontage, because these too were expressions of the language of light. He showed how exciting and unexpected patterns could be extracted from the world with an ordinary camera, simply by taking pictures from a bird's-eye or worm's-eye view *(page 208)*. Fascinated by the black-for-white reversal of

reality in the negative, he made prints in which negative and positive views were shown side by side—two parts that form a whole. He also produced a beautiful abstract motion picture called *Lightplay Black-White-Gray*. Filmed long before anyone thought of psychedelic light shows, it pictured a light-display machine having various surfaces—some opaque, some transparent, some brilliantly reflecting—as they were moved about by an electric motor. The viewer received an impression of pure form and light in motion, growing, fading, shifting into new shapes and rhythms.

Most of this experimentation took place during the '20s, when Paris and Berlin viewed each other as centers of artistic ferment. By the '30s, Europe was clearly heading into an era even more cruel and senseless than that of World War I. The Nazi press described the Bauhaus as a breeding ground of Bolshevism, and on April 11, 1933, storm troopers charged into the school, ostensibly to search for Communist pamphlets. Three days later, in the grim, cold dawn of Good Friday, the SS called at the house of John Heartfield to pick him up for arrest. Hearing their voices, the man who had continued to satirize Hitler in his photomontages jumped out the bedroom window. Shoeless, he began his flight over the mountains to Czechoslovakia. Man Ray was able to live peaceably in Paris until the Nazis occupied the city—and then he had to flee to America.

Moholy-Nagy, too, found refuge in the United States and lived there until his death in 1946. He founded a second Bauhaus in Chicago, and his ideas about the language of light, together with the freewheeling work bequeathed by Heartfield and Man Ray, inspired a whole new generation of photographers. And once again imaginative experimentation with the print is demonstrating how much more than a faithful record of nature a photograph can be. □

Carol Schwalberg

From the Radio Tower, 1928

The extreme-angle shot—a picture made looking straight down or straight up at the subject—was only one of the modern approaches to photography pioneered by László Moholy-Nagy. For the picture above he aimed his camera directly downward from the top of the Berlin radio tower. From that unusual perspective the snow-covered courtyard, the partially cleared walk, the bare trees and the foreshortened building all lose their identity to unite in a single design of abstract beauty.

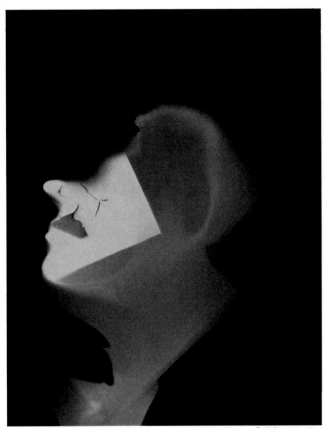

Self-Portrait, 1925

The shadow images of the photogram and the
multiplied images of the photomontage enabled
Moholy-Nagy to contrast the real and the
abstract in provocative ways. The photogram
above is a shadow of his own head on printing
paper. He created the bright wedge-shaped
segment by inserting an ordinary piece of paper
between his head and the printing paper for part
of the exposure. The photomontage at right
combines pieces of five photographs into a
satiric comment on society, suggesting that the
structure of the world may be only a flimsy
scaffolding supporting a leg-show and a scared
monkey for an audience of clacking pelicans.

Structure of the World, 1925

Far-out Prints of the Avant-garde

The same spirit of adventure that produced such unusual pictures after World War I—transforming the print with shadow images, multiple-exposure composites and reversed tones—blazed anew in the 1950s, soon after the end of another terrible war. Once again the avant-garde began trying out new concepts, new materials and new methods.

This renewal of experimentation with the print gained momentum in the 1960s and 1970s at a time when the old distinctions between photography, painting and sculpture were disappearing, particularly among boldly unconventional creators of Pop Art and photorealist painting. Utilizing the everyday images of technological society, Pop artists made paintings that looked like blown-up comic-strip panels, while the photorealists painted over gigantic enlargements of color slides projected on their canvases.

At the same time that the photograph was helping stir up the ferment in painting, a like ferment gave the photographic print itself different forms—all grounded in the photograph, but frequently borrowing techniques from printing, engraving, painting, even the tricks of old-time photographers, to create striking images of fantasy, beauty or heightened realism.

What is remarkable about the modern transformations of the print is their range. Techniques perfected during the 1920s are still widely used, but now they are often varied and combined. The two methods of reversing tones—solarization and negative printing—may be used togeth-er to make a single print *(page 216)*. Shadow pictures, also known as photograms, have in their turn become the basic subject matter for the multiple images of photomontages *(page 232)*.

Some of the manipulative techniques are appropriated from the photographic processing laboratory. The dye-transfer technique, for instance, was once only a high-quality, complex and expensive means for making color prints from transparencies; today, avant-garde photographers produce their own at home with stunning results *(pages 226-227)*.

Other processes have been revived from photography's earliest days. Chemical toning and hand coloring, formerly employed to add lifelike hues to photographs, are now used by printmakers to lend an otherworldly cast to images that they create from black-and-white negatives *(pages 218-223)*.

An even more basic technique, which dispenses with the negative altogether, has been used by California photographer and teacher Sheila Pinkel to create mysterious images like the one at right. Her print was made by crumpling up a piece of conventional enlarging paper and exposing it in the darkroom to light from her enlarger. Where the light struck the paper, it darkened; where the sensitized surface of the paper was folded in such a way that no light struck, the paper remained light. The paper flattened out when it was immersed in developer, leaving an abstraction in light and shadow that gives an illusion of depth.

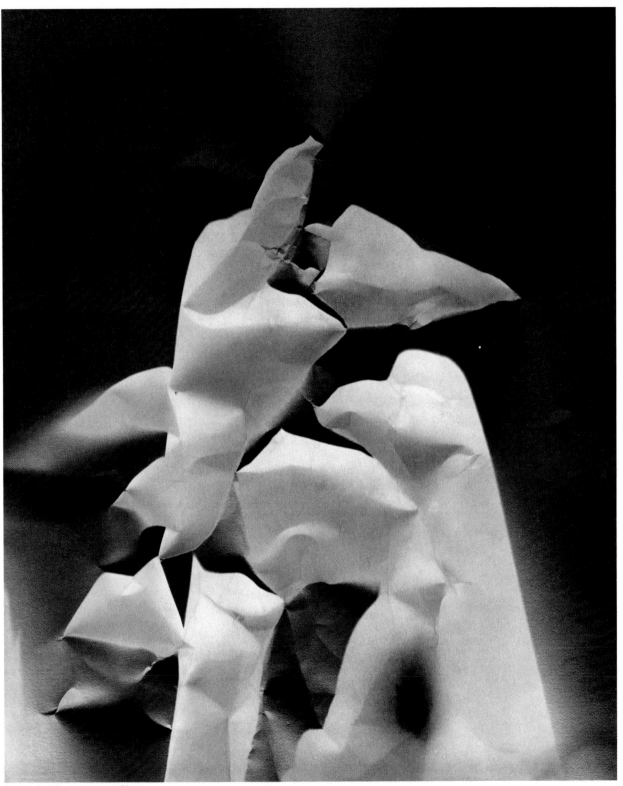

SHEILA PINKEL: *Lightwork*, 1980

The Drawn Pictures of Cliché-verre

GYORGY KEPES: *Photodrawing*, 1938

A *cliché-verre* (glass plate) is a print that is made not from a photographic negative but from an image drawn or painted on a transparent base. In its simplest form it has long been employed by painters who wanted multiple copies of a single work. But, in the hands of such artists as those represented on these pages, the *cliché-verre* becomes a photographic medium in its own right.

To make the print at left, Gyorgy Kepes began by dropping a small amount of paint on a glass plate and then putting another piece of glass on top of the first one to produce a partly smeared background. This created the grayish area on the print that extends from the upper right to somewhat past the center. After removing the top glass, he used a brush with oil paint and ink to draw the abstract figure on the bottom glass. This was then placed in an enlarger and printed as if it were a standard negative. He even dodged the smeared area to lighten it.

For the work at right, Sue Hertzel used two *cliché-verre* negatives. The inner rectangle was created by placing an ordinary household sponge on a piece of black-and-white film and exposing it to the light. While the film was submerged in the developer, she turned on a small flashlight and moved it across the exposed area, causing streaks to appear on the negative. The outer rectangle was formed on semitransparent rice paper; the artist added texture to the paper by drawing on it with a felt-tipped pen.

She then printed the negatives three times on paper that was hand-coated with a light-sensitive emulsion containing pigments—one coating for each of three colors: brown and two shades of gray. (This gum-bichromate process is described in detail on pages 184-192.)

SUE HERTZEL: *Paul's Window*, 1979

ROBERT CUMMING: *67° Body Arc off Circle Center, California*, 1975

BENNO FRIEDMAN: *From the series British Isles,* 1980

Making marks directly on the surface of a photographic print was once reserved for professional retouchers who attempted to enhance the image without letting their work show. Today, many of the photographers who manipulate the surfaces of their prints have no intention of concealing their efforts; their aim is to mark the print in a way that is clearly noticeable and frequently unusual.

Robert Cumming began making such a picture *(opposite)* with a straight print of a rather odd subject: a young man (the photographer himself) who appears to be exercising in a normal way until it is noticed that his forearms are sheathed in two-foot-long representations of pen points. Cumming then went to work on the print with his own drawing pen, ruler, triangle and compass, adding lines and circles to suggest that the man himself is turning into a mechanical instrument.

More whimsical is Benno Friedman's picture of a smiling pig *(left),* to which he gave brownish tones, ragged edges and a hand-drawn extension of the photographic image. When he enlarged his negative, Friedman used irregular pieces of torn paper to frame the central area. He exposed this central image for 6 minutes and then removed the torn paper from the lower left-hand corner for 20 more seconds of exposure. After normal processing, Friedman bleached the print in diluted potassium ferricyanide, which lightened the image, added contrast and turned the print brown.

When the print was dry, he added a thin line of spotting dye along the edges of the roughly shaped central image, so that it seemed to rest above the background. Finally, he drew in the image along the right side of the print and the borders around all four sides.

Solarization's Hint of Mystery

The haunting, otherworldly quality introduced when solarization reverses some of the normal tones of a print is eerily intensified in the two prints shown here by additional manipulation.

Edmund Teske's picture of a woman holding a flowerpot *(right)* is solarized to introduce a sense of unreality, an effect enhanced by negative printing; while Alice Wells's masquerade group *(opposite)* has been worked over with developing chemicals to alter individual tones.

To make his photograph, Teske first printed his negative on copying film, producing a positive transparency. It was this transparency that was solarized. He waited until it had been almost completely developed before turning on the solarizing light, which reversed some of its positiveness back to negative. Then he made a paper print from the solarized transparency.

The result is a print that is partly negative, partly positive—and mysteriously puzzling. The man's suit and the woman's jacket are clearly reversed, and her face is obviously positive—but her skirt, some of the buildings and the street can be interpreted either way.

Alice Wells used solarization to bring about a more dramatic transformation of the masked figures shown on the opposite page. The print, made from an old glass-plate negative, was solarized after about two thirds the normal development time; it therefore reacted more strongly to the light than did Teske's transparency, producing the weirdly gray faces at lower center and left. After development, but before fixing, an artists' brush was used to rub developer onto such areas as the faces at the center and right, blackening them to add to the bizarre appearance of the photograph.

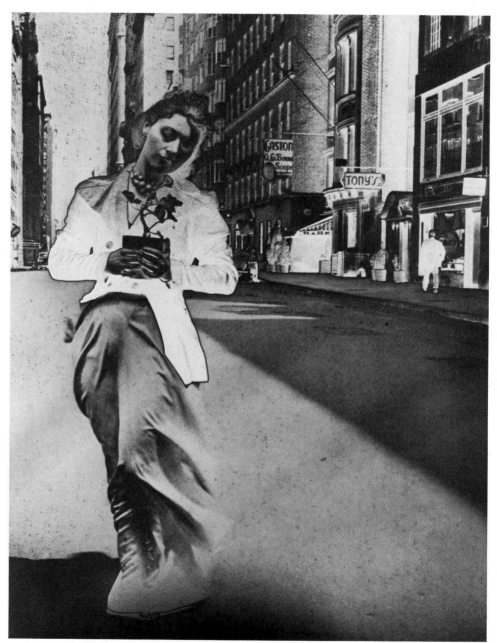

EDMUND TESKE: *Untitled,* 1939

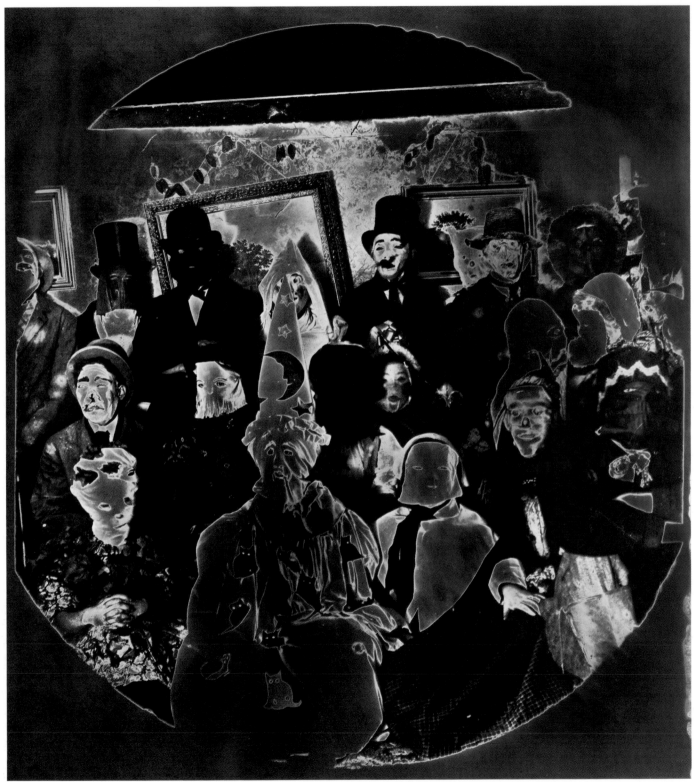

ALICE WELLS: *Untitled*, 1970

Images Made Cool and Warm with Toner

Toning was traditionally employed to give black-and-white prints an overall color that was appropriate to the subject—a warm sepia for portraits, for example, or a cool blue for seascapes. Today the photographer's objective is more often shades that nature never knew.

Olivia Parker gets a combination of several tones with a technique known as split toning. To achieve the frosty grays and warm browns of the composition at right, she started with a cold-toned silver chloride paper. Then she made a contact print of the entire negative—showing the indentations on two sides caused by the shape of the film holder and the notches at the top that identify the film type—and immersed the print in selenium toner.

This toner acts first on areas of a print that have the heaviest deposits of metallic silver—the shadow areas. When the toner had colored the dark areas—after an immersion of 10 minutes—she removed the print from the solution.

The middle and light tones remained a cool silver here, but the shadow areas had turned brown. This brown tone occurs only when selenium toner is used with papers containing silver chloride; with silver bromide papers, the toner produces a cool purple tone.

For his selenium-toned cabbage *(opposite),* Denis Brihat used a paper that contains both silver bromide and silver chloride. Without toner, this paper produces a quality suggesting warmth; toning turns it cool. Brihat's print required an immersion time of 2 minutes to produce the rich tones he desired. A longer immersion time would have resulted in the brown tones that characterize Olivia Parker's print.

OLIVIA PARKER: *On the Wing,* 1976

DENIS BRIHAT: *Red Cabbage,* 1976

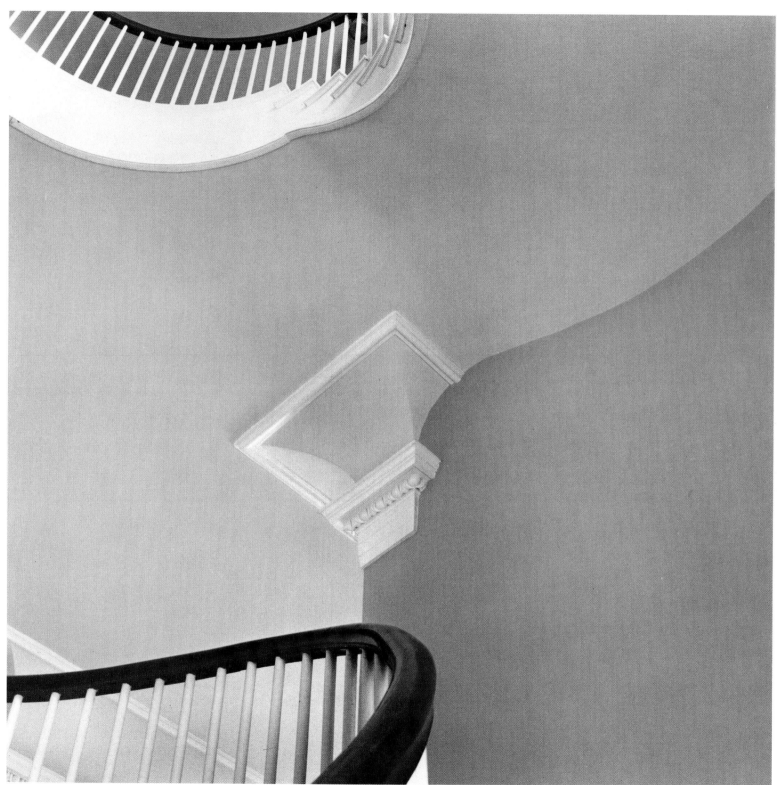

DENNY MOERS: *Bannister 3,* 1979

CHRISTOPHER JAMES: *Frank's Balloon, Oregon,* 1980

Many printmakers, seeking effects more dramatic than a single toning permits, selectively color areas of their prints during processing. Denny Moers processed his stained print *(left)* in the usual way up to the fixing stage. He brushed fixer only on selected areas—the areas with rails and balusters, for example—making them insensitive to light so that they would retain a normal tone. Then he turned on a light,

making unfixed areas—the ceiling, for example—turn shades of brown. When each area was colored to suit him, he dimmed the lights and applied more fixer to stop the staining.

To achieve the clear, rich colors in his picture of the underside of a hot-air balloon *(above),* Christopher James combined hand-painting with toning and dyeing in a process that took three days.

First, selenium and sepia toners turned dark areas brown. Then James masked the print with rubber cement except for parts he wanted red—the sharply delineated quadrangles near the center, for example—and immersed the print in red dye. He repeated the masking and dyeing with blue and orange. After the print dried, a violet oil pencil tinted the center, and enamel colored the arc of sunlight.

Hand-Painted Prints

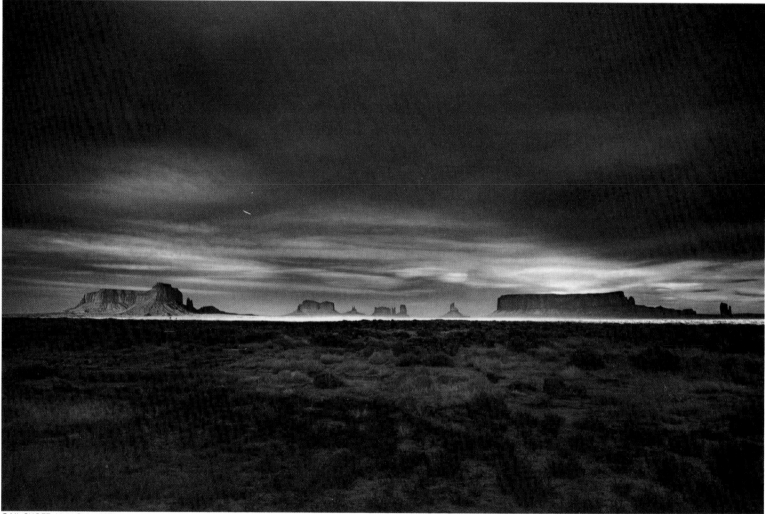

GAIL SKOFF: *Light Strip,* 1979

Before the widespread availability of color film, photographers sometimes hand-painted prints in an attempt to make them realistic. Today, photographers deliberately use colors that skew from reality.

In Gail Skoff's photograph of a Western landscape *(above),* the heightened colors dramatize the eerie light that accompanies a desert dusk. She used selenium toner to give the print a brown cast. Then she colored it with pencils and oil paints especially made for photographic prints.

Elizabeth Lennard obtained a more flamboyant print *(opposite)* by a similar method. She began with an enlargement, light and low in contrast, to make it easier to cover with paint. Then she hand-colored it with oils.

ELIZABETH LENNARD: *Arkansas House*, 1977

Adding On Real-Life Trimming

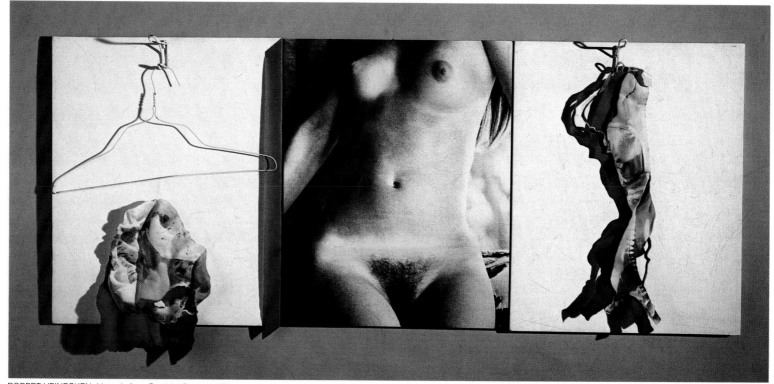

ROBERT HEINECKEN: *Lingerie for a Feminist Suntan*, 1972

The photographers represented on these pages have added something extra to their prints. The additions are three-dimensional objects projecting from the surface of the prints—a wire coat hanger, coat hooks and lingerie in the triptych shown above, a collection of model airplane propellers in the picture opposite.

The nude in Robert Heinecken's three-part print above is an ordinary black-and-white photograph enlarged on an artists' canvas that had been coated with light-sensitive emulsion. The coat hooks on the two outside panels are real—they are screwed into the canvases' wooden stretcher bars. A real hanger hangs from the hook on the left panel. But the under-pants at left and the brassiere at right are photographs printed on a stiff, emulsion-coated cloth called photo linen.

The linen was hand-colored with chalk, cut into lingerie shapes, crumpled and hung on the coat hooks. Purple shadows behind the lingerie were also cut from photo linen, but there the linen was not exposed, developed or fixed, and hence it darkened when struck by light. Real shadows, cast by the three-dimensional objects, appear on the surface of the work and also on the gray wall behind it.

Judith Golden's print *(right)* began with an 11-by-14 "lobby card" once used to advertise a Hollywood aviation melodrama. She copied the card on 4 x 5 black-and-white film and made a 30 x 40-inch enlargement. She also made a picture of herself in the heroine's role, then cut it out and pasted it onto the enlargement. She used oils to color the composite in the style of old movie posters, which were often printed in color though most of the films advertised were black and white.

To this spoof, one of her several take-offs on the daydreams of moviegoers who identify with the characters on the screen, the photographer attached toy airplane propellers, which project about one inch from the print's surface.

JUDITH GOLDEN: *Bombay Clipper,* 1977

Rich Hues from Dye Transfer

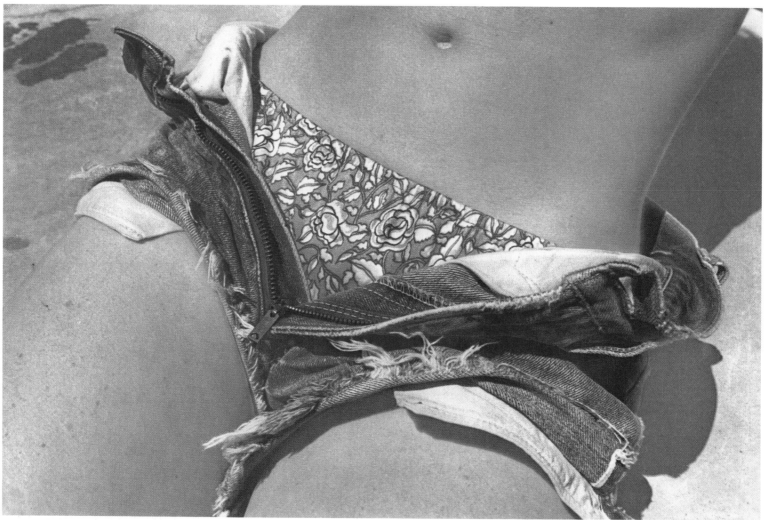

KENDA NORTH: *Dean's Jeans,* 1979

The dye-transfer process was introduced in 1946 as a means of making high-quality prints from color transparencies, but some photographers are now using elements of the process to produce color prints not from color slides but from im- ages originally shot in black and white.

When it is employed conventionally to print a slide, the slide is copied onto black-and-white film three times, each time through a primary color filter. These "separation negatives" are then printed individually onto special gelatin-emulsion film; each such "matrix" is dyed a prima- ry color. Then the dye is transferred by pressing each matrix, one after another, onto special paper.

For the print shown opposite, Charles

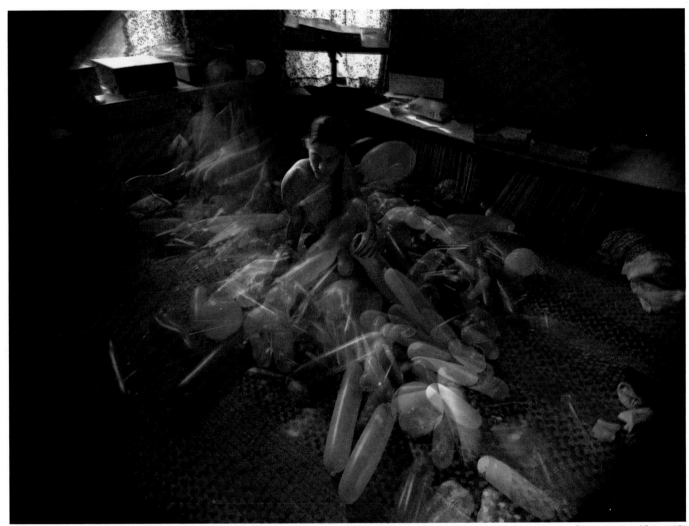

CHARLES SWEDLUND: *From the series, Reconstruction of Color,* 1976

Swedlund skipped the slide stage. He photographed the scene on three black-and-white negatives, made one at a time a few seconds apart, each through a primary-color filter. Then he used standard dye-transfer procedures. Because some balloons moved between successive exposures, they created strangely colored ghosts in the final image.

Kenda North deviated further from the standard technique for her picture. She began with a single black-and-white negative of a sunbathing friend, from which she made one matrix. She dyed it blue. Then she mixed dyes to paint the color she wanted directly onto each part of the matrix. Finally, she pressed the single, multicolored matrix onto special paper.

Impact of Many Images

By printing two or more negatives on the same paper, photographers can transform otherwise ordinary pictures into a single striking image. Though 19th Century photographers used similar methods in order to create naturalistic scenes, today's photographers continue the tradition of the Dadaists and Surrealists of the 1920s and 1930s *(pages 196-209),* combining incongruous elements to achieve bizarre, dreamlike effects.

One of the leading practitioners of the art of print transformation, Florida photographer and teacher Jerry Uelsmann avoids overlapping images, separating them so that each makes a distinct contribution to the central idea. In the print at right, branches growing upward are balanced by a lotus blossom whose petals, peeled back, delicately arch down from almost the same point in space.

Uelsmann achieved this separation by making two cardboard masks, one for each of the images in his print. When the negative of the branches was being printed, he blocked light from the lower part of the paper with the appropriate mask. When the lotus-blossom negative was being printed, he shielded the upper area of the paper with the second mask.

The number of negatives that can be used in a combination print is limited only by the imagination of the photographer. Bart Parker used either six or eight—he no longer remembers—to set the old against the new in the picture opposite.

He printed each of his negatives separately. He came across the pictures of the young girls *(bottom)* in an unlikely setting: They were decorating the walls of a southern roadhouse that had recently been closed by the police in a raid. The multiple images along the top of the print are all of Mrs. Parker and her small car.

JERRY N. UELSMANN: *Untitled,* 1968

BART PARKER: *Highway A1A*, 1968

Scissors-and-Paste Pictures

KEN JOSEPHSON: *Illinois,* 1970

The two prints shown on these pages— one a puzzle-like impression of a supermarket parking lot, the other a forceful expression of the motorcyclist's spirit— were made in similar ways. Both are collages, pictures made by pasting various elements on a background.

To create the scene above, Ken Josephson combined seven photographs taken over a half-hour period from the same spot outside a supermarket. Although the camera did not move, the activity in front of it changed, and several snatches of action have been pasted together, each one cleanly outlined by the familiar straight edges of conventional photographic prints. Some features remained stationary during most of the half-hour shooting— the car at left, for example, and the landscape mural, at rear, that decorates an outer wall of the supermarket. Portions of these elements appear in several prints.

To create the collage on the opposite page, John Wood adopted a more traditional method. He combined images that did not obviously go together and cut out only those parts of them that were relevant to his theme. He pasted up two negative prints— the group scene at upper left and the head of the motorcyclist at center— and one positive print of the driver on his machine *(lower right).* Wood then added the final design components by hand: He penciled in the circles, the "rear-vision mirror" in which the group scene appears, the partial contouring of the central figure and the straight and curved lines at far right.

JOHN WOOD: *Untitled*, 1969

A Magic Silhouette

The mysterious reddish flower picture of French photographer and teacher Jean-Pierre Sudre is one of a series in which he silhouettes plants (here, a stalk of fennel) against backgrounds composed of crystalized mineral salts. His procedure combines *cliché-verre (pages 212-213)* and photogram techniques *(pages 164-165)* with a special kind of toning.

Sudre began this print by making an unusual kind of *cliché-verre* negative. Instead of drawing or painting on a piece of glass, he covered the glass with a solution of potassium salt, which he allowed to dry, creating the spiky grasslike patterns at bottom. He then projected the glass negative onto photographic paper on which the second element of the picture, a stalk of freshly picked fennel, was placed as in making a photogram. The resulting black-and-white print combined the shadows of the plant and the mineral salts in one picture.

Sudre then began a process of toning that gave the final print the look of an engraved metal relief. First he bleached the print in homemade toner that attacked the gelatin emulsion, giving it an etched effect. Then he immersed it in an oxidizing solution that rusted all of the unexposed parts of the print, where no metallic silver had formed, turning them orange and brown. □

JEAN-PIERRE SUDRE: *Mineral and Vegetable, Lacoste,* 1978

Comparison of U.S. and Metric Units of Measurement

The United States lags far behind the rest of the world in adopting the universal system of metric measures—millimeters for inches, kilograms for pounds, liters for quarts, Celsius for Fahrenheit. Although January 1, 1979, signaled the official debut of American metrics—after that date wine had to be bottled in liters—the complete switchover to metrics in the United States promises to be slow and confusing as manufacturers place both the U.S. and metric measurements on their products.

To facilitate conversion in the years ahead, readers of the American edition of this book will find the measurements commonly used in photography included in the tables on this page.

Length

Inches (in.)	Millimeters (mm)	Feet (ft.)	Meters (m)	Miles (mi.)	Kilometers (km)
1 =	25.4	1 =	.305	1 =	1.61
2 =	50.8	2 =	.610	2 =	3.22
3 =	76.2	3 =	.914	3 =	4.83
4 =	102	4 =	1.22	4 =	6.44
5 =	127	5 =	1.52	5 =	8.05
6 =	152	6 =	1.83	6 =	9.66
7 =	178	7 =	2.13	7 =	11.3
8 =	203	8 =	2.44	8 =	12.9
9 =	229	9 =	2.74	9 =	14.5
.040 =	1	3.28 =	1	0.621 =	1
.079 =	2	6.56 =	2	1.24 =	2
.118 =	3	9.84 =	3	1.86 =	3
.157 =	4	13.1 =	4	2.49 =	4
.197 =	5	16.4 =	5	3.11 =	5
.236 =	6	19.7 =	6	3.73 =	6
.276 =	7	23.0 =	7	4.35 =	7
.315 =	8	26.2 =	8	4.97 =	8
.354 =	9	29.5 =	9	5.59 =	9

Weight

Avoirdupois ounces (oz. avdp.)	Grams (g)	Avoirdupois pounds (lb. avdp.)	Kilograms (kg)
1 =	28.4	1 =	.454
2 =	56.7	2 =	.907
3 =	85.0	3 =	1.36
4 =	113	4 =	1.81
5 =	142	5 =	2.27
6 =	170	6 =	2.72
7 =	198	7 =	3.18
8 =	227	8 =	3.63
9 =	255	9 =	4.08
.0353 =	1	2.20 =	1
.0705 =	2	4.41 =	2
.106 =	3	6.61 =	3
.141 =	4	8.82 =	4
.176 =	5	11.0 =	5
.212 =	6	13.2 =	6
.247 =	7	15.4 =	7
.282 =	8	17.6 =	8
.317 =	9	19.8 =	9

Capacity—Liquid Measure

U.S. fluid ounces (fl. oz.)	Milliliters (ml)	U.S. liquid pints (pt.)	Liters (l)	U.S. liquid quarts (qt.)	Liters (l)
1 =	29.6	1 =	0.473	1 =	.946
2 =	59.1	2 =	0.946	2 =	1.89
3 =	88.7	3 =	1.42	3 =	2.84
4 =	118	4 =	1.89	4 =	3.79
5 =	148	5 =	2.37	5 =	4.73
6 =	177	6 =	2.84	6 =	5.68
7 =	207	7 =	3.31	7 =	6.62
8 =	237	8 =	3.79	8 =	7.57
9 =	266	9 =	4.26	9 =	8.52
.0338 =	1	2.11 =	1	1.06 =	1
.0676 =	2	4.23 =	2	2.11 =	2
.101 =	3	6.34 =	3	3.17 =	3
.135 =	4	8.45 =	4	4.23 =	4
.169 =	5	10.6 =	5	5.28 =	5
.203 =	6	12.7 =	6	6.34 =	6
.237 =	7	14.8 =	7	7.40 =	7
.271 =	8	16.9 =	8	8.45 =	8
.304 =	9	19.0 =	9	9.51 =	9

Temperature

Celsius (Centigrade) (C.°) / Fahrenheit (F.°)

Bibliography

Techniques

Adams, Ansel:
Camera and Lens: The Creative Approach.
Morgan & Morgan, 1970.
The Negative: Exposure and Development.
Morgan & Morgan, 1968.
The Print. Morgan & Morgan, 1968.
Cory, O. R., *The Complete Art of Printing and Enlarging.* Amphoto, 1969.
†Curtin, Dennis, and Joe DeMaio, *The Darkroom Handbook.* Curtin & London Inc., 1979.
Eastman Kodak:
Basic Developing, Printing, Enlarging in Black and White. Eastman Kodak, 1979.
Creative Darkroom Techniques. Eastman Kodak, 1975.
Kodak Black and White Darkroom Dataguide. Eastman Kodak, 1980.
Kodak B/W Photographic Papers. Eastman Kodak, 1981.
Processing Chemicals and Formulas. Eastman Kodak, 1977.
Eaton, George T., *Photographic Chemistry.* Morgan & Morgan, 1965.
*Floyd, Wayne, *ABC's of Developing, Printing and Enlarging.* Amphoto.
Focal Press Ltd., *Focal Encyclopedia of Photography.* McGraw-Hill, 1969.
Fraprie, Frank R., and Florence C. O'Connor, *Photographic Amusements.* The American Photographic Publishing Co., 1937.
*Grimm, Tom, *The Basic Darkroom Book.* New American Library, 1978.
*Harris, E. W., *Modern Developing Techniques.* Fountain Press.
Heist, Grant, *Monobath Manual.* Morgan & Morgan, 1966.
*Hertzberg, Robert, *Photo Darkroom Guide.* Amphoto, 1967.
*Horenstein, Henry, *Beyond Basic Photography.* Little, Brown and Company, 1977.
Jacobson, C. I., *Developing: The Technique of the Negative.* Amphoto.
Jacobson, C. I., and L. A. Mannheim, *Enlarging.* Amphoto, 1969.
*Jonas, Paul, *Manual of Darkroom Procedures and Techniques.* Amphoto, 1967.
*Lahue, Kalton, ed., *Petersen's Big Book of Photography.* Petersen Publishing Company, 1977.
*Lewis, Eleanor, ed., *Darkroom.* Lustrum Press, 1979.
Lootens, Ghislain J., *Lootens on Photographic Enlarging and Print Quality.* Amphoto, 1967.
Mees, C. E. Kenneth, and T. H. James, *The Theory of the Photographic Process.* Macmillan, 1966.
Moholy-Nagy, L., *Vision in Motion.* Paul Theobald, 1947.
Neblette, C. B., *Photography: Its Materials and Processes.* D. Van Nostrand, 1962.
Nettles, Bea, *Breaking the Rules: A Photo Media Cookbook.* Inky Press Productions, Rochester, New York, 1977.
†Newman, Thelma R., *Innovative Printmaking.*

Crown Publishers, Inc., 1977.
Pittaro, Ernest, *Photo-Lab-Index.* Morgan & Morgan, 1970.
Pocket Darkroom Data Book No. 2. Morgan & Morgan.
Rhode, Robert B., and Floyd H. McCall, *Introduction to Photography.* Macmillan, 1966.
Satow, Y. Ernest, *35mm Negs & Prints.* Amphoto, 1969.
*Scopick, David, *The Gum Bichromate Book.* Light Impressions Corp., 1978.
†Spencer, D. A., *Color Photography in Practice.* Focal Press, 1966.
†Stone, Jim, ed., *Darkroom Dynamics: A Guide to Creative Darkroom Techniques.* Curtin & London, Inc., 1979.
*Vestal, David, *The Craft of Photography.* Harper & Row, 1975.
*Wade, Kent, *Alternative Photographic Processes.* Morgan & Morgan Inc., 1978.

History

Auer, Michel, *The Illustrated History of the Camera: From 1839 to the Present.* New York Graphic Society, 1975.
Camera Work. Alfred Stieglitz, New York City, 1903-1917.
*Crawford, William, *The Keepers of Light.* Morgan & Morgan, 1979.
Doty, Robert, *Photo-Secession.* George Eastman House, 1960.
Gernsheim, Helmut, *Creative Photography: Aesthetic Trends 1839-1960.* Faber & Faber Ltd., 1962.
Glassman, Elizabeth, and Marilyn F. Symmes, *Cliché-Verre: Hand-Drawn, Light-Printed, A Survey of the Medium from 1839 to the Present.* The Detroit Institute of Arts, 1980.
Lyons, Nathan, *Photography in the Twentieth Century.* George Eastman House, Horizon Press, 1967.
Newhall, Beaumont, *The History of Photography.* The Museum of Modern Art, Doubleday, 1964.
Scharf, Aaron:
Art and Photography. Penguin Press, 1968.
Creative Photography. Reinhold, 1965.
†Szarkowski, John, *Mirrors and Windows: American Photography Since 1960.* The Museum of Modern Art, 1978.

Biography

Frank, Waldo, *America and Alfred Stieglitz.* Doubleday, Doran & Co., 1934.
Gernsheim, Helmut and Alison, *Alvin Langdon Coburn: Photographer.* Frederick A. Praeger, 1966.
Livingston, Jane, *M. Alvarez Bravo.* David R. Godine, 1979.
Lyons, Nathan, *Photographers on Photography.* Prentice-Hall, 1966.
Moholy-Nagy, Sibyl, *Moholy-Nagy, Experiment in Totality.* The M.I.T. Press, 1969.
Newhall, Nancy, ed., *The Daybooks of Edward Weston.* George Eastman House, 1961.

Norman, Dorothy, *Alfred Stieglitz.* Duell, Sloan and Pearce, 1960.
Ray, Man:
Self Portrait. McGraw-Hill, 1979.
Photographs 1920-1934 Paris. Random House, 1934.
Seligmann, Herbert J., *Alfred Stieglitz Talking.* Yale University Library, 1966.
Steichen, Edward, *A Life in Photography.* Doubleday, 1963.

Photographic Art

Barr, Alfred H., Jr., *Fantastic Art, Dada, Surrealism.* The Museum of Modern Art, Simon & Schuster, 1947.
Bry, Doris, *Alfred Stieglitz: Photographer.* Boston Museum of Fine Arts, 1965.
Contemporary Photographs. UCLA Art Galleries, 1968.
Di Grappa, Carol, ed., *Landscape: Theory.* Lustrum Press, Inc., 1980.
Five Photographers. University of Nebraska, 1968.
John Heartfield. Institute of Contemporary Arts, London, 1969.
László Moholy-Nagy. Museum of Contemporary Art, Chicago, 1969.
Lyons, Nathan, ed.:
The Persistence of Vision. George Eastman House, Horizon Press, 1967.
Vision and Expression. George Eastman House, Horizon Press, 1969.
Man Ray. Los Angeles County Museum of Art, 1966.
Photography, USA. DeCordova Museum, Lincoln, Massachusetts, 1968.
†Rubin, William S., *Dada, Surrealism, and Their Heritage.* The Museum of Modern Art, New York Graphic Society, 1968.

Magazines

Afterimage. Visual Studies Workshop, Rochester, New York.
American Photographer. CBS Publications, New York City.
Aperture. Aperture Inc., Millerton, New York.
British Journal of Photography. Henry Greenwood and Co., London.
Camera. C. J. Bucher Ltd., Lucerne, Switzerland.
Camera Arts. Ziff-Davis Publishing Co., New York City.
Camera 35. U.E.M. Publishing, New York City.
Darkroom Photography. PMS Publishing Co., San Francisco.
Modern Photography. ABC Leisure Magazines, New York City.
Petersen's Photographic. Petersen Publishing Co., Los Angeles.
Picture Magazine. Picture Magazine, Inc., Los Angeles.
Popular Photography. Ziff-Davis Publishing Co., New York City.
Zoom. Publicness, Paris.

*Available only in paperback
†Also available in paperback

Acknowledgments

The index for this book was prepared by Karla J. Knight. For the assistance given in the preparation of this volume, the editors would like to express their gratitude to the following: Thomas F. Barrow, Associate Curator, Research Center, George Eastman House, Rochester, N.Y.; Diane Brown, Director, Diane Brown Gallery, Washington, D.C.; Peter C. Bunnell, McAlpin Professor of the History of Photography and Modern Art, Princeton University, Princeton, N.J.; Barbara Callahan, Director, Nexus Gallery, Atlanta, Ga.; Albert Champeau, Créatis, Paris, France; Carl Chiarenza, Arlington, Mass.; Walter Clark, Rochester, N.Y.; David L. Cooper, Consumer Service, Berkey Marketing Companies, Inc., Woodside, N.Y.; John Corey, Executive Assistant, Beseler Photo Marketing Company, Inc., East Orange, N.J.; John Craig, Department of Art, University of Connecticut, Storrs, Conn.; Darryl Curran, Los Angeles Center for Photographic Studies, Los Angeles, Calif.; Patrick Datre, Arkin-Medo, Inc., New York City; Robert M. Doty, Associate Curator, Whitney Museum of American Art, New York City; Albert E. Elsen, Department of Art History, Stanford University, Palo Alto, Calif.; James Enyeart, Director, Center for Creative Photography, University of Arizona, Tucson, Ariz.; Kathleen Ewing, Director, Kathleen Ewing Gallery, Washington, D.C.; William Ewing, Exhibitions Curator, International Center of Photography, New York City; Professor L. Fritz Gruber, Cologne, Germany; Ted Hartwell, Curator of Photography, Minneapolis Institute of Art, Minneapolis, Minn.; Marvin Heiferman, Director, Castelli Photographs, New York City; Gerald Jacobson, New York City; Allan Janus, Kensington, Md.; Harold Jones III, Associate Curator, Exhibition and Extension Activities, George Eastman House, Rochester, N.Y.; Carole Kismaric, Managing Editor, *Aperture*, New York City; Jean-Claude Lemagny, Curator, Bibliothèque Nationale, Paris; Tom Lovcik, Department of Photography, The Museum of Modern Art, New York City; Nathan Lyons, Director, Visual Studies Workshop, Rochester, N.Y.; Peter MacGill, Director, Light Gallery, New York City; Beppe Preti, Art Director, Il Fotografo, Milan, Italy; Howard Reed, Director, Robert Miller Gallery, New York City; Charles Reynolds, Chairman, Department of Photography, School of Visual Arts, New York City; Jerry Scarrett, PCI Publications, Eastman Kodak Co., Rochester, N.Y.; Lawrence Shustak, Instructor, Department of Photography, School of Visual Arts, New York City; Aaron Siskind, Providence, R.I.; Claudine and Jean-Pierre Sudre, Lacoste, France; Marilyn Symmes, Assistant Curator of Graphic Arts, The Detroit Institute of the Arts, Mich.

Picture Credits *Credits from left to right are separated by semicolons, from top to bottom by dashes.*

Index
Numerals in italics indicate a photograph, painting or drawing.

Printed in U.S.A.